Cinema Raw

Cinema Raw

Shooting and Color Grading with the Ikonoskop, Digital Bolex, and Blackmagic Cinema Cameras

Kurt Lancaster

Focal Press
Taylor & Francis Group

NEW YORK AND LONDON

First published 2014
by Focal Press
70 Blanchard Road, Suite 402, Burlington, MA 01803

and by Focal Press
2 Park Square, Milton Park, Abingdon, Oxon OX14 4RN

Focal Press is an imprint of the Taylor & Francis Group, an informa business

Library of Congress Cataloging in Publication Data
Lancaster, Kurt, 1967–
Cinema raw: shooting and color grading with the Ikonoskop,
Digital Bolex, and Blackmagic Cinema cameras/by Kurt Lancaster.
 pages cm
 ISBN 978-0-415-81050-0 (pbk.)
 1. Digital cinematography. I. Title.
 TR860.L36 2014
 777–dc23 2013041381

ISBN: 978-0-415-81050-0 (pbk)
ISBN: 978-0-203-78342-9 (ebk)
Typeset in Giovanni and Franklin Gothic
by Florence Production Ltd, Stoodleigh, Devon, UK

Printed and bound in India by Replika Press Pvt. Ltd.

This book is dedicated to my film and multimedia journalism students.

They work hard to do it right.

Bound to Create

You are a creator.

Whatever your form of expression — photography, filmmaking, animation, games, audio, media communication, web design, or theatre — you simply want to create without limitation. Bound by nothing except your own creativity and determination.

Focal Press can help.

For over 75 years Focal has published books that support your creative goals. Our founder, Andor Kraszna-Krausz, established Focal in 1938 so you could have access to leading-edge expert knowledge, techniques, and tools that allow you to create without constraint. We strive to create exceptional, engaging, and practical content that helps you master your passion.

Focal Press and you.

Bound to create.

We'd love to hear how we've helped you create. Share your experience: **www.focalpress.com/boundtocreate**

Focal Press
Taylor & Francis Group

Contents

About the Author

Kurt Lancaster is the author of *DSLR Cinema: Crafting the Film Look with Large Sensor Video* (Focal Press, 2013, 2nd ed.) and *Video Journalism for the Web: A Practical Introduction to Documentary Storytelling* (Routledge, 2013). He teaches digital filmmaking and multimedia journalism at Northern Arizona University's School of Communication. His documentary work has appeared at national and international film festivals, as well as in the Pulitzer-Prize-winning paper, *The Christian Science Monitor*, where he formerly worked as a consultant training print reporters to shoot video. He has also edited video for the *San Francisco Chronicle*. Kurt earned his PhD in performance studies from NYU.

Photo by Kathryn Moller.

Foreword
Virgin frames. Untouched.
by Michael Plescia

CHEAP WINE AND THE SNOBS

Historically in my life, I often felt lucky that my sense of taste was so oblivious and forgiving that I could easily enjoy a three-dollar bottle of wine as much as a fifty-dollar bottle, and that my ear was not discerning enough to ever care much about the difference between listening to music on vinyl versus a CD. This simply allowed me to carry my music in my pocket and made me a cheap date. But then, back when new films shot on the first generation of digital cinema cameras—cameras like the CineAlta, the Genesis and the RED One—first started appearing on movie screens—my eyes revolted.

I suddenly knew what wine "snobs" and vinyl "evangelists" must have felt as newer, lesser forms grated against their senses. I realized why these passionate enthusiasts had gone kicking and screaming into the era of digital music. Or why they had scoffed when Trader Joe's Charles Shaw three-dollar wine became all the rage. And why they had desperately tried to explain to unsuspecting victims that a sort of crime had been committed.

I was now in their position.

It seemed that if I had any palette sensitive enough to drive me to the point of neuroticism it was my visual one, and I was unfortunately overly sensitive to the lack of color depth, absence of good grain structure, and changes in rendition of motion (due to lack of physical shutter mechanisms) that were characteristic of the new rigs. With these subtle changes in image quality and character, I felt my suspension of disbelief—my whole viewing experience—suffer, and I found myself having a very hard time becoming enveloped in the stories shot on the first wave of digital cinema cameras. I felt like I was watching actors play dress-up rather than soaking in their emotional truths.

So it was during the growing pain years of inferior sensors, when some movies started to look like bad television, at a time when film-trained cinematographers were still struggling with how to create visually rich images on a new capture medium, that my visual perceptual system felt that cinema was dying and that something holy to me was under assault.

THE GREEN ONE

Even though at the time I agreed wholeheartedly that these cameras would end up creating a democratization of filmmaking that would probably effect amazing changes on cinema as a whole and give otherwise undiscovered filmmakers a voice, I still developed an irrational and deep—almost moralistic hatred—for the RED One camera. I felt deep compassion and pity for the artists who I was convinced had been tricked by hyped-up marketing to destroy their artistic vision with an inferior recording medium.

At dinner parties, I began to call the RED One camera the "Green One" because of the tinny, sickly quality it gave skin tones. I created a game with my wife where I would play new movie trailers to see how quickly I could spot something filmed on the RED. I would see how fast I could pause a trailer the moment I spotted a human face that looked like it had been covered in a layer of green peanut butter, and then I'd run to the IMDB technical specs to confirm my smug accusations. My record for spotting a RED camera was four seconds into a trailer. I was never wrong. I made empty threats that if I were to shoot a feature digitally, I would shoot it on a Canon DSLR sensor that reproduced skin tones and red values better (ironic much?), and didn't exaggerate every skin pore an actor had.

I was guilty of much use of hyperbole during these years, but I was not alone. I was on set at the end of the last decade with a famous DP who had just lensed (on celluloid) the critically acclaimed blockbuster of the summer. Before the first shot of the day, while standing against a giant 35mm Panavision rig, he went on to blast the RED One for what he called an anemic sensor, and a business model that he said was based on great marketing rather than great quality of image and look. He had a nickname for it too; he called it the "Red Bull" of cameras (referencing the highly marketed energy drink).

I, like many others, became very involved in an emerging camera community that grew into a massive market partly due to this dissatisfaction with the new looks. Tracking the innovations and announcements by manufacturers was a little bit like chasing a carrot on a stick. In a progressively more post-celluloid world, there existed a feeling amongst indy filmmakers that someday the camera we were all waiting for would arrive. The chosen one. The savior. The one that would look like film.

HOLLYWOOD'S DIRTY LITTLE SECRET

Sensing that this was probably a very unhealthy trap, several independent filmmakers came up with the same advice, "Don't wait. Pick up a camera, any camera will do. Grab the damn thing and point it at good performances." And this was well meaning, but also terribly annoying. I hadn't waited; never for money, for permission, or for the dream camera to come along. But just because I told stories with cameras that I was not completely happy with, didn't mean I had to like how they looked. It didn't mean that lifeless imagery couldn't

distract and undercut great performances. Besides, with the kind of money and crew that many of these established filmmakers enjoyed, any camera pointed at their gorgeous lighting setup would do. What us steerage passengers of the film world wanted was a camera that when pointed at less than stellar lighting and makeup would forgive us a bit for what was lacking. Like celluloid used to do.

Eventually, things got a bit better. A bit.

I softened on the RED—especially the RED Epic. I could especially celebrate what they and their kin began to do for independent film, and I became enamored by the looks and production methodologies born from the advantages the cameras offered much larger productions: like David Fincher being able to burn 90-odd takes for scenes in *The Social Network* (2011) in order to achieve the stellar performances he needed. Other directors used the 4K resolution to "punch-in" to medium-length shots without having to change setups and lenses. Peter Jackson used 48 RED Epics housed in various rigs to film *The Hobbit: An Unexpected Journey* (2012) in 3D at 48 frames per second. I even recently saw Terrence Malick's *To the Wonder* (2012) and found myself unable to differentiate what was shot on 35mm and 65mm versus the RED Epic. (Part of this, though, was due to the high contrast color grade that eliminated tell-tale signs of digital capture in the lowlights of the image.)

But as much as I had caught up to modern times in my embrace of digital capture as an originating medium for other people to shoot with and defile themselves with, I still felt that the new cameras produced no life in the low lights, color rendition, and skin tones. After all, on a behind-the-scenes featurette on the set of *The Hobbit*, Peter Jackson even admitted to having the makeup department paint the dwarves' faces a bright ruddy red hue because, as he stated, "The RED eats color."

The sentiment I heard around me in the film community was that digital acquisition wasn't yet on par with the quality of 35mm film, but that the gap would be closed soon—that if digital left anything to be desired, innovations in resolution and dynamic range would end all discussion next year. But it was always next year.

This argument also confused me. My problem with the cameras had never really been an issue of how much detail I could see. The RED One already shot in 4K, close to the theoretical resolution of 35mm film. It already had a rather impressive dynamic range that rivaled film. I could already count the actor's blackheads. So why did it look so inferior to me still? I got to thinking that in the visual effects industry, we were nearly always working on frames with a final output resolution of only 2K. I recollected that I had only worked on two 4K resolution shots in my whole career. Hollywood's dirty little secret was that most images presented on the silver screen were of a rather low pixel count. All of this, yet, I never found quality to be lacking when I'd seen the work projected in the theater.

COLOR BIT DEPTH NOT RESOLUTION

What this indicated was that maybe resolution wasn't necessarily the lynch pin in the problems with these cameras. Maybe it was the bit depth of laser-scanned film that was responsible for its richness of color, or maybe it was the lack of compression of the .dpx files that we used professionally, or the shimmering grain structure of film, or how the highlights rolled off softly in celluloid. Maybe these were all more important than how many pixels were in an image. In other words, you could have all the pixels in the world, but if they were crappy pixels, it wouldn't help the cause.

Even Steve Jobs, when he appeared during one of his last Worldwide Developers Conferences echoed this suspicion of the fetishization of resolution when he said, "Everybody loves to talk about things that are very tangible when it comes to photography, like megapixels, but we [at Apple] tend to ask the question, 'How do we make better pictures?'—and they're different things."

I was in a strange position. Steve Jobs wasn't about to make the iRED or write me a check for a lifetime's supply of Kodak stock. Emotionally, I considered myself a director who worked solely on film, and since there was the small matter of rarely having actually shot with film, my prosumer videography must have just been a temporary embarrassment. Originating my ideas on film was a symbolic dream. Symbolic that somewhere, out of my reach, images could look good. But that wasn't the whole story. Complicating matters was that even if I had a lifetime's supply of Kodak, most of my experience making home movies had been in creating images using analog or digital video tape. My entire directing style had evolved around the ease of cheap recording media. From the way I worked on set to the conceptualization of my productions I was a "digital" filmmaker. I liked that, but hated the look of most anything that didn't originate on film. Here I was swearing by film, a dying technology, and in an almost hypocritical way, by not patronizing it, I was also contributing to its death. I was a wine lover who abhorred cheap wine but never had the means to drink the expensive wine he defended vehemently.

CYBORG CAMERAS

It was around that time, I heard of a new camera called the Ikonoskop A-Cam dII and then awhile later, I learned of another company's plans for the similarly conceived Digital Bolex D16. What struck me was that neither company seemed to fetishize resolution. In fact, Ikonoskop's designer Göran Olsson didn't seem concerned that his camera captured at a near HD resolution as opposed to 2K, and said in an interview that you really couldn't tell the difference. Joe Rubinstein, the designer of the Digital Bolex, even wrote an essay about why they would not be pursuing 4K resolution in the D16 Digital Bolex. This philosophy was intriguing and one that I hadn't heard from other camera manufacturers. It wasn't so much that I didn't want resolution, but I thought, if these camera designers were willing to turn their backs on the resolution

arms race, what might they be concentrating on instead—for the quality of the pixels they did have? What other overlooked aspects of camera design might they bring to life?

The answer was that the designers had created cameras whose data-pipes were so robust and storage cards so fast that they could capture truly uncompressed 12-bit raw frames. First the Ikonoskop and then the Bolex had opted to remove the heavy (and hot) processing and compression hardware from the camera to focus on recording images from an analog sensor and write them to unadulterated raw wrapped by Adobe's open source CinemaDNG format. Raw frames converted from an analog source. Truly uncompressed. Virgin frames. Untouched.

When I saw test footage from these cameras, I couldn't believe my eyes. It was cinematic and narrative in feel. It looked like a chimera—half film and half digital. It was like seeing a cyborg that was passing unnoticed—with robotic innards and human flesh on the outside. In a blind taste test, I probably would have guessed it was a 50 ISO daylight Kodak stock shot at a Super 16mm aperture.

As I got early access to work with these cameras, I found that when you had an untainted color-depth spared from the meat grinder of compression, combined with a global shutter and an analog sensor, things came back to life. Richness of color, life in the skin tones and shadows, and in gradient nuance. With so much retrievable information, you could underexpose to protect the highlights from clipping and then lift the footage to a healthy level in the grade to create the soft roll offs in the highlights. The image was not all about depth and bokeh and closeups like with DSLRs. These new cameras were about surfaces, textures, skin, and performances. You felt permission to film wider; to let the mise-en-scéne unfold. The images came alive in traveling masters. Lock-offs didn't feel so harshly static. The image had confidence, so *you* had confidence that the camera would capture the life in front of it—and with that, you had less of an impulse to overcompensate for a lifeless frame by moving the camera and over-cutting in editing. The analog sensor made grain pleasing, lowlights had a soul again, the image felt like story. These cameras were certainly an adjustment from shooting with a DSLR. The way they saw light. What they wanted to be pointed at.

> When I saw test footage from these cameras, I couldn't believe my eyes. It was cinematic and narrative in feel. It looked like a chimera—half film and half digital. It was like seeing a cyborg that was passing unnoticed—with robotic innards and human flesh on the outside. In a blind taste test, I probably would have guessed it was a 50 ISO daylight Kodak stock shot at a Super 16mm aperture.

Images didn't at first appear to come out of the sensor looking as beautiful as DSLRs. The cameras were not Easy-Bake ovens. At first glance, this could feel discouraging. But the data needed good grading—both to neutralize the image

of any color shifts and then to make it sing. It could look tinted at first, but then colors that you thought were all mushed together, would suddenly separate and the camera's magic would emerge. This type of grading would have broken DSLR footage. After a good grade, I found the images finally expressed a very substantial quality to them. Rather than feeling thin, tinny, pallid, finally the images of digital cinema had weight.

This moment was a tremendous emotional relief for me. More so than I'd like to admit. So I'm here to tell you that you can breathe easy. The gap is closing, the cameras have made it. I've been fooled plenty of times now thinking that something was shot on celluloid film when it wasn't. I no longer play the movie trailer game. I now call the "Green One" the RED and the looks that I've been able to get with the new wave of raw cameras amaze me. And, although they may look exactly like film, nowadays, when I'm at a dinner party of film enthusiasts, holding my glass of exceedingly cheap wine, I'm not so much of a grouch when somebody makes the mistake of bringing up the subject of cameras.

> Rather than feeling thin, tinny, pallid, finally the images of digital cinema had weight.

Michael Plescia is a writer, filmmaker, and photographer from the San Francisco Bay Area. He has ten years' experience as a visual effects compositor in feature film, commercial, television and promo. His work has been seen in films including Jumper, The Legend of Zorro, Zodiac, *and most recently* Jack Reacher, *where he was tasked with digitally removing Werner Herzog's fingers.*

He has worked closely with a roster of high-profile clients including Nike, Audi, AT&T, Hugo Boss, Gatorade, and Janet Jackson. Michael now resides in Los Angeles. A sampling of his visual effects work can be seen on Vimeo (https://vimeo.com/62194191).

Acknowledgments

There's an entire host of people I need to acknowledge in writing this book. First off Dennis McGonagle, my publisher at Focal Press, who not only hosted a dinner for me at NAB, but pushed me to make the book better than the original pitch. I also want to thank my original editor on this project, Lauren Mattos, who got really excited about the idea and shepherded it through the proposal stage, and Emily McCloskey, who took over from Lauren, and has helped with the overall vision of the book. In addition, my current editor, Peter Linsley, has been instrumental in helping finalize the book into the production phase. He expressed a lot of patience for missed deadlines as we waited for cameras to get released to the market. Denise Power, the production editor, made sure the book was well designed and came in on deadline.

When I first heard about the Digital Bolex on a Twitter feed from Philip Bloom, I went to the Kickstarter page for the D16 and saw Joe Rubinstein and Elle Schneider pitch their cinemaDNG raw camera. I was sold. Both Joe and Elle have gone out of their way to open the doors and allow me a peek into the camera-making process more so than any other company I've encountered. Joe is a visionary and quality for him is far more important than quantity. Elle envisioned cutting-edge design concepts and made sure the camera had the features needed to make it something special. Both Joe and Elle allowed me to hang out with them at their offices in Los Angeles and I took a trip to Toronto where I saw them interact with the Ienso team, the group who built the camera. They were all open to my questions and helped assure me that they really had no secrets. A small company with a big vision, they were there to help build a quality camera. So special thanks to Mike Liwak, VP of product development, Joe Bornbaum, VP of finance, and Stelio Derventzis, President of Ienso. They're sincere people.

John Brawley, a master cinematographer, allowed me to observe him use the Blackmagic Cinema Camera on the set of *Offspring* in Melbourne, Australia. He's a gentleman and answered my questions about how he got involved with Blackmagic Design. He also agreed to provide technical feedback on the manuscript. I also want to thank Stephanie Hueter at Blackmagic Design, who

went out of her way to make sure I received a Blackmagic Cinema Camera for five days, so I could test it out on a shoot. The camera went beyond my expectations and I can only thank Stephanie for stepping up and making it happen.

My good friend Beau L'Amour agreed to drive me around Los Angeles to find camera stores with lenses, where I received technical advice from such people as Brendan Lay at Alan Gordon Enterprises, Hollywood and Patrick Gee at Samy's Camera. We also drove to the depths of an industrial section of LA and met Andrew Cochrane and Michael Plescia, two filmmakers passionate about the Ikonoskop. Each is, in their own way, a visionary about the next wave of cinema cameras—and both avoid the tech spec camera wars to discuss the intricacies of camera designs that express character in ergonomics and the film-like character of the A-Cam dII. Michael was so passionate about the camera, I asked him to write the Foreword to this book. Following the Ikonoskop theme, I also want to thank Peter Gustofsson, who not only agreed to meet me at his offices outside of Stockholm, but also lent me an A-Cam dII for a couple of days so I could test it on a short documentary in the field. My former film student and friend, Katie Holmdahl, agreed to take a train from Gothenburg to Stockholm, so she could help out with the shoot. She not only found the story—an organic farm outside of Stockholm, but she produced the project and edited it. I couldn't have done it without her.

I'm really indebted to those who agreed to be in my films. In Stockholm, several farmers discussed their work on an organic farm under the eye of the Ikonoskop A-Cam dII. Jay Ruby, and his amazing performance team, the Carpetbag Brigade, were great on-camera for the Blackmagic Cinema Camera. I love making documentaries because people open up their heart for you and Jay's one of those people who shares his heart easily. And several street performers at Venice Beach, California were good sports for letting me shoot them with the Digital Bolex D16, with assistance from Rubinstein and Schneider, as well as Michael Plescia on audio.

It's not easy to write a book and I couldn't do it without people agreeing to be a part of it. I look at films online and when one grabs my attention I track down the filmmaker and ask if I can interview them for the book. This is what makes the book special—the fieldwork reporting where I find out about the stories people are telling and what makes the cameras they use special to them and their projects. Sometimes they become friends, sometimes I never hear from them again, but they always hold a special place for me since they became a part of my book. This includes Michael Plescia, who I mentioned above, as well as Marco Solorio, Alec Weinstein, Alex Markman, Antonin Baches, Philip Bloom, Jonathan Yi, and Joe Kyle—all of them pushing the boundaries of filmmaking by using cutting-edge technology and pushing the form in new directions, paving the way for other independent filmmakers. Plescia became key in teaching me about the digital film look, use of digital film grain, and he walked me through the complexities of Adobe's Camera Raw software.

I offer special thanks to Northern Arizona University for a summer grant from the Faculty Grants Program—this gave me the time to sit down and write a good chunk of the book. I also want to thank my film and journalism colleagues at NAU—Mark Neumann, Janna Jones, Paul Helford, Jon Torn, Angele Anderfuren, Brandon Neuman, Dale Hoskins, Norm Medoff, Bob Reynolds, Harun Mehmedinovic, Rory Faust, Laura Camden, Annette McGivney, Mary Tolan, Peter Friederici, Marty Sommerness, and Kira Russo, as well as my dean, Stephen Wright, among others at NAU who make it a fun place to work.

And lastly I want to thank my partner Stephanie and her son Morgan, who are always there for me.

Introduction
What camera to choose?
What story to tell?

THE PROMISE OF CINEMA DNG RAW WITH THE NEXT GENERATION OF LOW BUDGET CINEMA CAMERAS

The holy grail of independent filmmakers is to shoot raw video with an inexpensive camera. When RED announced their Scarlet camera in the spring of 2008 at NAB with a projected price of $2,500 the independent film and professional video world went into a frenzy as they dreamed about cinematic possibilities with an inexpensive camera. Because RED developed most of their technology in-house—including the creation of their own type of compressed lossless raw and lenses—their R&D skyrocketed and the production of the Scarlet was delayed until late 2011 with a base cost of $11,000 (not including required accessories and lenses)![1]

Canon filled the cost gap with the 5D Mark II (announced in October 2008), creatively utilizing its video potential by Vincent Laforet with *Reverie*,[2] proving that someone with a trained eye could shoot cinematic images with a $2,500 camera. Indeed, it revolutionized the prosumer video camera market, forcing such companies as Sony and Panasonic to release video cameras with removable lenses and large sensors in order to compete. But all of these prosumer cameras (whether DSLRs or other HD video cameras) compromised their image with a compression codec (8-bit) that looked good in-camera but was too "thin" to do strong color grading work in postproduction. It many ways it's worse than working with jpg vs. raw images in Photoshop (see Figures I.1 and I.2 below, where we can begin to feel the thickness of the image as colors are recovered in the final corrected image—it would be nearly impossible to engage this kind of grade to 8-bit compressed video).

1 By the time the Scarlet came out, it was the rename of the RED One—the original design, concept, and price point of the Scarlet, scratched.
2 See https://vimeo.com/7151244

FIGURES I.1 AND I.2
The potential of shooting raw. Figure I.1 shows the image washed out, the image holding data in a wide dynamic range, while Figure I.2 reveals details and richness of color after color grading. (Images courtesy of the author.)

THE IKONOSKOP

Swedish filmmakers Göran Olsson and Daniel Jonsäter released the first CinemaDNG camera with Ikonoskop's A-Cam dII in late 2010. They focused on ergonomics with famed Swedish design creating a beautiful simplicity in their camera. When DSLR guru Philip Bloom saw the footage coming off the camera at the 2012 NAB, he tweeted how it was the best-looking image coming off *any* camera that year.[3] Unlike the digital CMOS sensor, Ikonoskop leaned toward using an analog Kodak CCD sensor. Ultimately, Ikonoksop's camera would become key on several indy productions—and the look would become a benchmark for creating a camera with character—but by the summer of 2013, Ikonoskop had stopped production of their camera and were attempting to sell the company. The A-Cam dII was too expensive (over $9,000) to really capture the market—especially when compared to cameras coming out of the DSLR cinema revolution. (They eventually found a buyer in the fall of 2013.)

CinemaDNG is a software coded "wrapper" that encodes raw data from a camera's sensor. CinemaDNG takes the digital negative format (DNG) and adds certain types of metadata, such as framerate, audio, and timecode. It's as close as you can get to unprocessed and uncompressed, although it does allow for compressed versions, such as the "lossless" spec found on the Blackmagic Pocket Cinema Camera and a "lossy" spec on the 4K version of the Blackmagic Production Camera. It converts the files into individual frames—a series of still pictures (24 per second), which is actually a throwback to old-school filmmaking where you can look at a series of stills on a roll of film, which provides an illusion of movement when projected at 24 frames per second. The standard for CinemaDNG (digital negative for cinema) was developed by a team at Adobe—they made it an open-source format, meaning that it is not proprietary and anyone can use this standard in any application.

DIGITAL BOLEX

Attracted to the open source CinemaDNG format—and inspired by the quality of the image coming from the Ikonoskop camera—Joe Rubinstein and Elle Schneider got together a team (including engineers from Ienso in Toronto) and built a cinema camera crafted from the retro looks of the classic 16mm Bolex camera. They decided to focus their market on independent film-makers and film students, so they set their specs and manufacturing process for a camera that is priced at $3300. In short, they were able to do what RED failed to do, because they used existing technology rather than R&D a camera from scratch.

3 Philip Bloom, 2012. Tweet: "My favourite image from a camera at the show? Probably the @ikonoskop. Lovely! [H]ope to shoot with it soon!" http://propic.com/23N9

BLACKMAGIC CINEMA CAMERA

At the same time, Blackmagic Design—known for production hardware and postproduction software (such as DaVinci Resolve)—announced their own raw cinema camera at NAB in April 2012 for about the same price as the Digital Bolex, of $3,000.[4] Presales shot beyond their expectations. The sensor is 2.5K and sits between super 16mm and super 35mm, and a super 16mm lens will vignette on it. We're in a moment of digital cinema where the technology is creating a new democratization of cinema—with cinema cameras as opposed to video cameras—similar to the advent of sync sound 16mm film cameras developed in the early 1960s. In April 2013, Blackmagic Design announced the release of a 4K version of their 2.5K Blackmagic Cinema Camera (BMCC) for $4,000—upending the high-resolution video camera market. Furthermore, they also announced a $1,000 Pocket Cinema Camera (BMPC) that they claim shoots a compressed form of CinemaDNG ("lossless") and Apple ProRess 422 (HQ), again attempting to blow the doors off of the competition.

Because the Pocket camera records to an SD card, filmmaker Marco Solorio of OneRiver media wanted to know more about how Blackmagic Design could create a raw camera in such a small package. He interviewed Grant Petty, founder and CEO of Blackmagic Design at the industry trade show, NAB, in Las Vegas, April 2013.[5] Petty explained how they were able to get raw CinemaDNG onto an SD card at 24 frames per second, but ran into issues at 30 fps. They really wanted to do raw, so they went back to the CinemaDNG spec sheet. They discovered that not only was there uncompressed raw that they put into their 2.5K Cinema camera, but there were two compression types for 12-bit raw[6] CinemaDNG. Petty explains:

> There's a lossless compression (which is about 2.5:1 to 1.5:1[7]—that's not very much compression—it's mathematically clean, it's perfect). And then there's a slightly lossy version, which is like a variation of jpg—it's visually lossless; it's very clean—and of course you're still getting 12 bit raw, so it's awesome. . . . So we've decided to implement those standards.

4 By August of 2013, Blackmagic reduced the price of their Cinema Camera to $1995.

5 OneRiver Media. "NAB 2013—Marco Solorio interviews Grant Petty of Blackmagic Design." https://vimeo.com/63892665.

6 According to John Brawley, the BMCC utilizes a 16-bit file at the sensor level, encoding it as a linear file, but when it recorded to the SSD, it's converted to a 12-bit logarithmic file. It's the only way they can get the data rate fast enough for the SSD. See http://www.qvolabs.com/Digital_Images_ColorSpace_Log_vs_Linear.html for a good overview of the difference between linear and log files.

7 Adobe lists the lossless compression at 2.5:1 and 8:1 for lossy compression. *CinemaDNG Image Data Format Specification*. Version I.I.0.0, September 2011. http://wwwimages.adobe.com/www.adobe.com/content/dam/Adobe/en/devnet/cinemadng/pdfs/CinemaDNG_Format_Specification_v1_I.pdf

Blackmagic Design had actually developed their own 3:1 compression codec, but they decided to stick with the open standard of CinemaDNG.[8]

The Pocket Cinema Camera (BMPC) contains the CinemaDNG lossless compression, while they added the "slightly lossy" DNG codec to their 4K camera in order to keep the data rate down. Petty claims that, "[m]ost people are going to find that you cannot tell the difference" between the compressed CinemaDNG and the uncompressed. Furthermore, Blackmagic is also developing a QuickTime wrapper for the CinemaDNG format. "What we want to do," Petty says to Solorio, "is to save the DNG into the QuickTime movie. That would potentially let us decode and read the files. We'll make it a QuickTime movie, but it's actually CinemaDNG inside—so that would be much more readable by Final Cut Pro and other applications like Premiere Pro."

And on top of all of this, software programmers who are camera enthusiasts—working as a hobby—developed free/donation software in May 2013 that allows Canon DSLRs to record raw HD video. (See Chapter 2 for more information.)

RAW VIDEO IS HERE

The desire for raw video is here and several companies are making it happen. This book covers camera operations and postproduction workflow with low budget CinemaDNG cinema cameras, where the images are not compressed, providing a strong potential to shape a filmic image (raw video at 12-bit 4:4:4), a feature not found in *any* camera in its projected price range, so these companies are leaving many of their higher-end competitors in the dust, essentially providing the democratization of raw filmmaking for those who can't afford high-end cameras. I will also address Magic Lantern's raw mode in Canon DSLRs, because it's such an important topic when discussing production and postproduction methodology. Between May 18 and May 28, 2013, Planet5D. com had collected over 100 video tests dealing with Canon raw video.[9] I do not include any high-end cinema cameras shooting a form of raw, but focus

8 According to the CinemaDNG standard document, this compression has not been accepted, yet: "B.3 Lossy Image Compression. Some use cases call for lossy compression (8:1 or better) and constant bit rate. This would reduce storage needs and transfer times. Candidate methods for lossy compression would have to be evaluated against requirements such as performance, power consumption, complexity, licensing, availability, and standardization." Adobe Systems Inc. "CinemaDNG Image Data Format Specification." Version I.I.0.0, Sept. 2011. In addition, the original marketing document for Blackmagic's Pocket Cinema Camera did not mention any type of raw. Apparently this request was by Blackmagic officials at the CinemaDNG user group at NAB in 2013.

9 Planetmitch. "Largest collection of Magic Lantern RAW HDSLR video on the planet," 18 May 2013. http://blog.planet5d.com/2013/05/largest-collection-of-magic-lantern-raw-hdslr-video-on-the-planet/

Against High Resolution

Filmmaker Michael Plescia, who fell in love with Iknoskop's A-Cam dII and Digital Bolex's D16, pushes back against 4K resolution, because it goes *against* the film look:

> In 4K cameras I felt resolution was unforgiving, forensic, harsh. What people don't realize sometimes about the look of film is how it can be so soft and so sharp at the same time. Each frame of film has a lattice of randomized grain structure that is in a different place on each frame giving new halide crystals a chance at capturing flecks of resolution that previous frames might have missed. When you look at a single frame of film it does not appear to contain much resolution or sharpness, but when in motion through the persistence of vision, a dancing resolution accumulates in the human perceptual system over time. Details 'dapple' in and out.

In digital capture the resolution and details exist on every frame so a pore on somebody's skin will be there on every frame in its ugly glory. In film, if you watch high resolution blow up analysis of running footage, a small skin pore may or may not register in the lattice of halide crystals on any given frame. So on one frame you don't see the skin pore, on another frame you see it. This gives dancing impressions of accumulated sharpness and softness. Amazingly high resolution but lack of microscopic harshness.

For the type of films I was making and planning to make, that were more tonal, psychological, and based on performances that would pull an audience into a dream, seeing details that would allow an audience to fixate on could harm the experience. I felt that more information could be a detriment, in that the more information the cameras could capture the less of a dreamscape it felt because it became literal. What wasn't being talked about enough in these discussions of new cameras was the *look* that these new sensors and their accompanying compression schemes created. Compression and processing in camera after the light hit the sensor and before the data was written to data capture was killing and homogenizing details in the black for me and so impressions of sharpness would be lost to cutthroat lossy algorithms that declared them unimportant. If a pore was dappling in and out on the sensor, compression schemes would make sure that it was always there or never there. So the impression of shapes in the shadows would be gone. Compare the haunting graininess of James Cameron's *Aliens* (1986) with clean blacks in *Prometheus* (2012). And details and grain in the lurking lowlights was where certain genres of film came alive to my eye because the experience was of seeing images, but images that were hard to decode, lending the experience more to a psychological realm than literal.

on CinemaDNG cameras that have been recently released—and only those cameras I have been able to shoot and take it through the postproduction process.

Each camera contains different features and they really become a tool for different types of shooters and shooting. The Ikonoskop, Blackmagic Cinema Camera, Digital Bolex, or even the uncompressed version of a Canon DSLR are each uniquely different. This book will cover many of these differences, while keeping the broader principles of cinema shooting in raw at the forefront. For example, Blackmagic Design's camera includes a touchscreen LCD rear screen (you can type in metadata, as well as adjusting camera functions, such as ISO, shutter speed, etc.), a Thunderbolt port, 1/4-inch RCA audio inputs, and a built-in SSD recorder. The Digital Bolex D16 includes professional XLR audio inputs, a 4-pin XLR to hook the camera up to a battery pack, a USB

3.0 port, as well as other accessories, including an HDMI output for external monitors.

But aside from the physical differences, different cameras containing different sensors express different characters. A 5D Mark II sees the world differently than a RED or an Arri Alexa. That's the nature of the interior design (as well as by the types of lenses used)—the sensor and debayering process by which the raw image is converted into a form recognized by the internal processor. For starters, a CMOS (a digital sensor) is going to have a different look and feel than a CCD (an analog sensor). Cinematographer Jonathan Yi, who shot the HBO series, *East Main Street,*[10] observed how Ikonoskop was marketing the advantages of raw in the A-Cam dII, but Yi "noticed that every project shot on it retained its distinct look." He realized:

> Like film stocks, sensors all have distinct looks to them, and the CCD sensor in the A-Cam dII has a strong retro look while also retaining the clarity of digital. The image also has a look reminiscent of some great older European cinematography. I haven't found a comparable sensor in any camera that looks at all similar. I have yet to try the Digital Bolex, but the sample footage I've seen so far, definitely has a different character to it.

In many ways camera comparisons are useless because of this. The footage from the Blackmagic Cinema Camera doesn't look anything like the footage coming out of a Digital Bolex or Ikonoskop, for example. These cameras might be all using Adobe's CinemaDNG raw, but how it gets processed through the sensor and debayer alters the look and feel of the footage.

Yi decided to shoot a test video at Coney Island in order to capture the unique look of the Ikonoskop (http://vimeo.com/jonyi/coneyisland).[11] He utilized available light, except for a gold bounce card during the ice-cream eating sequence, as well as an ND filter. (See Figures I.3 and I.4.) To really see the difference, compare the above images to a behind-the-scenes photograph from on location (see Figure I.5). So just as important as it is to get a camera that shoots raw, part of the decision on what camera to buy or rent shouldn't be a discussion about its specs, but should really be about how it feels in your hands (ergonomics) and how it delivers its image. Does it capture the look and feel you want for the film you're shooting?

Furthermore, Yi argues that shooting raw is good and bad for film students. He feels that 8-bit DSLRs are a great tool for learning how to get the look of

10 Yi directed the series for four seasons. In addition, he's shot music videos for Poison and Twisted Sister.

11 He discusses his process with PlanetMitch at: http://blog.planet5d.com/2013/07/ikonoskop-raw-video-isnt-dead-coney-island-by-jonathan-yi/.

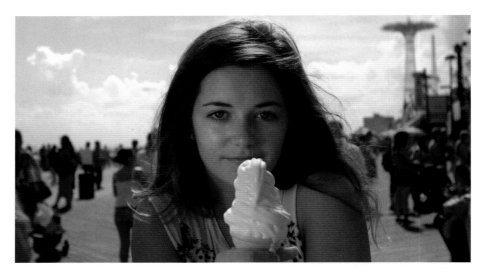

FIGURES I.3 and I.4
Screengrabs from Jon Yi's "Coney Island," a test short for Ikonoskop's A-Cam dll. Notice the smooth skin tones on the subject in I.3 (shot by Jon Yi) and the rich retro color look in I.4 (shot by Mary Perrino). The look and feel of the film expresses a different character than the footage found on the Blackmagic Cinema Camera, for example.

the film right in-camera, treating it like reversal film stock, allowing for the student of cinematography to learn about "exposure, latitude, and lighting since the dynamic range of HDSLRs is so limited and awful—similar to that of shooting reversal film," he explains. Limits are great for learning what a camera is capable of doing. However, Yi feels that when you shoot raw, you have to really master your shots, since you're limited in the number of takes

FIGURE I.5
Jon Yi sets up a shot for "Coney Island." Notice the color of the sky and umbrellas in the background and compare it to the color in Figures I.3 and I.4. These cameras each express a different type of character. (Image by Lance Lee, courtesy of Jonathan Yi.)

you have (due to the large file sizes of raw). "I think it is a great tool to instruct people to work within limitations and to really think about their shots," Yi explains. "Also the post process is incredibly educational since it puts you back into a dark room environment where you print your shots and reflect on the technical decisions you made on set," he adds. Raw provides a similar process that old-school filmmakers had to learn when shooting on film stock.

Ultimately, the central concern of any filmmaker should be the story. Raw adds another palette for independent filmmakers and students who may be ready to master another filmmaking tool. Like the DSLR, relatively inexpensive raw cameras provide those who can't afford high-end cinema cameras another tool that professional filmmakers have received access to—these CinemaDNG raw cinema cameras open up different kinds of shooting and postproduction possibilities for the rest of us.

OUTLINE OF THE BOOK

In Chapter 1, I tell the story of how a startup company created the Digital Bolex D16. Chapter 2 provides a comparison to a scene shot with the Blackmagic's Digital Cinema Camera and Canon's C100, as well as covering the differences in shooting 8-bit DSLRs and 12-bit raw—and I reveal some of the real reasons you may want to shoot in raw.

For those who want to know how to put together different packages for different cameras—on a relatively tight budget—Chapter 3 covers some of the cameras and equipment you can purchase. I don't get into the high-end accessories, such as matte boxes and cinema lenses. There are plenty of resources out there for that. This chapter is just a jumpstart for those who want to shoot as minimally as possible, keeping in mind students and beginning shooters' budgets.

In Chapters 4 to 6, I transition to case studies of those who have shot films with these CinemaDNG raw cameras, including the Ikonoskop A-Cam dII, the Blackmagic Cinema Camera, and the Digital Bolex D16. I include my hands-on experiences as well as interviews with others who have shot projects with them. I go over how each camera operates, menu functions, and how they were used in the field.

Chapters 7 and 8 cover postproduction, the subject of the third section of the book. Chapter 7 focuses on importing raw footage into a computer and color correcting with DaVinci Resolve and looks at how to utilize Captain Hook's look up table plugin for DaVinci Resolve—a plugin that gets you 90 percent there when using Blackmagic. Chapter 8 examines how to use Adobe's Camera Raw software for grading CinemaDNG files, walking you through a case-study shot with the Digital Bolex, as well as Pomfort's easy to use LightPost, designed specifically for the D16 camera.

The conclusion looks at the future of cinema storytelling in raw and how it echoes in many ways the workflow of old-style Hollywood filmmaking.

PART I
Getting the Raw Deal

CHAPTER 1

Creating a New Paradigm

Behind the Scenes at Digital Bolex[1]

GETTING THE BOLEX BRAND

Joe Rubinstein and Elle Schneider radiate energy like thousand watt bulbs, and it's infectious. They're fun to be around.[2] They certainly don't suit-up with executive airs, as corporate spokespeople do at other camera companies. Some might think they should, especially when you take on the 85-year-old Bolex brand. They're the South-By hipsters who upended the camera world during the spring 2012 music and film festival in Austin by announcing the first CinemaDNG raw camera for $2500 on their Kickstarter.com campaign.

And as some Kickstarter projects feel half-slapped together, this is what many people at first thought about the Digital Bolex announcement. Indeed, at first glance people may have felt a certain wannabe attitude—if RED couldn't pull it off with Jim Jannard resources for their original Scarlet, if Canon couldn't (or wouldn't) do it with their DSLRs, then how could these upstarts make it happen? One such post at prolost.com, commented:

> Aren't these two just adorkable? I desperately want them to succeed. But after watching the well-financed and well-intentioned Red Digital Cinema company struggle to deliver on their promises, and abandon the "3K for $3K" design/price-point of their Scarlet camera, one has to wonder if these filmmakers-turned-cameramakers have any idea of the challenges they're about to face.[3]

1 I'm focusing on the Digital Bolex due to their willingness to allow access behind the scenes, granting interviews with key personnel and observing the camera-making process. Blackmagic did not reciprocate this kind of access. I did get some access to Ikonoskop, but emails to the original designers/founders of the company remained unanswered at the time of writing.

2 Unless otherwise noted, all interviews in this chapter were conducted by me at NAB, Las Vegas 2012 and at Ienso in Toronto, February 26–27, 2013.

3 Prolost.com, March 13 2013. "Digital Bolex," http://prolost.com/blog/2012/3/13/digital-bolex.html (accessed February 19 2013).

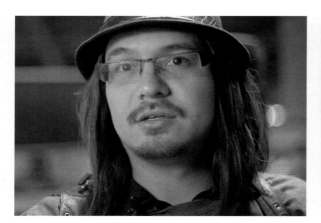 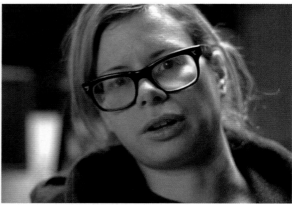

FIGURES 1.1 and 1.2
Joe Rubinstein, CEO and camera developer, and Elle Schneider, creative director of Digital Bolex. They're the brain trust behind the Digital Bolex. (© 2013 Kurt Lancaster.)

Indeed, they are rebels who want to challenge the prosumer video camera market. As Schneider, wearing angled blonde hair sculpting her cheekbones, explains, "The establishment is going to hand you these tools, and these are the only tools that you're allowed to use"—meaning compressed 8-bit video cameras, DSLR or otherwise. She feels that "[i]f any of these major camera companies had wanted to release a raw camera, they could have done so years ago."

Their partner in Switzerland believed in them, and the Bolex company ended up donating to their Kickstarter campaign. But it wasn't an easy win for Rubinstein, sporting shoulder-length brown hair, who spent nine months putting together a market research paper before contacting Bolex, asking them to partner with his vision for a digital Bolex, to use their brand name. Executives told him to contact their American distributors first. He did so. They told him to contact Bolex headquarters. He explained to them that he had already done that. Rubinstein says he contacted all of the American distributors and got them:

> excited about the project, and then I asked them to contact Bolex and say, "Hey, this is actually a good idea." So a lot of them did that. And I went back to Bolex, a month later, and I said, "Okay, so I've talked to everybody you suggested that I talk to, and they all said I have to talk to you, 'cause, you know, you're the real deal," and they said, "Okay, write us a description of what you're trying to do."

And that's when he told them that he had a market research paper. Rubinstein, if anything, is persistent.

FROM FILM EDITOR TO CAMERA DEVELOPER

Originally, Rubinstein wanted to be a film editor. In film school at the Savannah College of Art and Design in Georgia other students asked him to shoot their projects for them, because of the quality of work he did on his own films. And he agreed, as long as he could also edit their films. He graduated with an editing reel and a cinematography reel, which helped him land a job as an editor for a documentary "about freight train-riding hobos" funded through Project Greenlight in the early 2000s.

But after wading through 250 hours of footage—delivering a rough cut six months later—he fell out of love with editing. "It was such a miserable experience for me," Rubinstein says, "that I basically never took another editing job and switched to a focus on DP." He worked as a director of photography for about five years and felt it was much more natural for him to be on set, and shooting mostly on 16mm film. By the mid-2000s, the prosumer HD camera revolution hit, with Panasonic's HVX series camera and its proprietary P2 cards being released in December 2005. But rather than jumping on the affordable high-res HD bandwagon like many independent filmmakers, Rubinstein—similar to his experience with editing—"fell out of love with shooting." He told me, "It was no longer fun for me" due to issues with "compression, and because of the extreme hurdles to technology that were set up."

It was much easier to shoot on film, Rubinstein felt. With a film camera, he explains, "you have film stock, you have frame rate, and it becomes all about lighting and lenses and f-stops. And when we move to HD it became more about in-camera settings than it was about the stuff that I loved about shooting."

Rubinstein got out of the film game, partnered with one of his college buddies, and attempted "about ten different business models" using the original Canon 5D (which came out in August 2005). He was inspired by the book *Free: The Future of Radical Price* by Chris Anderson, which Rubinstein explains is "about how to give your product away for free, but still make money." He may have failed on his first ten tries, but after he and his business partner read that book, they shaped their business model around it, creating the company Polite in Public. (See Figure 1.3.)

The company used a photo booth with studio quality paper and raw images for event marketing—the photo contained an advertisement at the bottom. As Rubinstein says:

> So you go to a party for Warner Brothers and there's this really cool photo booth that has studio quality cameras, studio quality lighting, studio quality retouching, you get your picture in two minutes, and it looks like a magazine photo, and it says Warner Brothers across the bottom, for instance.

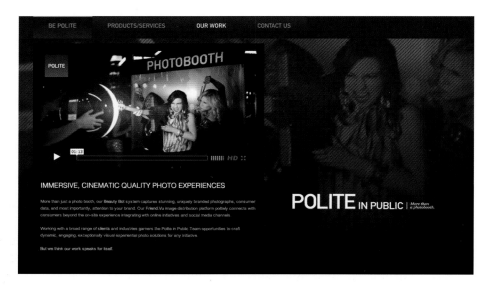

FIGURE 1.3
Rubinstein's former advertising/photobooth company, Polite in Public, using raw photo technology, garnered him success and he started researching how he could take it to the next level with raw video, but no such camera existed at the time. (Courtesy of Polite in Public, Inc.)

By 2008, the company got popular, really popular. "Where most companies in 2008 sort of collapsed, we grew 800 percent," Rubinstein says. He did the hardware design and he worked with software engineers to create custom software. And by a certain point, he wanted to change the model. He wanted a video booth with the same quality of raw coming out of the 5D stills camera. He asked himself the question: "Okay, well how do I make a video booth without changing my workflow?" He realized the answer didn't exist in a tangible form: "I need a camera that shoots 24 frames a second in raw, for less than 10,000 dollars. Where do I get one of those? Oh. It doesn't exist."

THE BIRTH OF A DIGITAL BOLEX

This moment birthed the concept camera that would become known as the D16 Digital Bolex. The existing digital cameras didn't cut it for him. He wanted raw images with ease of use, without a complex workflow with the camera operation and in post. Even Canon's 5D Mark II, which took the independent cinema world by storm when Vincent Laforet posted his short *Reverie* online in the fall of 2008, wasn't good enough for Rubinstein. Although he does admit to falling in love with the camera—especially since he was already familiar with the first 5D—after he put the footage onto his computer "and opened it up to full screen, I was much less in love," he says. "I was a little disappointed." And when he projected it on a big screen with his HD projector, the love faded away. He couldn't stop comparing the image to the 16mm film he had previously

shot. "When you shoot film, you're shooting sequential still images," Rubinstein explains. "And no matter what you do with interleaved video, it's always interleaved video. And it has the feeling of interleaved video. There's just nothing you can do to get around that. And when you capture sequential still images in film, it feels different." The limited dynamic range (easy to blow out highlights) and rolling shutter issues all contributed to his desire to create a camera that would not compromise its image.

The Canon 5D Mark II with its full frame sensor and interchangeable lenses may have blown the doors off other digital cameras—especially conventional prosumer video cameras—but Rubinstein never liked the HD video world. He got out of shooting movies because of it.

The differences may be subtle—and even undetectable by non-cinematographers—but you must remember Rubinstein isn't trying to create a digital camera by comparing it to other digital video cameras. His baseline is 16mm film. "The ethos behind the D16 Bolex is to look at what made 16mm film format in the 60s appealing," he says. Then you could buy, he explains,

> Rubinstein isn't trying to create a digital camera by comparing it to other digital video cameras. His baseline is 16mm film. "The ethos behind the D16 Bolex is to look at what made 16mm film format in the 60s appealing," he says.

the same film stock as the professionals. It's just a smaller format than 35mm film. But you're shooting the same thing. And the camera is just the carrier for the film stock. It doesn't really affect the image quality. Maybe you could argue the angle of the shutter or something like that.

It's really about creating an image that a professional film camera would expose. Amateur filmmakers, students, and independent filmmakers all had access to the same film stocks as professional filmmakers. This is not the case in the HD video world. Rubinstein wants to create the same thing for the digital cinema world. For example, "[i]f you're making a drama," Rubinstein argues, "there's no reason why you can't make a film that looks just as good as a feature you'd see in the theater on the same camera that you're shooting your family vacation on." But video cameras change all that. There was a

split between amateur or home recording mediums and professional mediums. It kind of became this video ghetto, where unless you can afford a professional quality camera, your film is never going to get shown anywhere. You can't get it into a festival, it's not going to be taken seriously.

So he was driven to really make a digital cinema camera that is not only affordable, but where the final digital project looks like 16mm film. "I started researching what it would take to make it," Rubinstein explains, "and I realized, if I make this thing, I'm not going to be the only person that wants one. There are going to be other people that are interested in it. So I started researching what it would take to make a retail version. And when I was explaining to people what I wanted to do, 'It's just like the idea of a Bolex, but digital,'" he says. At this point, he did the market research paper and put together a business plan before approaching Bolex. And this was before Kickstarter, before Schneider.

Rubinstein doesn't give up. After getting many of the American distributors behind his idea for a new Bolex camera, he submitted his business plan and market research paper and emailed them to his contact in Switzerland. They told him they would get back to him soon. He waited six weeks, his patience running out. Rubinstein started "calling them all the time, and bugging them," he says, telling them that "the ideas behind this digital camera that I'm making, and the ideas behind the original Bolex are very close, and you know, this is really something that I want you guys to be a part of." He asked them to let him "take a shot at it." They agreed and signed the paperwork before the 2012 SXSW festival, where Rubinstein and Schneider made their Kickstarter announcement. Bolex in Switzerland saw the "market reaction after the Kickstarter," Rubinstein says, and "they are super happy. They're fully behind us."

MEETING ELLE SCHNEIDER

Rubinstein met Elle Schneider, a recent graduate of USC's film school, at the famed nerd-festival ComicCon in July 2012. Ironically, there was only two degrees of separation between them. Rubinstein's wife is friends with one of Schneider's roommates. After ComicCon, they all met up for dinner. Schneider says that Rubinstein was "looking for someone to work with, and it just clicked overnight. It was very quick. Within two days I was working on this project." He didn't talk about the camera being a Bolex, since the deal wasn't signed at the time they talked. He told her, "'I have this camera project that's going to replicate the idea of 1960s 16mm camera but in digital with raw,' and she was really interested," Rubinstein says. He liked the fact that some of Schneider's projects had the 1970s look. Even though Schneider shot projects on the Canon 7D—the camera of choice for many low-budget indies—she "was getting more and more frustrated by the footage."

Schneider would monitor the footage, and "I thought it was really great footage for documentary interviews, and I'd light it really well and it was awesome, and then I would put it onto the computer and it was not awesome." As part of her workflow she would take a still snapshot of her setup (which, of course, can be set to a still raw image) in order to test the lighting "and to show the director different options." But when she compared "the raw version of the

image next to the compressed video" she became frustrated.[4] And she would say, "See it's not me that has messed up, it's just the way that the video is being captured": the compression would make the video look worse than the still comparison. "That's why when Joe mentioned the camera to me I was like, 'Yes,'" Schneider recalls.

The next thing she knew, Schneider found herself editing a schematic of the yet to be named Bolex camera in Photoshop. The classic Bolex had a hand crank, and she says she fought hard to keep the crank, which would eventually become assignable, such as with filters, follow focus, among other features. She likes to think outside the box. "People get so locked into the idea that this is the way a camera has to be because this is the way I've been told that I need to use it, and these are the functions we're told that it has to have, and I just don't see why there's any reason that we need to be locked into that," Schneider says.

So at first glance "the crank now seems unnecessary," Schneider explains, but the better question is, "How can we, integrating it with a digital technology, give this a new function that people wouldn't have thought about before?" She wanted to come up with some "cool ways" to "think outside the box" and find new ways to use a camera, ways not normally used "with a normal little black box camera."

Schneider worked as a game designer for math and science-based games. She graduated from USC in May 2008, but started working for a game company in November 2007. She wrote code when she was younger, she says. For the company, she designed game play, performed as a producer and project manager, as well as designing graphics, and doing user interface design. For Bolex, she says, "I bring a unique mix of some technical expertise and creative expertise, so I can do menus. I don't come from an establishment camera background, but as a user. I can communicate better with the engineers when in meetings about technical elements and follow it and translate to Joe or ask questions that are understood by everybody." Having worked with engineers and software programmers, "you learn what's possible or even if it's possible," she adds.

Schneider is the ultimate multi-tasker, designing screen graphics for the Bolex in Photoshop as she talks a mile a minute. She's at "one with computers," she says. The ultimate filmmaking nerd, she shows her technical knowledge of computers and cameras as she comments on the reason why the menu should include shutter angles rather than shutter speed ("Because, Joe, you keep saying it's a cinema camera, so be consistent," she says in a meeting at Ienso in Toronto).

Mike Liwak, the VP of product development at Ienso, says that Schneider is indispensable to the team. She was actually brought into Digital Bolex after

4 The live view screen on back of DSLRs actually shows an uncompressed raw image, so it looks much better than it does after it's compressed to 8-bits.

Ienso agreed to become partners in Rubinstein's Bolex vision. She became a valuable asset to the Bolex team, working directly with Rubinstein in Los Angeles. "Sometimes if you have a roomful of engineers just trying to figure out how a camera should work or function the experience from the user point of view can be pretty dry or it won't work the way that users expect it to work," Liwak explains, adding, "how the camera operates and the user interface, were her ideas."

CREATING AN EASY-TO-USE CINEMA CAMERA

Fundamentally they want the camera to not only have the retro look, but be unintimidating and fun to use. Schneider shot on Panasonic's fixed zoom lens DVX100 and later the HVX series, both of which contain a lot of menu options and a lot of buttons. This can be intimidating for some people. "People think that if it's this big black box with all these buttons on it, it must be difficult to use," Schneider says, "And they're not willing to try it for fear that they're going to be perceived as doing something wrong."

Schneider feels that a lot of girls who do YouTube video and vlogging, are not using complex digital video cameras. They play with easy-to-use cameras. She says:

> They're taking advantage of their webcams, they're taking advantage of the video bursts on their point and shoot cameras, and it's because it's the same mentality—this is not intimidating. Whereas if you hand them a bigger camera, if you hand them a Panasonic AF100, a lot of people will run away from that.

This reflects the spirit of what Schneider and Rubinstein both feel about how a lot of professional filmmakers came out of the 1960s and 1970s as children who played with the original Bolex cameras. "It was this little toy that their parents had around that they could pick up and start shooting and say, 'Hey I really like this thing,'" Schneider explains. "There was no commitment to it, there was no, 'I want to be a filmmaker, or I need to know these skills already to be able to pick it up and use it.'" Both Rubinstein and Schneider want to carry that same experience to their digital Bolex.

Rubinstein compares his camera experience to the standardized design of computers in the 1990s. "They were beige boxes and it was just about the stuff inside them and the faster processors and bigger hard drives and more RAM you could stick in it, and all that kind of stuff," he explains. But Steve Jobs changed all that during his 1997 Apple resurrection, releasing the Blueberry iMac in 1998. Rubinstein says:

> All of a sudden it was a computer that wasn't a 1.4 blah blah, it was a Blueberry. And it was not as intimidating as the big computers, but it

was still a serious machine! You could still do real work with it. It had a FireWire port, you could edit video on it. It was accessible conceptually. And it looked pretty—it was a nice design.

Rubinstein was impressed by the integration of performance and design, how the iMac created an "experience using it" rather than focusing on how its performance rated on paper. "And that's really what we want to do with this camera," he says. The Digital Bolex team wants to create an experience that's easy "from the moment you buy it to when you're projecting your movie in a real movie theater." They want the experience to be good, pleasant, and not frustrating.

Rubinstein explains how he isn't "interested in the numbers game" in cameras (bigger sensors, higher ISOs, faster frame rates, ultra high resolution, etc.). These are not the concerns of the people he wants to use the digital Bolex:

> If you're a numbers person and that's what you want from it, there are plenty of cameras out there that you can buy. But if you're in it because somebody is designing a really unique, fun experience, then we're making that. Because as filmmakers, we understand that it's not just numbers that make films.

He doesn't want a complex camera that will "require a digital tech on set to even get the thing turned on and running." Rather, he explains, they want to create a camera that when you turn it on "you're ready to start shooting" without worrying about color balance, or setting "any black point levels, any of that stuff, because you're going to do all that in post, in a really intuitive, fun way." Fundamentally, they're going to give you the camera, and if you're using the same ISO and frame rate throughout, "you just turn it on and start shooting," he says.

It may not be as simple as that, but that's their goal.

GEEKING OUT WITH TRANSCODING ALGORITHMS

In addition, one of the key concepts that they want to challenge is the fixed point algorithm of video—the means by which the video signal gets processed, how it gets transcoded. Most cameras, Rubinstein says, have two algorithms, one providing a video look, another a film look. But, he says:

> when you're transcoding footage, what you're doing is you're taking this huge color space, this giant capture of light, and you have to fit it into a much smaller color space, right? So, basically for every clip you should have a high quality algorithm that treats each clip a little differently giving them a more subtle, more accurate color representation.

In the world of video, he says,

> there's an algorithm that does the change from essentially a black and white image to a color image called transcoding. And most companies give you one algorithm, maybe two, that's it. And you use the same algorithm for all of your footage, no matter what color space your footage is going into, no matter what color space you started with, whether you shot really bright images with lots of blue, or really dark images with lots of red.

Because of this, a set algorithm is never going to fit every piece of footage. Rubinstein has challenged his team to do better. He contacted a Russian software engineer to help design a "floating point algorithm," which was designed and put out by the German company, Pomfort, allowing for the subtle treatment of each clip in order get the best color possible. The significance of this software cannot be understated. As Rubinstein says, "the algorithm rewrites itself to fit your color space you started with, and the color space you're going toward, and it will be much, much, much more accurate color-wise." He feels it'll "blow everybody else's transcoders out of the water."

CREATING A PARTNERSHIP IN TORONTO WITH IENSO

Armed with the free spirit of success from his previous business, Rubinstein avoided the conventional business model approach. He doesn't feel that monster-size conglomerate corporations are good for innovation and believes that within 50 years they'll be gone. Small companies express better advantages for innovation—they move much faster. Big companies, on the other hand, "do not move within a marketplace efficiently and quickly," Rubinstein adds, while "little companies that can focus on one thing can do so much faster." As a result, he says, "lots of small companies" can make a "healthy living," as opposed to huge corporations where a "few people make billions of dollars."

But he couldn't go it alone. He could come up with concepts and design schematics all day, but the actual manufacturing obviously had to be farmed out. He still needed to build a camera. It required molding, circuit board design, getting the right sensor—all of the elements to get the camera made and working. Even at this level he didn't approach the work conventionally.

Rubinstein spent months researching electronic companies and ended up talking to representatives from a "lot of different electronic design firms and companies that work with sensors," he explains. And many of their responses went something like this, Rubinstein says: "'When you're ready to make a million units, call us back.' That's the kind of the attitude I got from easily half of them. And I said, 'Okay, but I don't want to make a million units.'"

Others suggested that he contact venture capitalists to fund the manufacturing of the camera. "'You need x number of dollars to get off the ground,'" they told him, and "'when you have that amount of money come talk to us and we'll help you make a camera.'" But this went against Rubinstein's previous business venture experiences and philosophy. "That is not the way that I do things or want to do things." He'd been burned in the past by venture capitalists not understanding his product, and they ended up "making really bad decisions because of it," he says. He only wanted to make a few hundred cameras at first. He needed a small company, one that was fast and innovative.

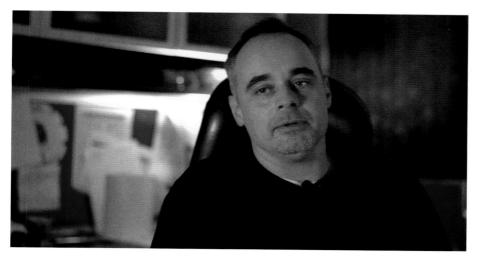

FIGURE 1.4
Mike Liwak, VP of product development at Ienso, responsible for leading the team that built the D16 Digital Bolex camera. (© 2013 Kurt Lancaster.)

Rubinstein came across a small electronics company, Ienso, a contract design service firm outside of Toronto, Canada and shared his vision with the owners of the company. Mike Liwak, a partner at Ienso and VP of product development, talks about how when Rubinstein first approached him, it was to create the camera for his Polite in Public photo booth:

> Joe had an idea for a particular camera that fit the application he was working with. So I started off conversations back and forth which started to evolve. And in parallel with that he was looking for other solutions, or to see what technologies are out there and he started to gradually realize that there was a lot of potential for the digital Bolex camera. At that time of course we didn't have the Bolex name trademark. We wanted a cinema-type camera that was shooting raw, but not super expensive, not super high-end, but still good quality and robust.

FIGURE 1.5
Joe Bornbaum, VP of finance at Ienso, was willing to take the risk in getting behind the D16 Digital Bolex camera. "We're betting the company on making this work. Just as Joe has bet everything he has on this," he says. (© 2013 Kurt Lancaster.)

However, Rubinstein didn't want to give them money to build the camera. He wanted a partnership.

Joe Bornbaum, the VP of finance at Ienso, was open to the idea. He knows their company can build and design cameras, "But we're not the guys who are in touch with the market. And here came Joe with his vision. And as I probed him and as I pushed him he had the answers. There was a logic to it. And I thought, you know what, we are going to take a gamble here and bet on this." After the commitment from Ienso, Rubinstein hired Schneider to come on board to be the creative director for the project.

Digital Bolex wasn't the first company to approach Ienso. Liwak says that they get offers quite frequently:

> We've had offers for partnership before with other companies or technologies and after running our own business and doing some things on our own we have a bit of a feel of what makes sense and what doesn't, and what's viable and what's not viable. So what Joe described to us as the potential market and how we could fit in, and combined with the technology which we thought we could develop, all of the pieces of the puzzle went together. So we thought it was worth the risk.

This meant investing money, manpower, and technology to make it happen. As Bornbaum says, Rubinstein's offer was an opportunity. "I use this analogy," he adds: "You're running towards a cliff and you hope that you can build a bridge by the time you get there. And that's literally what we're committed to doing here. We're betting the company on making this work. Just as Joe has bet everything he has on this." Their partnership was officially named Cinemeridian in 2011.

DON'T NEED THE BIG GUYS

When asked about why the bigger companies are not releasing cinema raw cameras at a low price point, Bornbaum explains that for "the big guys, it's not big enough for them. Where for us this is perfect, innovative. And we can do it, and it's a market that nobody is servicing properly today. There are not a lot of products out there." Liwak also adds how, as a small company, Ienso has more flexibility to move quickly:

> Our experience with bigger companies is they typically don't move very fast. They take a while to adopt new technologies or new ideas. But one of the nice things about having 20 or 30 people working on a project is the flexibility, and pace. We're able to make decisions quickly and move quickly, change quickly. We're not afraid to try new things, so it's a different dynamic than at a big company. And I don't think a large company would want to do what we're doing, at least not yet.

He explains how the market for this camera is too small, today, for a big company to take such a risk as they have. But, he adds, "if it works, a market could be created and become—in five years or three years, whatever it is— much, much larger than it is today." Although they don't know what the potential market for the Digital Bolex will be, Bornbaum feels they can only "speculate" on the potential size based on the user feedback on the Digital Bolex website forums. But after the first 100 are made, they will make 500, then more. They expect to plan on developing the next generation Bolex camera—perhaps a 4K model when the market is ready for it.

The business model for Rubinstein revolves around direct sales, not retail. You won't be seeing this camera at B&H Photo anytime soon. In this way, Rubinstein feels they can keep the cost of the camera low. He feels that if you go through a retail store you need to multiply your cost of the camera to build by 1.3 times ($100 cost = $230 retail), in which his company would get half of the profit, while the seller takes half ($65 each). He would have to price the camera at over $4000, and he doesn't believe that makes good business sense. Web sales allow him to keep the price of the camera around $3300. If there are cameras sitting in a warehouse, then retail is a good option in order to keep the product moving. He envisions at some point providing Bolex retail stores in Los Angeles and New York in order to cater to film students and independent

filmmakers. For sales to film schools, Rubinstein would plan to give a discount or provide additional material for free (such as lenses), as well as visits to the school and the provision of a demo.

THE "INTANGIBLE" BENEFIT OF AN OPEN CAMERA DESIGN

So the upstarts are really not upstarts, after all. Rubinstein knows how to build a successful business from the ground up. Schneider brings her creativity and experience shooting digitally to the team. She is still in some disbelief about some of the initial negative reaction to their announcement in March 2012. Rubinstein's company, Polite in Public, she says, "is a successful international company." When people saw the Kickstarter video, they assumed it was some wannabe newbies shooting in the dark. "People assumed that we're starting from scratch when we put up the Kickstarter video," Schneider says. "In reality, the Kickstarter was the tail end of a multi-year project, and was the launching point to the public."

Kickstarter became the beginning of the feedback stage. Rubinstein wanted his backers and other potential buyers of the camera to tell them what they would like to see in the camera. User forums on the company's website provide for such feedback. With such an openness, some companies might feel there's too much risk for letting not only customers, but also the competition take a peak behind the curtain. Bornbaum was at first uneasy with Rubinstein's approach. "Initially I was a little uncomfortable with how open he was," Bornbaum says. "Because I think we're naturally open and sharing, but Joe takes it to a new level. As I reflect back, there's more good than harm that comes from that." There's an added value benefit because of Rubinstein's "openness and communication" with customers. "That's an intangible benefit," Bornbaum explains, adding, "I don't know how to quantify that, but I guess the end result will be if we have a camera that everybody is thrilled with, then I would say the process is the right one."

And this gets back to Rubinstein's original philosophy in creating a business, inspired by giving away things for free. Bornbaum believes, philosophically, that there must be an "integrity underlying" creativity, which leads to success:

> And if you are going to be true to yourself and honest, and honest with everybody, I think you have a better chance of succeeding—if you're on the right track. I've just found in life that if you compromise or if you are worried about the other guy, then you are not paying attention to what you need to be paying attention to. And so I'll take whatever harm comes from that because I believe at the end of the day that having the openness allows us to be as good as we can be and we'll see.

This is one of the key elements that makes the Digital Bolex process so different to a lot of the competition. This type of openness includes Rubinstein spending several hours each day reading posts on the digitalbolex.com forum, and responding to questions. He uses these posts to find new ideas and to debate ideas about the camera—some ideas may get added after the initial release, others to new cameras down the road. Many of the decisions for the D16 camera came from "smart" members of the forum, Rubinstein says, and include everything from camera layout, lenses, crank function, and so forth. "Literally hundreds" of ideas were generated on this site and he ended up posting a blog, "100 Changes," on January 28, 2013, which listed many of these changes requested by potential customers of the camera. One such change included adding a tripod hole on the bottom of the camera grip: "After a forum member pointed out it is a good place to mount a wrist strap, we not only implemented the mounting point, but we also purchased vintage style wrist straps for all of our Kickstarter camera backers!"[5]

Crank Position: We also moved the crank forward and a little lower, making it more comfortable to use.

Improved Sensor Gain Stage Controls: We have doubled the fidelity of control on the sensor board. This means we have much more finely tuned control over how the sensor behaves than most cameras makers do. The use of a CCD sensor instead of a CMOS sensor in this camera has many benefits.

- CCDs have a more flexible analog gain stage. If used properly this can dramatically improve sensor performance.
- CCDs also don't do any analog to digital conversion, which means that we as the camera makers can decide how that happens, again improving performance.
- CCDs are generally less noisy especially in the darks at their native ISO. This is important for the economy of bits and the final image.
- CCDs can be passively cooled much easier so internal fans and limited record times are not a problem.
- And of course our sensor has a global shutter instead of a rolling one.

Mounting Screw Holes on Top: We have recently added 4 screw holes in the top of the camera to allow more placements points for accessories and contact points for rigs.

FIGURE 1.6
A portion of Rubinstein's blog, "100 Changes," published January 28, 2013. This section lists the advantages of the CCD sensor over the CMOS sensor (used in DSLRs and Blackmagic Design's Cinema Camera). (© 2012 Digital Bolex. Used with permission.)

5 Digital Bolex, January 28, 2013. "100 Changes," www.digitalbolex.com/100-changes/ (accessed February 26, 2013).

Another concept includes how the crank in default mode, expresses metadata—meaning the user can assign sections of the take they're shooting to special effects, such as slow motion or fast motion. (The user spins the crank fast and it provides data that during post shows how that over-cranked section can be translated into slow motion.)

There was something different about how Joe Rubinstein interfaced with his Kickstarter backers and potential customers, offering not only a peak behind the curtain, but allowing customers to provide feedback *before the camera was built*. In some ways, members of the user forum helped design the camera. Because of this, many began to realize that this was not going to be just a slapped-together or copycat camera with a cool name, but the real deal.

One such post echoes the initial fear of many who felt that this camera was for posers, then how they changed their mind after digging deeper into the Digital Bolex site:

Neil
on February 13, 2013 at 4:14 am said:

When I first saw this camera on Kickstarter I must be honest, I didn't see any true use out of it except as a niche camera that hipsters would use just to look cool. However, I've been following the project for some time and I'm amazed at how much thought, time and energy is being put into the camera to not only make the camera useful, but exceedingly useful.

You could have just jammed a sensor into a Bolex-shaped box and I think most people that invested would have been satisfied as long as it worked. But you have gone above and beyond to an entirely higher level of goodness with the camera and have become the perfect model of a kickstarter generated product.

FIGURE 1.7
Forum member, Neil, writes how he at first thought the D16 was just a "hipster" camera, but later realized it was much more. (© 2013 Digital Bolex. Used with permission.)

This is the kind of validation Bornbaum says gave them hope. Despite his initial doubts as to whether or not they could pull it off, his technical team never had any doubts. Towards the end of the process, Bornbaum tells the story of how Mike Liwak's son plays on a soccer team. Mike talked to one of the fathers, asking him what he does. He found out he teaches film at one of the local universities. Then this father asks Mike what he does, and he replies:

> "Have you ever heard of Digital Bolex?" and he said, "Yeah! You know I'm waiting for that. I've been following that." And he validated everything that Joe had talked to us about. This guy from Toronto who had only been reading about it on the Internet. Everything Joe said, he said. And I thought, Wow! What a validation.

The Digital Bolex D16 is just the beginning. Rubinstein and Schneider, as well as their partners at Ienso are not only planning accessories, they're looking down the road at more Bolex cameras.

FROM DELAY TO RELEASE

At several points, the camera production went into delay. By taking the time to receive user feedback, the team decided to incorporate additional features and update some of the hardware elements. One of their decisions involved an advanced sensor with an analog to digital converter. They expected to engage a working image by the end of February 2013, but it kept failing. By the end of April and into May, Rubinstein had brought in an electronic design expert who validated the quality of their design. Then he brought in John Compton, formerly of Kodak—and since Rubinstein had chosen a Kodak-designed sensor, he was going to the source. Rubinstein says that Compton "took a deep look into the designs, paths, concepts, and came away impressed. He talked to our team at a conceptual level. He helped us see the sensor in a new way."[6] Compton recommended another former Kodak employer, Les Moore, to help them at their end game. At the end of the first day of Moore's arrival, they had a clean image coming from their sensor. The major hurdle was over.

By the middle of August 2013, they had a working camera in which they offered their fans, potential buyers, and Kickstarter backers the ability to download footage for color grading on August 14, 2013. (See Figures 1.8 and 1.9.)

Rubinstein's reaction was ecstatic—from his initial concept to the long process of creating a business plan, finding a small manufacturing company and convincing them to come on board, the challenges of putting together the right

6 Rubinstein, Joe, May 28, 2013. "Image Improvements," www.digitalbolex.com/image-improvements/

FIGURE 1.8
A screen grab from the first recorded moving images from the Digital Bolex D16. Screen shot of Elle Schneider stripping her painting surface. Image courtesy of Joe Rubinstein.

FIGURE 1.9
Joe Rubinstein operating the Digital Bolex D16 for the first motion image test. Take note of the light used for the scene. Due to the small sensor, this camera will need light. Image courtesy of Joe Rubinstein.

engineering team, the frustration of getting so close to having the camera work and then have something go wrong—all became worth it at this moment. The camera worked. It was still in the beta test stage, and Rubinstein said that Liwak basically told them to "break" the camera so the engineers can fix the issues camera users will face so as to make sure the camera worked before shipping to customers. So the first shoot wasn't perfect, but the images that came out of it exceeded Rubinstein's expectations. He wrote on his blog:

> This weekend, after watching our footage on the camera monitor and later on the computer, I truly understood one of the big reasons uncompressed raw is important to me. It's because the D16 (and all uncompressed raw cameras) is pixel democratic, meaning it doesn't hold any one pixel as any more or less important than any other pixel. When looking at DSLR footage it is very clear that out of focus areas, large color blocks, and soft gradations are less important than the detailed areas. Their algorithms literally compress those areas more. As if to say, we know you aren't looking at the out of focus background. But sometimes the out of focus bit is the most beautiful, the most precious. The D16 thinks all of your pixels are important. And there is something beautiful about that.[7]

And all of the naysayers who complained about the "vaporware" of the camera evaporated into the ether. The camera became real, as one reply on the blog facetiously stated, "So you hipsters are making a camera for real, huh?!"

Rubinstein and Schneider, as well as the Digital Bolex team, can be credited for creating a camera that included a strongly open, full disclosure process. They could talk about how everything was worth it and how they deserve to brag about what they did—but that would be too self-serving, and would go against the humility they expressed throughout the process. The best praise would probably stem from those who were not even planning to get the camera, as best expressed by Guillaume on the same blog post:

> It is more than just a camera, for me you are incarnating a new way of doing bizness [sic]. With technology, art craft, passion and authenticity.
>
> I'm following your progress since the beginning and I'm not that interest[ed] in RAW, because it doesn't fill my needs. But when I saw your faces opening up the box, and I saw this little beautiful machine, I just wanted one.

7 Rubinstein, Joe. August 14, 2013. "The D16 in the Wild," http://www.digitalbolex.com/d16-in-the-wild/

I give up, you got me there.
I'll adopt one and I will love her like my child, for the beauty of it, and then, I will create with it.

If journeys have an end—or at least the end of a chapter—Rubinstein couldn't ask for a better way to launch the next stage of the Digital Bolex company.

CHAPTER 2
What's the Deal with Raw?
The Advantages (and Disadvantages) of Shooting Compressed vs. Raw

In this chapter I'll examine footage shot with the Blackmagic Cinema Camera compared to the footage of a camera costing thousands more, the Canon C100.[1] In addition, I'll take a look at what raw video looks like in the Canon 5D Mark III (using the Magic Lantern raw module) as compared to its native H.264 compression (8-bit vs. 14-bit raw). I'll also include material from Marco Solorio as he walks us through some vivid comparisons between raw and compressed video in pointing out an increase in detail and sharpness to footage, as well as depicting how he recovers a blown-out shot through a window, and takes an outdoor day shot and turns it into a night shot (day for night) by using the deep set of information found in raw.

BLACKMAGIC CINEMA CAMERA AND THE CANON C100

I had the opportunity to shoot a segment of the Carpetbag Brigade's "Callings," a performance art piece performed on stilts. I enlisted one of my students, Kent Wagner, to shoot their rehearsal and performance on the Canon C100, while I shot with a Blackmagic Cinema Camera. What follows is a discussion of the comparison between the footage of these two cameras. I've placed a 70-second segment of the performance doing a contrasting shot progression of the two cameras at: https://vimeo.com/65939859.

Ultimately, if you get the look of the shot right in-camera during the shoot, those with an untrained eye will not discover vast differences between an 8-bit DSLR, an 8-bit Canon C100, and the uncompressed version of the 16 linear to 12-bit log CinemaDNG found in the Blackmagic, for example. But if you look closely, the differences are there. If you're shooting a compelling story and the shot is professionally lit and exposed properly (and in focus with clean audio and proper color-balance), very few people will fault you if you've shot on

1 This wasn't a planned test. We just happened to have both cameras on hand for the shoot and decided to compare the two just to see if there was a tangible difference.

a Canon 60D, rather than a Blackmagic camera. Those who shoot in raw are choosing it because there's a certain look that comes out of these cameras that gives them a unique feel. Similar arguments were used when I interviewed film-makers who were using Canon DSLRs for the first time for my book *DSLR Cinema* (Focal Press, 2013, 2nd edition).

Rodney Charters, ASC, shot a series of moving images for Neil Smith on the RED One, Canon 5D Mark II, and the Canon 7D. Smith had the shots intercut to see if anyone could point out which ones were shot on which camera at the HD Expo in New York in the fall of 2009. No one could point out the difference.[2]

Now, with the advent of inexpensive CinemaDNG raw cameras, people are pretty much saying the same thing. This next section reveals how the differences may be considered subtle by some people, but become more obvious with a trained eye. The subsequent section about postproduction capabilities is where the *real* differences occur—the ability to recover details in the darks and highlights as well as to apply effects to the shot. Then there's *no* comparison between the power of 12-bit raw vs. an 8-bit compression. The comparison between 8-bit compression of DSLRs with the 14-bit Magic Lantern software upgrade also reveals some remarkable differences.

Two Codecs

Fundamentally, when comparing the BMCC and Canon's C100, we're talking about two vastly different types of format. The raw cameras covered in this book utilize Adobe's open source CinemaDNG format, which Adobe announced in early 2008. Cinematographer John Brawley, who tested the first Blackmagic Cinema Camera, explains how the "DNG file is a container, so how each application processes it is up to the application. It's an objective thing like I've seen a lot of amazing footage that's been processed through Capture One's raw conversion software" (http://www.phaseone.com/capture-one). Brawley feels that in the circles he walks, the debayer capabilities are powerful (the process of converting the raw collected light into a form recognized as images on the computer). In short, different software could process the raw files differently, so Brawley believes that the Blackmagic philosophy (and really the philosophy of Ikonoskop and Digital Bolex), is to make the image "unadulterated and give you the basic sensor data, so you can do what you want with it depending on which application you use." He feels that Blackmagic has regenerated the use of CinemaDNG.

The C100, on the other hand, uses the Panasonic- and Sony-led 2006 initiative of AVCHD container of the compressed H.264 codec (designed for consumer cameras). In addition, the camera utilizes an S35 sensor—the size of 35mm

2 Lancaster, Kurt, *DSLR Cinema*, Focal Press, 2013 (2nd ed.), p. xix–xxi.

film (and slightly larger than the APS-C sensor found in Canon Rebel, 60D, and 7D DSLRs). It also contains Canon's cinema log file—basically a flat-look format that preserves data in the highlights and blacks, providing a potentially powerful film look when graded in post.

Setting Up in Post

For the *Carpetbag Brigade* short, we kept the shooting simple on the C100. For the two rehearsal run-throughs, the camera sat on a tripod with a Canon 16-35mm f/2.8L lens, while the BMCC utilized the Canon 24-70mm f/2.8L lens. For the performance, the C100 used the Canon 70-200mm f/2.8L lens and the BMCC used the Canon 24-70mm f/2.8L lens with an aperture of f/2.8. The BMCC was set in Film mode shooting raw. The C100 engaged the Canon cinema log.

For color correction, I imported the footage for the BMCC into DaVinci Resolve (lite) and utilized Captain Hook's nice Look Up Table (LUT) in that software (see Chapter 7).

When shooting with the C100 or the BMCC, the image looks flat, for both are utilizing a form of a film curve that helps preserve data in the highlights and blacks, providing more headroom in post so that you can dig out more details—it essentially extends the dynamic range of the camera. (See Figures 2.1 and 2.2.)

FIGURE 2.1
The BMCC flat film look as seen through DaVinci Resolve. The image does not pop and not only does it look flat, but it feels flat—emotionless. (© 2013 Kurt Lancaster.)

FIGURE 2.2
The flat Canon log gamma file from Canon's C100. The image is bright and flat, washed out. It needs color grading in post. (© 2013 Kurt Lancaster.)

The BMCC correction in DaVinci Resolve is discussed in Chapter 7, but the final result sitting in Final Cut Pro can be seen in Figure 2.3.

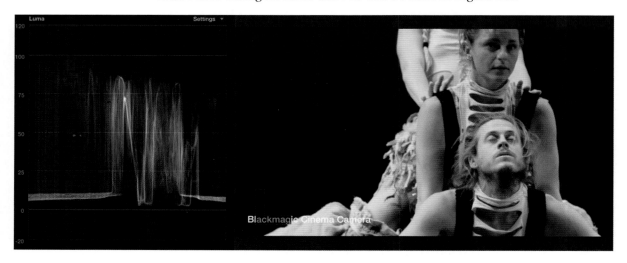

FIGURE 2.3
The BMCC colors pop, removing the flat quality of the image. The waveform monitor in Final Cut shows the results of the DaVinci Resolve color correction and grading. (© 2013 Kurt Lancaster.)

Taking the C100 file and adjusting exposure in Final Cut Pro, we can see how the image sharpens and begins to pop out of the screen (see Figure 2.4).

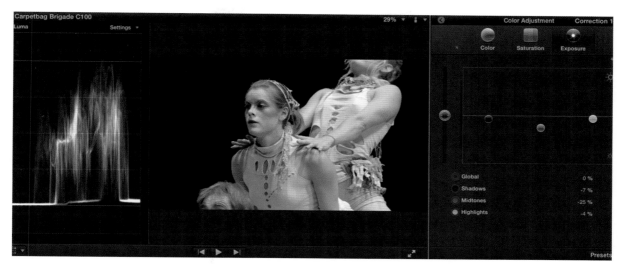

FIGURE 2.4 (above)
The C100 Final Cut Pro correction through an exposure adjustment. (© 2013 Kurt Lancaster.)

Let's take a look at the close-up of the image in Figure 2.5.

FIGURE 2.5 (left)
Close-up of the C100 Final Cut Pro color correction.
(© 2013 Kurt Lancaster.)

The overall problem is the lack of the color equality of the C100 image when compared to the DaVinci Resolve BMCC footage. Rather than putting the C100 footage into Resolve, however, I tried a trick—Final Cut's Color Match function. I clear the correction I made and apply "Match Color," selecting one of the similar BMCC clips I have in the timeline. The results are close to the BMCC footage. (See Figures 2.6–2.8.)

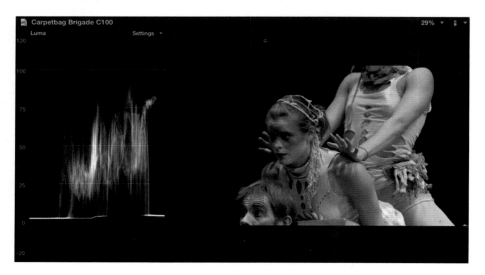

FIGURE 2.6
C100 footage now matches more closely to the colors of the BMCC by using the Match Color feature in Final Cut Pro. (© 2013 Kurt Lancaster.)

FIGURE 2.7
Close-up of the C100 color match. (© 2013 Kurt Lancaster.)

FIGURE 2.8
Close-up of similar footage from the BMCC, corrected using Captain Hook's LUT in DaVinci Resolve. Notice the similarity of the look when compared to the C100 in Figure 2.7. But the feel is different–the C100 is crisp, more like video, while the BMCC feels organic with roll-offs of shadow and lights, more filmic. (© 2013 Kurt Lancaster.)

So despite the close color and exposure match between the C100 and the BMCC, we can see that the C100 conveys a different feel—again this is subtle and for the casual viewer caught up in the story, they will likely not notice it. But for some, the difference is not subtle. Filmmaker Michael Plescia in his Foreword to this book discussed how he felt there was a strong difference between what he was seeing in Ikonoskop's A-Cam dII and D16 Digital Bolex CinemaDNG footage compared to higher-end cameras (such as the early model RED One). After seeing some of the A-Cam's early footage on Vimeo, he said, "I couldn't believe my eyes. It looked like a chimera image. It looked to be half film and half digital." He is not referring to a BMCC, and Plescia feels the Kodak (TrueSense) CCD in the Ikonoskop is superior to CMOS sensors (found in the BMCC), but we can compare the fact that both cameras use Adobe's CinemaDNG format.

Let's take a look at both images again, enlarged (see Figures 2.9 and 2.10).

Details remain in both (notice the flow of hair strands that remain sharp in both images), but there's a distinctly different feel to each image. The C100 feels sharper, a bit more clean, with a slight industrial plastic-like feel to it (perhaps a bit of a cold science-fiction feel), while the BMCC feels like it has more film-like texture, warmer in its presence onscreen—this feel drives not from the difference in resolution, but from a difference in bit depth.

FIGURE 2.9
A blowup in Photoshop of a
still from the BMCC.
(© 2013 Kurt Lancaster.)

FIGURE 2.10
A blowup of a still from the
C100. (© 2013 Kurt
Lancaster.)

The distinction of feeling between the two cameras becomes more heightened in the wide shots (see Figures 2.11 and 2.12).

FIGURE 2.11
The BMCC camera from the back of the house and at a high angle—details remain sharp. (© 2013 Kurt Lancaster.)

FIGURE 2.12
The C100 from the front of the house (and a level angle). The image does not appear as sharp as the image from the Blackmagic Cinema Camera from the *back* of the house (Figure 2.11). (© 2013 Kurt Lancaster.)

In both of these images, the colors are closely matched, but the DNG footage from the BMCC feels different, a bit warmer and not expressing the plastic-like feeling from the C100.

As I mentioned before, these distinctions may be a moot point for most audiences and remain, perhaps, an academic or cinematographer's argument for those with a discerning eye. But for those who make films, the feel of the camera's body may be less important than the feel of the image, especially when the image moves. The C100, for me, expresses a clean plasticity. But that's not necessarily a bad thing. The compression of the C100 may actually be perfect for news shooters and those who want the versatility of the camera's onboard audio, extended battery life, and the ability to record hours of footage on an SD card. Members of Stillmotion, one of the best video production houses in the world, swear by the versatility of the C100.

But for filmmakers, those who are attempting to regain the feel of film by digital means, they're likely going to gravitate towards the Ikonoskop, or Blackmagic, or the Digital Bolex—because they know that to shoot in raw is the closest they may ever get to shoot on the nearly extinct format of chemical film emulsion.

In the next section, I take a look at some of the differences (and similarities) of the raw video coming out of Canon's 5D Mark III and the standard H.264 8-bit compression.

WHAT'S LOST IN COMPRESSED AND WHAT'S GAINED IN RAW

Canon 5D Mark III Compressed vs. Raw

Magic Lantern, a software devised by hackers, created a code that gets placed on the memory card of the camera (and engages when you activate the firmware update of the camera—although it doesn't actually alter or update Canon's firmware). In essence it embeds a software interface that allows the user to tap into the potential of the camera—a potential that Canon refuses to give users access to within their software interface. Some of these changes include presenting functional overlays—from audio meters to histograms—that make the Canon DSLRs better, in many ways providing features you would find on a normal high-end video camera. The software makes the Canon DSLRs much more user-friendly, and Magic Lantern continues to improve the software. In May 2013, they announced the beginning stages of recording raw video uncompressed from the sensor data—creating 14-bit raw files that can be converted (or wrapped) into the CinemaDNG format. For those who already own Canon DSLRs and for those who don't want to purchase a raw cinema camera, this software update—although requiring technical savvy to make it work—becomes another option for independent filmmakers working on a tight budget.

Alec Weinstein, a filmmaker based in San Diego, started out his career as a business consultant for over ten years, but when the Canon Rebel T2i (550D) was released in the first quarter of 2010, he bought one and made a short film with it (along with some friends). It got the attention of some television cinematographer types and within a few weeks of his short film's release, he was offered commercial work within television. Needless to say, he quit his job and "dove head first into professional camera work," he tells me in an interview. He uses Canon's 5D Mark II and III doing network-level work at CBS, NBC, Fox, Bravo, A&E, VH1, and Style. Weinstein does shoot with higher-end ENG video cameras, but he says he prefers the DSLRs for their "versatility and ability to shoot superior imagery."

Using a Canon 70-200mm L series lens with a two times extender adapter (making the zoom lens a 140-400mm lens), Weinstein placed this gear on his Canon 5D Mark III, taking footage of palm trees and the ocean at an effective focal length of 400mm. He shot nice 5D Mark III "standard" footage in the normal 8-bit H.264 compression mode of the camera. He then compared this footage to similar footage shot in raw with Magic Lantern's software, circumventing the limits of the camera's 8-bit compression, allowing him to record 14-bit raw on a high-speed CF card.

Below are a series of frame grabs from the video shot by Weinstein described above, showing the difference between video shot in raw in contrast to the camera's normal 8-bit H.264 compression. See Figures 2.13–2.17.

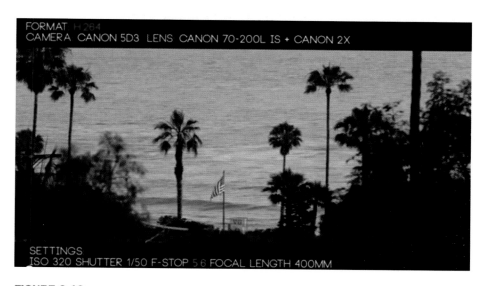

FIGURE 2.13
Frame from 5D Mark III H.264 footage. The frame reveals the original 8-bit compression. It expresses a good DSLR cinema look. (© 2013 Alec Weinstein. Used with permission.)

FIGURE 2.14
Frame from 5D Mark III raw footage. You can see sharper images, such as within the leaves and ocean in the background. The color is obviously different, appearing richer than the 8-bit compression. (© 2013 Alec Weinstein. Used with permission.)

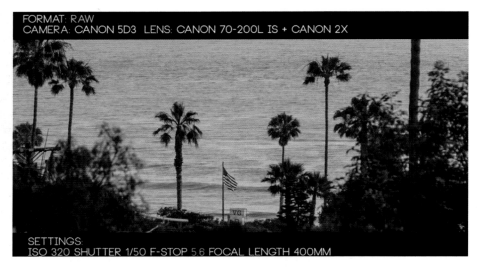

FORMAT: RAW
CAMERA: CANON 5D3 LENS: CANON 70-200L IS + CANON 2X

SETTINGS:
ISO 320 SHUTTER 1/50 F-STOP 5.6 FOCAL LENGTH 400MM

FIGURE 2.15
5D Mark III H.264 color corrected for saturation and contrast. It reveals the warmth found in the 14-bit raw version and at first glance, looks pretty close—not a vast difference between the two. (© 2013 Alec Weinstein. Used with permission.)

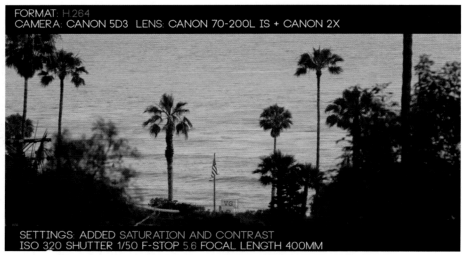

FORMAT: H.264
CAMERA: CANON 5D3 LENS: CANON 70-200L IS + CANON 2X

SETTINGS: ADDED SATURATION AND CONTRAST
ISO 320 SHUTTER 1/50 F-STOP 5.6 FOCAL LENGTH 400MM

FIGURE 2.16
Now Weinstein takes the raw footage coming out of the Canon 5D Mark III and provides a contrast and saturation color correction. Already it's looking stronger than the corrected compressed look. If you still can't quite see the difference, he brings it home in Figure 2.17. (© 2013 Alec Weinstein. Used with permission.)

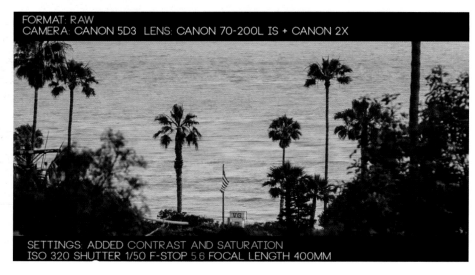

FORMAT: RAW
CAMERA: CANON 5D3 LENS: CANON 70-200L IS + CANON 2X

SETTINGS: ADDED CONTRAST AND SATURATION
ISO 320 SHUTTER 1/50 F-STOP 5.6 FOCAL LENGTH 400MM

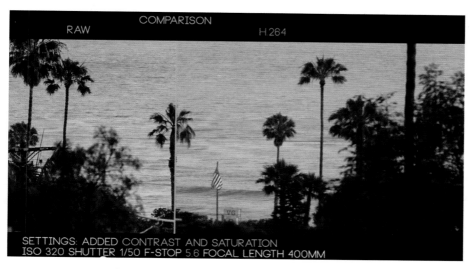

FIGURE 2.17
A side-by-side comparison of Weinstein's footage comparing the color graded raw version with the H.264 corrected compressed version. This is where we really see the difference. While the standard compressed footage—by itself—looks good, it lacks the sharpness and richness of the raw footage. (© 2013 Alec Weinstein. Used with permission.)

Side by Side: 8-bit Compression vs. 12-bit Raw

Marco Solorio of OneRiver Media demonstrates this in a series of tests comparing normal compression of 8-bit Canon 5D Mark III to 12-bit images from the Blackmagic Cinema Camera.[3] See Figures 2.18 and 2.19.

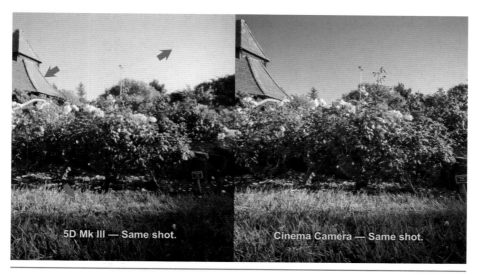

FIGURE 2.18
Solorio's comparison of the BMCC (16-bit linear to 12-bit log uncompressed) to the 5D Mk III (8-bit compressed). He notes with arrows how the details of the grass and roof shingles are less defined in the 5D when compared to the BMCC. He also points out how the color of the sky and banding issues appear on the 5D, but truer colors appear with no banding for the BMCC. (© 2012 Marco Solorio/OneRiver Media. Used with permission.)

3 OneRiver Media, undated. "Comparing the Cinema Camera and the 5D Mk III," https://vimeo.com/49875510

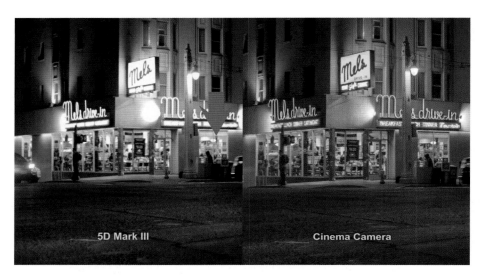

FIGURE 2.19
In a night shot lit with practicals, Solorio notes how the colors and definitions of lit signs are washed out (Mel's drive-in signs) in the compressed image. In addition, he points an arrow at a blown-out light in the diner for the 5D, but when compared to the BMCC, the highlights are held and the shape of the light is defined. Notice the practical lamp to the right of the "Mel's drive-in" sign on the far right. On the 5D sign, the white light blows out. On the BMCC side, we see gradations of light detail. (© 2012 Marco Solorio/OneRiver Media. Used with permission.)

When you're shooting with a compressed format, such as with the Canon 5D, Andrew Cochrane of Guilllermo Del Toro's studio Mirada explains, you're getting about five stops of usable latitude:

> So your exposure needs to be right—you can't miss it by a stop. In the H.264 compression color space—and it's pretty heavily compressed—you don't want to change your image very much in post. You want to use filters. You want to nail your stop and you want to nail your look, you want to set your white balance. You want to look at your LCD and have it be at 90 percent final image—if not 95 percent—because that's how much wiggle room you have in post before the image just goes to hell.

Fundamentally, there are two camps of filmmaking, Cochrane explains:

> There's film and there's digital. Film's all about the shadows. Digital's all about the highlights. The reason a lot of people have had trouble transitioning to digital is because the mentality is 180 degrees from film—you're protecting your shadows, when you should be protecting your highlights in digital.

This can be astutely seen in the next section.

POSTPRODUCTION ADVANTAGES WITH RAW

Where there is no subtlety between compressed vs. raw footage is in the post-production world. The 12-bit CinemaDNG raw footage excels in postproduction—when you need to change exposure, engage color grading, to really change the look and feel of your film. In the 8-bit compressed world of images, you need to get the look of the film as close as possible in-camera. If you shoot in a "flat" look format (such as Canon's cinema log), then you are giving more leeway in post to change the look of the film—but it still doesn't come close to the work you can do in post with 12-bit uncompressed files.

It's important to note the difference between linear and logarithmic encoding of images. The linear process applies equal values to each bit of color data—linear. The log is a logarithmic curve, where the bits of color data can be spread out, allowing for a natural simulation of how film (and the eye) responds to light. While the film or cinema settings on cameras record a "flat" look, it's creating a log space for getting cinematic-looking images, while the Rec 709 setting defines a broadcast standard look. One is designed to engage color grading, while the latter is for expressing a realistic look without using color grading.[4]

In the creation of a day for night scene, Solorio takes us through the process, showing how easy it is to manipulate the image in post without any degradation of the image.[5] See Figures 2.20–2.22.

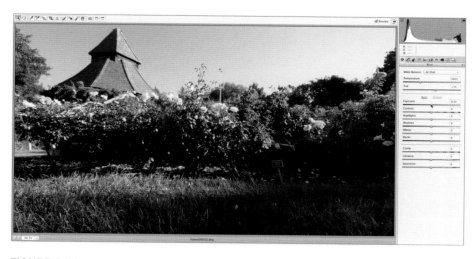

FIGURE 2.20
The original day image, shot on the BMCC in 16-bit linear to 12-bit log raw. (© 2012 Marco Solorio/OneRiver Media. Used with permission.)

4 See Adams, Art. "Log vs. Raw: The Simple Version." 2013. PVC Pro Video Coalition. http://provideo coalition.com/aadams/story/log-vs.-raw-the-simple-version.
5 OneRiver Media, undated. "Comparing the Cinema Camera: Part 2, The Impact of 12-bit Raw," https://vimeo.com/52269416

FIGURE 2.21
The raw CinemaDNG file adjusted day for night using menu settings in Adobe Camera Raw.
(© 2012 Marco Solorio/OneRiver Media. Used with permission.)

FIGURE 2.22
The same image with compositing effects of stars, moon, and glow effect.
(© 2012 Marco Solorio/OneRiver Media. Used with permission.)

This shows the power of shooting with 12-bit raw. In many situations, no such effects are needed and shooting 8-bit compressed files—such as in documentary or news shooting situations—will be the right choice, since having the space to record needed footage and edit it quickly is more important than lacking

space and dealing with the time needed to convert raw files when shooting uncompressed. However, another case where shooting raw can reveal a decisive advantage occurs when you need to recover detail in the highlights and darks. Again, Solorio shows us this advantage later in the same video referenced above. See Figures 2.23–2.27.

FIGURE 2.23
Here's Solorio's original 8-bit decompressed H.264 image (likely converted to ProRes 422). Notice the blown-out highlights in the window as well as the dark corner of the room. (© 2012 Marco Solorio/OneRiver Media. Used with permission.)

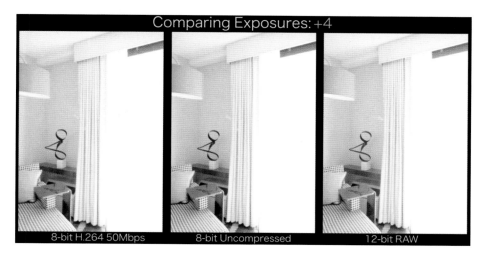

FIGURE 2.24
Solorio's comparison of 8-bit H.264 compression, 8-bit decompressed, and 12-bit raw. He's opened up the exposure four stops in order to reveal details in the shadowed corner. Everything looks similar—which shows again that the differences between the 8-bit image and the 12-bit image are subtle. (© 2012 Marco Solorio/OneRiver Media. Used with permission.)

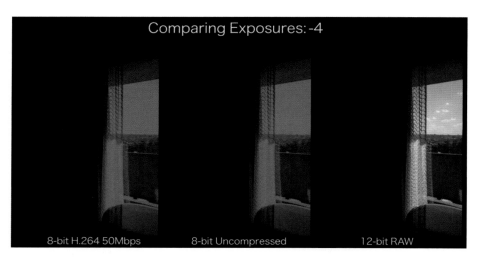

FIGURE 2.25
Here's where we see the real difference. When adjusting for the blown-out window, Solorio's 8-bit files turn gray—there's no recovering of clipped highlights in the 8-bit world. However, the 12-bit raw image recovers the clouds and blue sky, providing a color corrected image that really shines. Notice how the details in the lower half of the curtain are also recovered in the raw image. (© 2012 Marco Solorio/OneRiver Media. Used with permission.)

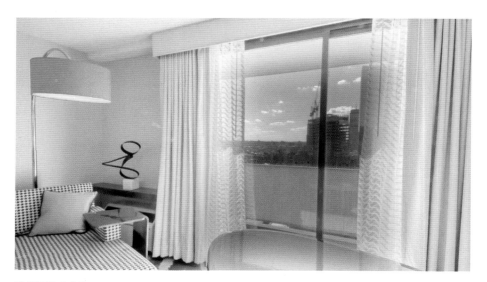

FIGURE 2.26
Solorio layers the corrected 12-bit raw file for the window and the dark corner (he exposed them separately and adjusted accordingly). (© 2012 Marco Solorio/OneRiver Media. Used with permission.)

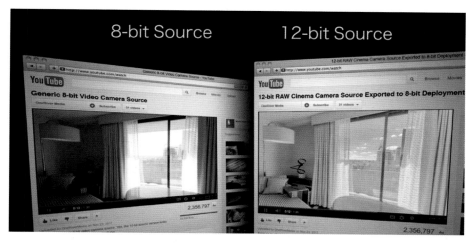

FIGURE 2.27
As for the argument that web videos don't need to worry about utilizing raw, because it's so compressed, Solorio begs to differ. Here he shows the compressed YouTube version of the 8-bit version contrasted with the YouTube compressed 12-bit source. (© 2012 Marco Solorio/OneRiver Media. Used with permission.)

Another form of postproduction that can be applied to CinemaDNG files is film grain. For some, the idea of shooting in raw reflects in some ways an approach to filmmaking that harkens back to the days of working on film. What is lost in digital filmmaking involves the loss of texture. Film grain is one way to help bring texture back to the filmmaking process. Filmmaker Michael Plescia discusses this below. Take note of the stills and how they exemplify Plescia's argument about film grain (see "Digital Bolex D16 Downtown LA Test Shoot" at https://vimeo.com/74438041).

Film Grain in Postproduction

by Michael Plescia

My recommendation: grain in your post pipeline while the image is flat, so that the grain acts as a dithering mechanism allowing for color corrections that can be much more aggressive in the DI. Also, by doing so, you avoid weird color banding and color blocking that I've seen in badly color-corrected RED footage. Footage originated on film is grained from the beginning because grain *is* the image which helps dither any non-linear color correction curves and that's why film shot images can be pushed to such degrees of saturation and richness—where digitally originated footage usually falls apart. (Notice how *The Girl with a Dragon Tattoo* and many RED shot films excel with very desaturated grades.)

I degrade the image slightly with a post-applied "optical blur" filter on a base layer (What!? Blurring HD resolution footage and making it effectively *less* sharp?) I do this in a compositing package to take away things like too-sharp skin pores or leaves in the background and then I use a grain pattern scanned from neutral grey 16mm film stock as a track-matte that acts as a screen or a sieve that allows areas of the sharp, non-degraded HD footage through in speckles.

So this helps mimic the effect of "dancing resolution accumulated over time." In other words the skin pore that hangs on the face in Digital Bolex and Ikonoskop footage does not appear on all frames although I should mention that these cameras lack of compression gives the footage inherently *much* more of this dappling effect already.

This type of more aggressive graining, for the looks I love, also has further benefit in the pipeline because as the final film goes through compression algorithms for blu-ray, Vimeo, YouTube etc., the compression schemes that

look for uniformity over time, like H.264 algorithms, have more difficulty finding blocks of uniform image to simplify—especially in the lowlights where information is often thrown away.

By "stumping" the compression schemes that hunt for information to throw away, it becomes more difficult for the algorithm because it cannot as easily identify and hold steady blocks of temporally consistent patterns over multiple frames and the algorithm can't hold a key frame of compression over subsequent frames. The first thing

FIGURES 2.28 and 2.29
Stills from "Digital Bolex D16 Downtown LA Test Shoot" by Michael Plescia. It is, Plescia says, "an attempt at accentuating the inherent celluloid look of the camera by marrying it with my shimmer-graining processes to give it an early 90s-era Kodak appearance."

YouTube and Vimeo compression algorithms do is see if they can lower the data rate allotted to a given video by degraining the image, so I always like to have my grain intensity at a level so that YouTube can't declare my black levels meaningless.

Again, I argue that in the grain of the blacks exists such an important component of the aesthetic experience in genres like horror, art films, thrillers etc. Overall, when you compare a frame of Vimeo or YouTube compressed video where on one version you "confused" the algorithm with this type of grain and on another version you did not

(given the data rate is the same), you will see the grained version looks to be of much less quality because the algorithm is struggling and distributing its same data rate over the entire image.

I actually like this look better and would argue that your eye is actually "seeing" more depth over time than in an image where the lossy algorithms had their way. I'd rather spend it over the whole image rather than letting the algorithm decide that the actor's blackheads are the fine detail that should be preserved.

Lighting with Raw

For those of us used to shooting with DSLRs, we'll find a bit of a shift of understanding in how to use lighting when shooting with the CinemaDNG cameras using small sensors (16mm for the Digital Bolex and Ikonoskop, and larger for the Blackmagic Cinema Camera). Filmmakers are always aware of lighting. Documentary filmmakers and video journalists tend to use natural light with reflectors and diffusers, while fiction shooters will almost always use lighting setups. Since the sensors in DSLRs are large (near S35 size in most cameras and much larger with the full frame sensors), they have the advantage of engaging low light shooting capabilities. With the CinemaDNG raw cameras, you will need to pay more attention to light when shooting. Outdoor day, the cameras work great. They love light.

But beware of clipping the highlights—stay within a fairly tight dynamic range. In an interview about shooting with the Blackmagic Cinema Camera, Philip Bloom tells me:

> You think that you have this enormous dynamic range, but there's only so much it can hold when you have something that's blown out. If you've exposed something and then you have something that's so blown out it's blown out by maybe six, seven stops. Just because it has thirteen stops dynamic range, doesn't mean you're going to get that back. Keep it within about three stops.

Getting a light meter may be important. In low light, you may be able to push the exposure in post, but the image gets noisy fast. Heed Bloom's advice.

Joe Rubinstein, the CEO and Founder of Digital Bolex, recommends that you use daylight balanced lights. Although LED lights are nice and portable and easy to use, he feels that you may often find a little green cast in your shots when using them, while he found Kino lights give you a little magenta. To overcome the tinting issues with these lights, Rubinstein recommends that you shoot with a color chart, so you have an easy reference when correcting them in post. It's also wise not to mix lighting types. Stick with one kind of light so you're not fighting these slightly different color differences among lights in post. If you're going all the way with lighting, Rubinstein says that HMI and plasma are the truest color light sources.

CHAPTER 3
Film Gear for Raw Filmmakers
A Low-Budget List

Getting camera and audio gear can be the most exciting part of purchasing a new camera. The potential stories are nearly limitless. Professional filmmakers with high-end budgets seem to have access to any camera and gear they need. Many professionals in the filmmaking world rent their gear. But for independent filmmakers and production houses shooting on low budgets, as well as multimedia journalists and students on an even tighter budget, getting the right gear is essential. This chapter examines *some* of the film gear low-budget filmmakers and video shooters may need on their projects. It lists cameras and gear with approximate mid-2013 prices and it only focuses on CinemaDNG, starting from the lowest to highest priced camera packages.

I will only list gear that I feel is needed for basic shooting setups. I lay out the gear for each camera, then list optional lenses and audio gear afterwards. I do not include extensive audio or any lights, since there's a plethora of these items and this book doesn't have the space to go into these areas deeply. For active links for the products listed below, please see my website: http://kurtlancaster. com/equipment/.

I will not tell you which camera to get. Each one has its merits, quirks and challenges to use. In most situations, professionals will tell you that they will rent the right camera for the particular job they're doing. One camera does not fit every bill. With that said, I'll make the following recommendations as a ball park for those needing guidance.

- **Blackmagic Pocket Cinema Camera**. For journalists and advanced casual shooters. Shoot in ProRes mode for run and gun situations. If you're a journalist or documentary filmmaker and you have this camera on you, you can get some things as they arise—especially if you're wanting to shoot low profile. This is a great portable camera, allowing you to shoot broadcast quality images on the run.

- **Blackmagic Cinema Camera**. For many who were used to shooting with DSLRs, this camera was a shock when they saw the sharpness of the uncompressed image. It's a solid camera for production houses doing

promotional and commercial videos. For just about $2000, this seems to be the best deal—if you can overcome its quirks, but realize you will need to pay thousands more to get this up to a field- or studio-ready camera. It has the capability to shoot CinemaDNG raw, as well as Apple ProRes (422), and DNxHD format (for Avid). This flexibility makes this a fairly versatile camera, and with a 2.5K sensor you can do some crop work in post for full HD composition. However, you will need to buy the right camera for the mount you want (EF or micro 4/3). It provides a sharp look and some filmmakers are shooting some nice-looking commercial and promotional videos with this camera. It has its own character and the image coming out of the camera does not look like the other cameras profiled in this book. For documentary and/or news work, use the ProRes format to save space and postproduction time. After shooting with this camera, I have no problem using it for certain documentary work, as well. It wants to be placed on a tripod with an EVF, especially when shooting outdoors day. I was able to place this on a monopod and shoot handheld in some situations.

- **Digital Bolex D16.** For independent filmmakers, those shooting fiction and independent feature narratives, this is hands down one of the best digital cinema cameras on the market today—and for the price point it's unparalleled. Some filmmakers state that for all of the digital cinema cameras out there, this is the real deal. If you're pixel counting and making an argument for 4K, you're in the wrong game. This camera, like others in its class, is about harnessing color depth, filmic texture, and nice skin tones. Filmmaking isn't about ultra high resolution. For those who want to shoot documentaries, it's possible with this camera, as long as you're investing enough cards and hard drive space. This camera will feel like you're shooting with a film camera. I feel, image-wise, this is the best camera covered in this book for shooting narrative and documentary work.[1] Ergonomically, it's certainly easier to shoot with than the BMCC, but not quite as cool looking as the Ikonoskop.

- **Ikonoskop A-Cam dII.** For independent filmmakers. This is the first and the most ergonomically pleasing. It shoots beautiful images and as one filmmaker states, it makes you feel like you're shooting poetry when using it. However, due to the high price point you're better off getting the Digital Bolex D16, since it expresses a similar feel in its final image.

1 I state this with the bias of knowing I'm a Kickstarter backer for this camera. But I also shot with every camera in this book and I liked every camera I shot with. Every camera had its pluses and minuses. But if I were to buy only one camera from this list, this would be it due to its character. Not everyone will like this character, so they should look at all of the others and make their own decision. *This is my own opinion of what I would do. I'm not telling you which camera to get, or what is better for you.*

All of the cameras profiled in this book are not out-of-the-box consumer video cameras or DSLRs. They're cinema cameras and every one of them represents the base price to get the body. You can't do cinema without other gear, so you must factor that into your budget.

BLACKMAGIC POCKET CINEMA CAMERA KIT: ~$2300

Although not a fully uncompressed CinemaDNG camera, it's modeled to have a "lossless" (compressed) DNG format, as well as Apple ProRes (HQ) settings. I include it, since it is in many ways the successor to the Blackmagic Cinema Camera (2.5K model), and could in some ways replace it due to the fact that many people will likely gravitate towards the 4K BMPC.

For this price point, you're getting the camera body and a basic go-to lens, as well as two high-end 64GB memory cards (records 50 minutes of video in ProRes recording mode), as well as three batteries, a battery charger, and a monopod—for stable static and moving shots. This is probably a great run and gun setup for video journalists, documentary filmmakers, and indie shooters on a tight budget. As you get additional gear, you will likely want to invest in better lenses. Just getting two good micro 4/3 lenses could cost up to an additional $2500! See the website for updated gear for this camera: kurtlancaster.com/equipment.

Equipment type	**Camera**
Equipment model	**Blackmagic Pocket Cinema Camera**
Approximate cost	**$995 (body)**

FIGURE 3.1
Image courtesy of
Blackmagic Design.

Full HD video (1920 x 1080 at 23.98p, 24p, 25p, 29.97p, 30p)
Super 16mm sized sensor (12.48 x 7.02mm)
Resolution: 1920 x 1080

Recording formats: Apple ProRes 422 (HQ) (220mbps, providing 50 minutes of recording on a 64GB card)

"Lossless" CinemaDNG Raw (recording rate unknown)

Crop factor the same as Super 16mm: 2.97x (1.3x when compared to the BMCC)[2]

More info at: http://www.blackmagicdesign.com/products/blackmagicpocketcinemacamera/

This camera is for those who want portability above anything else. The BMCC is a better camera in that it shoots at 2.5K and *uncompressed* raw, while the "lossless" CinemaDNG raw format is compressed, but it remains to be seen as of writing how it compares to uncompressed raw.

However, with that said, if you can get the look of your scenes in-camera, then the 10-bit Apple ProRes 422 (HQ) is a solid format and good enough for broadcast. If you're wanting to shoot cinema, then use this as a backup camera and use the Ikonoskop, BMCC, or Digital Bolex.

This camera may actually be perfect for those doing video journalism in the field, foreign correspondence, and documentary work where portability and the ability to keep a low profile and move quickly is essential–although you'll need to overcome its audio weaknesses.

Certainly for the price, you cannot go wrong. If you want uncompressed raw, this is *not* the camera to get.

If you want this camera, CheesyCam.com offers some words of advice. Be sure to get the Extreme SDHC card (SDXC). (See the one from SanDisk, below.) According to CheesyCam, you cannot format the card in-camera. It must be done with your computer. Format to HFS+ or exFat. Have plenty of batteries on hand—they tend to drain fast. Unless there is a fix, there are no audio meters on-camera. Use the external audio recorder for your primary audio and be sure to check levels. (See http://cheesycam.com/blackmagic-design-pocket-cinema-camera-a-few-tips/.)

Equipment type	**Lens**
Equipment model	**Noktor SLR Magic Hyper-Prime Cine 12mm T/1.6 lens**
Approximate cost	**$500**

FIGURE 3.2
Image courtesy of Noktor.

2 Brawley, John, April 9, 2013. "The pocket rocket ... Blackmagic downsizes the BMCC and does a 4K upsize of the original!," http://johnbrawley.wordpress.com/2013/04/09/the-pocket-rocket-blackmagic-downsizes-the-bmcc-and-does-a-4k-upsize-of-the-original/

It's ironic you can purchase a cinema camera for around a $1000, but the lenses cost so much more. But it must be remembered that the camera body is what gets replaced—the lenses (or glass) are what will last a long time and are irreplaceable.

Out of all the lenses listed here, this may be the best go-to lens for interviews and portrait work, as well as capturing action (it's equivalent to a 35mm lens on a full frame sensor camera). The Noktor is also designed as a cinema lens.

For those doing journalism or documentary work, you should consider getting the Panasonic 12-35mm f/2.8 lens, for about $1200—it'll give you a 36-105mm range equivalency. And if you're on a really tight budget, the Panasonic lens (14mm f/2.5) pictured above on the BMPC costs $325.

If you want to get a nice set of fast primes with a good range, the Olympus set stands out: 12mm f/2.0 ($800), 45mm f/1.8 ($400), 75mm f/1.8 ($900)—see below for more information. This will provide about a 35mm, 130mm, and 225mm equivalencies.

Equipment type	**Mic**
Equipment model	**Zoom H1 kit and cold shoe mount adapter**
Approximate cost	**$185 + $30**

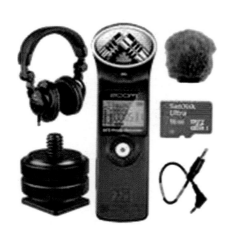

FIGURES 3.3 and 3.4
Images courtesy of Zoom and Pearstone, respectively.

More info at: http://www.zoom.co.jp/products/h1/

B&H kit info: http://www.bhphotovideo.com/c/product/731488-REG/Zoom_H1_H1_On_Camera_DSLR_Audio.html

For price and utility, this setup is a decent audio recorder for a camera. It has the advantage of not only being able to record audio to the Zoom H1, but it has the added benefit of being able to input a cable from the Zoom H1 to the Blackmagic camera. This also provides the advantage of listening to the microphone from the input of the camera.

The cold shoe mount attaches to the top of the camera, allowing you to add the mount that's included in the kit. The included windscreen is essential when shooting outdoors.

If you need a shotgun mic, then use the Sennheiser MKE400 (profiled below in the audio section) for $200. The advantage of the Zoom H1 setup is that you have secondary audio being recorded onto the recorder and into the camera. But if you already have your own audio recorder, use the Sennheiser for good reference audio and audio backup.

Equipment type	**Memory card**
Equipment model	**64GB SanDisk Extreme Pro**
Approximate cost	**$120 each**

FIGURE 3.5
Image courtesy of SanDisk.

More info at:
http://www.bhphotovideo.com/c/product/824149-REG/SanDisk_SDSDXPA_064G_A75_Extreme_Pro_64GB_SDHC_SDXC.html

Memory is getting cheaper, but for those of us shooting raw video (or near raw), then getting a reliable card is important. This SanDisk SDXC card has a write speed of up to 90 MB/s and is one of the fastest cards in this class. SanDisk makes a slower SDXC card (60 MB/s write speed) for around $85, but you will want the fastest one you can get when shooting raw.

Equipment type	**Batteries**
Equipment model	**Nikon EN-EL20 battery**
Approximate cost	**Battery: $38 each Charger: $35**

FIGURES 3.6 and 3.7
Images courtesy of Nikon.

For those of us who've shot on Canon DSLRs and collected batteries, the Nikon will be a disappointment. But at least you can take the battery out of the camera, unlike the BMCC. According to Blackmagic Design, each battery will give you about 50 minutes of shooting, so have plenty on hand if you're doing a long shoot. Philip Bloom's test of the camera placed the battery life at less than half of the rated 50 minute specs.

It doesn't look like the camera comes with an external charger (but you can charge in camera), so getting an external recorder is essential. Watson offers a dual battery charger for ~$80.

Equipment type	**Monopod**
Equipment model	**Benro monopod**
Approximate cost	**$140**

I have not used this monopod, but it's half the price of the Manfrotto, which I use a lot for video shooting. I feel that due to the small profile of the Blackmagic Pocket Cinema Camera, this one will work well for most shooting situations, providing the functionality of stability, while allowing not only for pans and tilts, but push-in and pull-out shots by leaning the monopod in and pulling back and vice versa. Use the handle to keep the shot level. Includes a level bubble.

The feet provide stability and there's the ability to lock and adjust the pan, tilt, and drag elements on them.

Stillmotion's monopod tutorial and 3 Over 1 Rule is essential viewing for monopod shooting:

* https://vimeo.com/26869155

* http://stillmotionblog.com/h234hs23dkw21/ (first video)

FIGURE 3.8
Image courtesy of Benro.

BLACKMAGIC CINEMA CAMERA KIT: ~$6000

This is where the price point goes up. You can just get the camera—but you still need lenses, external batteries, SSD for raw recording and storage, audio, a tripod or monopod. It adds up. But the Blackmagic Cinema Camera was the first base-priced inexpensive raw camera to hit the market. Despite some of its quirks, such as the attempt to be a large DSLR in its ergonomic design, it shoots a beautiful image (although there are still issues with moire and rolling shutter).

Equipment type	**Camera**
Equipment model	**Blackmagic Cinema Camera (Micro 4/3 and EF lens mounts)**
Approximate cost	**$2000 (body)**

FIGURE 3.9
Image courtesy of
Blackmagic Design.

Full HD video (1920 x 1080 at 23.98p, 24p, 25p, 29.97p, 30p)
Sensor: 16.64 x 14.04mm (actual), 15.6x8.8mm (active)
Resolution: 2.5K 2432 x 1366 cmos
Recording formats: CinemaDNG 12-bit raw,
Apple ProRes 422 (HQ), Avid DNxHD (1920 x 1080)
Audio: 1/4" TRS inputs
Thunderbolt interface

This camera is for those who want affordable CinemaDNG raw—*and* want the option to shoot Apple ProRes 422 (HQ) or Avid DNxHD.

The 2.5K sensor actually gives you a nice-looking HD image. Furthermore, there's also professional HDSDI and Thunderbolt outputs (but no XLR audio connectors!) It also comes with a full version of DaVinci Resolve, one of the industry standards for color grading.

With the ability to shoot uncompressed raw for under $2000, this camera stands up to high-end professional cinema cameras costing thousands more.

There are two versions of the BMCC—one with a micro 4/3 mount and one with the Canon EF mount. Both mounts are passive—meaning you cannot control automatic features of lenses. But these cameras contain a 2.5K sensor, meaning you can crop in on an image without losing resolution in a 2K/HD workflow. Furthermore, for those who want to shoot in the world of 4K, they offer an S35 sensor model at 4K resolution for $4000.

Philip Bloom writes, "One of the biggest issues for me by far was the choice of lens mount. I love Canon glass and have a lot of it, but they are designed for way bigger sensors than the small BMD sensor. This resulted in a large 2.3x crop of the image, but worse than that, the only light hitting the BMD sensor was from the center part of the glass, not the whole thing, meaning the image was compromised straight off because of that."[3]

Equipment type	**Lens**
Equipment model	**Noktor SLR Magic HyperPrime Cine 12mm T/1.6 lens**
Approximate cost	**$550**

FIGURE 3.10
Image courtesy of Noktor.

More info at: http://www.slrmagic.com/products.php

Out of all the lenses listed here, this may be the best go-to lens for interviews and portrait work, as well as capturing action (it's equivalent to a 35mm lens on a full frame sensor camera). The Noktor is also designed as a cinema lens.

3 Bloom, Philip, March 29, 2013. "Review of the Blackmagic Micro Four Thirds Cinema Camera." http://philipbloom.net/2013/03/29/bmdmft/

Equipment type	Mic
Equipment model	**Zoom H1 kit and Pearstone cold shoe mount adapter**
Approximate cost	**$185 + $30**

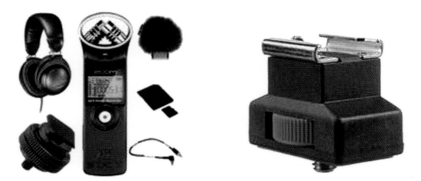

FIGURES 3.11 and 3.12
Images courtesy of Zoom and Pearstone, respectively.

More info at: http://www.zoom.co.jp/products/h1/

B&H kit info: http://www.bhphotovideo.com/c/product/731488-REG/Zoom_H1_H1_On_Camera_DSLR_Audio.html

For price and utility, this setup is a decent audio recorder for a camera. It has the advantage of not only being able to record audio to the Zoom H1, but it has the added benefit of being able to input a cable from the Zoom H1 to the Blackmagic camera. This also provides the advantage of listening to the microphone from the input of the camera.

The cold shoe mount attaches to the top of the camera, allowing you to add the mount that's included in the kit. The included windscreen is essential when shooting outdoors.

If you need a shotgun mic, then use the Rode VideoMic Pro ($220) or the Sennheiser MKE400 ($200). The advantage of the Zoom H1 is that you have secondary audio being recorded onto the recorder and into the camera. If you're using a different audio recorder, then use the Rode or Sennheiser as microphones for decent reference audio and as a backup.

The Perstone shoe adapter is required for the Blackmagic cameras, since they do not have a shoe mount.

Equipment type	Memory
Equipment model	**ScanDisk Extreme II SSD 480GB**
Approximate cost	**$530 each**
More info at: http://www.sandisk.com/products/ssd/sata/extreme-ii/	

FIGURE 3.13
Image courtesy of SanDisk.

This SanDisk drive will record about 90 minutes of raw footage. You'll want to probably invest in two to four of these for a day-long shoot. If you're doing documentary work and need more storage, you may want to consider shooting in Apple ProRes mode, unless you have the budget to get more. However, this is not an enterprise-level SSD (found in a Digital Bolex), and you may find that you'll need to replace it sooner than you'd like. Just place that in your budget.

Equipment type	**Batteries**
Equipment model	**Switronix PowerBase-70 external battery for BMCC**
Approximate cost	**$300**

More info at: http://www.switronix.com/products?page=shop.product_details&flypage=flypage.tpl&product_id=116&category_id=31

FIGURE 3.14
Figure 3.14 Image courtesy of Switronix.

The battery inside the BMCC is internal and cannot be swapped out. It'll last about one hour (perhaps up to 90 minutes). If you're doing a long shoot, this Switronix is essential. It'll give you six to eight additional hours of life.

Equipment type	**Monitor, sunhood and arm**
Equipment model	**Ikan D5 SDI Camera Monitor, sunhood, and articulating arm (6")**
Approximate cost	**$630 + $22 + $72 + $45 = ~$770**

FIGURES 3.16
Image courtesy of Ikan

FIGURE 3.15
Image courtesy of
Ikan.

FIGURES 3.17
Image courtesy of Ikan.

FIGURES 3.18
Image courtesy of Redrock Micro.

Because the BMCC has no HDMI out, you must purchase an SDI capable monitor and other accessories. You will only need this if you're shooting daylight outside (or inside under really bright conditions) in order to overcome the glare that'll hit the rear screen of the BMCC. There's really no other way around it that I'm aware of.

The LCD screen on the BMCC is fine indoors, especially in dark conditions—but forget it when you're shooting outdoor day. Even the supplied hood on the camera is quite useless in daylight.

This Ikan is a solid monitor. Be sure to add the sunhood, otherwise there's really no point in getting the monitor. You'll also need a way to mount the monitor onto the BMCC. Use the Redrock Micro ultraPlate that attaches to the top of the BMCC, where you'll be able to use 1/4" screw holes to mount the articulating arm, as well as a Zoom H1 audio kit.

Equipment type	**Cage accessory**
Equipment model	**Redrock Micro ultraCage for BMCC**
Approximate cost	**$500**

More info at: http://www.redrockmicro.com/Blackmagic-Cinema-Camera/ultraCage-blackmagic.html

For those shooting with accessories—external audio, microphones, external LCD screen, and so on—this gear may be one of the best investments for the ergonomically challenged BMCC. Include the top plate and a handle and you'll be able to shoot some low-angle handheld shots. The base attaches to a tripod or monopod. But you could just purchase the ultraPlate for $45 and add some accessories to it and save the $500 to put towards a lens.

For a top-plate and handle, you can get both for $155.

FIGURE 3.19
Image courtesy of Redrock Micro.

Equipment type	**Monopod**
Equipment model	**Manfrotto Blackmagic Cinema monopod bundle**

More info at: http://www.bhphotovideo.com/c/product/737980-REG/Manfrotto_561BHDV_1_Fluid_Video_Monopod_W_Head.html

The Manfrotto monopod—which I use a lot for video shooting—is probably the best stabilization gear you will ever buy. I used it for some of the shots for *Carpetbag Brigade* with the Blackmagic Cinema Camera (https://vimeo.com/65856805) profiled in Chapter 5.

Stillmotion's monopod tutorial and 3 Over 1 Rule is essential viewing for monopod shooting:

* https://vimeo.com/26869155

* http://stillmotionblog.com/h234hs23dkw21/ (first video)

FIGURE 3.20
Image courtesy of Manfrotto.

D16 DIGITAL BOLEX KIT: $5000 (NOT INCLUDING LENSES)

The first affordable raw cinema camera announced, the D16 Digital Bolex is beautiful and boasts an ergonomic design—though not quite as sexy as the Ikonoskop A-Cam dII, it expresses a lot of thought and is the only raw cinema camera on the market that welcomed input from its potential users throughout the entire design process (see Chapter 1).

Equipment type	**Camera**
Equipment model	**D16 Digital Bolex**
Approximate cost	**$3300 (250GB SSD) or $3600 (500GB SSD)**

FIGURE 3.21
Image courtesy of
Digital Bolex.

If you're looking for a digital camera with character, this is it. The look is as strong or stronger than the Ikonoskop and at one-third of the price, you cannot beat this deal. Some filmmakers shooting with the beta test camera say that the D16 is the real deal capturing the essence of what it is like to shoot on 16mm film in a digital format. It provides nice skin tones and ability to shape a film stock look in post. For independent narrative films, this may be just the camera to get. It is the digital replacement of Bolex's 16mm film camera.

Equipment type	**Lens**
Equipment model	**Kish Lens**
Approximate cost	**Price unknown at time of publication. See Digital Bolex website for price.**

FIGURE 3.22
Image courtesy of
Digital Bolex.

More info: http://www.digitalbolex.com/kish-lenes-na/

At the time of writing, the price of this set of C-mount lenses is unknown. In addition, you can get a different mount plate for the camera. It not only includes the C-mount, but you can also get an EF, PL, M43, and eventually a C-mount turret. The EF mount will also allow you to attach Canon lenses if you have a collection from your DSLR set. I shot with Zeiss Contax lenses using a C-mount to EF adapter during the beta test phase of the camera with good results (using the photodiox Zeiss to EF adapter ring attached to the lenses).

Equipment type	**EVF**
Equipment model	**SmallHD external viewfinder**
Approximate cost	**$600**

FIGURE 3.23
Image courtesy
of SmallHD.

This external monitor and viewfinder combo package blows the doors off of its competition.[4] Shooting with an external monitor on the D16 is imperative. The camera includes a small LCD on top of the camera, but it is small and if the camera is up high, then you can't see what you're shooting. This one from SmallHD is not only a decent price, but you will fall in love with the image coming out of the camera when you view it through this package.

Equipment type	Memory card
Equipment model	CF card
Approximate cost	$500 (two 128 GB)

http://www.bhphotovideo.com/c/product/895471-REG/Lexar_lcf128ctbna8002_128GB_Pro_Compact_Flash.html

The enterprise quality internal SSD drive of the D16 is not removable. Instead, images can be off-loaded through the USB 3.0 port. In addition, the camera contains two CF card slots. At 3.5MB per second for CinemaDNG, a 128GB card will give you about 25 minutes per card. Fast cards are recommended (such as 800x), but slower cards will work, because the data is buffered from the SSD drive. Digital Bolex recommends the Lexar Professional CF cards. B&H sells a two pack for about $500.

Equipment type	Batteries
Equipment model	Switronix PowerBase-70 external battery
Approximate cost	$300

More info at: http://www.switronix.com/products

This is the same external battery I used for the Blackmagic Cinema Camera shoot as well as for the Digital Bolex D16 shoot. Plan to get this battery for any long shoot. The D16 internal battery will last for an hour or two, so you're good for a short shoot, but the investment in this battery is necessary for any kind of professional or semi-professional shoot. Take note that Switronix makes a variety of models for different cameras.

Equipment type	Mic
Equipment model	Rode NTG-2 Shotgun Microphone Kit
Approximate cost	$300

For more info: http://www.bhphotovideo.com/c/product/400806-REG/Rode_NTG_2_Battery_or_Phantom.html

4 I shot with another brand's EVF attached to the D16 and it didn't come close to the quality of the image coming out of the SmallHD monitor.

This kit includes a shotgun microphone that can be powered through an AA battery or phantom power (through the camera's battery). It includes a shockmount and XLR connector. You really only need this setup for run and gun situations and backup audio if you're recording audio externally. Plan to spend another $40 for a wind muff for outdoor shooting.

The Digital Bolex D16 includes XLR connectors, so getting a professional mic makes it easier than using little microphones through the minijack of a DSLR, for example. You can attach a shockmount on top of the camera and hook in your favorite shotgun mic and/or lav mic.

Equipment type	**Monopod and/or tripod**
Equipment model	**Manfrotto 561BHDV-1 Fluid Video Monopod and Head**
Approximate cost	**$300**

This Manfrotto monopod is a great tool for any low budget filmmaker, whether you're doing docs or making a feature. If you're using lenses without image stabilization, you may want to consider a tripod for steady shots.

IKONOSKOP A-CAM DII KIT: ~$12,000

The first 16mm raw cinema camera, Ikonoskop's A-Cam dII expresses a sense of character to the image and strong ergonomics. However, as of the middle of 2013, the company stopped production of the camera due to low sales. By late 2013, the Swedish company was bought by a new owner in Belgium, and they are "in the process of renewing and improving the Ikonoskop ecosystem to better support our fellow community of A-Cam dII owners, users, and professional filmmakers," their website notes as of Dec. 2013. Check the website for the latest information (www.ikonoskop.com). In the meantime, some rental houses do rent the camera.

PART II
Raw Production
Case Studies

CHAPTER 4
Filmic at 16mm Digital:
In the Field with Ikonoskop's A-Cam dII

THE MAGIC OF SHOOTING IN RAW

Tucked north of Stockholm, the city of Kista boasts low-rise facilities helping to define the European cutting-edge where inlets from the Baltic sea shape a land of technological suburbia and organic gardens. It's Sweden's Silicon Valley—where form and function coalesce into many of their products, including Ikonoskop's A-Cam dII, an ergonomically sexy 16mm cinema camera. It's the first to hit the market with the CinemaDNG open source format. No similar camera offers such a sleek design, with faint echoes (at least in size) of Sony's 1990s VX1000. It has weight and feels substantial and elegant at the same time.

Swedish filmmaker Katarina Holmdahl says, "You pick it up and it's like you've got wings." She adds: "The body of the Ikonoskop is pure beauty. I saw it on the table, and couldn't wait to pick it up, already imagining what it would feel like, which is one of the biggest differences between any other digital camera I've used." The camera spoiled her: "I will never get the same feeling from

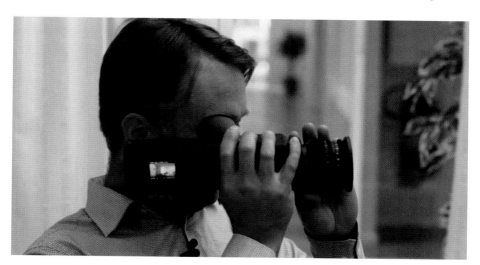

FIGURE 4.1
Peter Gustafsson demonstrates how to hold the A-Cam dII cinemaDNG raw camera in the Ikonoskop offices outside Stockholm. Photo by Kurt Lancaster.

viewing an LCD screen a foot or two in front of my face with a DSLR, and holding a camera like this—it's a completely different experience."

Peter Gustafsson, a professional filmmaker hired by Ikonoskop to field test and troubleshoot the camera and its postproduction workflow, tells me during an early autumn day that the camera "should be something you can hold in your hand like this, without any particular accessories"[1] (see Figure 4.1). Holmdahl says that Daniel Jonsäter and Göran Olsson, who developed the Ikonoskop, started their careers shooting on film. Indeed, the first Ikonoskop was a 16mm film camera, but with the rise of the digital cinema age, they shifted their energies in creating a digital cinema camera that provides a 16mm film look. (Ikonoskop halted production of the camera in summer 2013 and was later purchased by a Belgium company with plans for the camera unknown.)

WHY DESIGN MATTERS

In an interview with Les Films Associés in 2010,[2] Olsson explains the importance of their design. The key feature was to remove "the processing of the image. There's no compression—we don't touch the image. We take all the information from the sensor and put it down to a memory card. For two reasons. First, to keep the quality. Secondly, we took all the processors and software and hardware out of the camera, so you use your own computer to develop the film." In this way, Olsson continues, "we save a lot of space, and we save a lot of power, and we save a lot of heat. Modern film cameras, they have fans to cool them down, and . . . fans are just not really something you should have on film cameras."

This is the camera that you have to have some kind of concept of what you want to do in the grading if you want color. It's much like film in that way.

What they've kept in the design is a removable Sony battery, their own memory card,[3] and a mount for the lens. "This is for me the most perfect combination. I love the design, it's made for filmmaking," Olsson explains. By going with raw, they were able to remove the processing of the footage from within the camera—which is found in all compressed image cameras, saving weight, size, and power. "This is not a camera that you shoot something, take it to your computer, and broadcast it," Olsson explains.

This is the camera that you have to have some kind of concept of what you want to do in the grading if you want color. It's much like

1 Lancaster, Kurt, 2012. "Interview with Peter Gustafsson at Ikonoskop," https://vimeo.com/50774055
2 Interviews of Göran Olsson from: Les Films Associés, 2010. "Ikonoskop A-cam dII – Part 1: Introduction," https://vimeo.com/15187386; and "Ikonoskop A-cam dII – Part 2: RAW vs Film, Inspiration and concept," https://vimeo.com/15185866
3 They designed the fastest memory card on the market in order to maintain a robust data throughput for the raw files—250 megabytes per second.

film in that way. But the upside, of course, is that you have another latitude, and you don't have the complication with compression. I love compression. And you have to compress at some point, but the later the better, and we do not compress in the camera.

Olsson feels like the raw is very close to shooting film—at least in the process. It's not just the quality, but you also have to "develop it in the computer or the post process. And then when you develop it, you have a lot of options. And you have another exposure latitude, and you can do things with the color and so on. So I think what we've actually done is to create the first digital film camera."

For Olsson, this camera design he and his partner created was really about a failure of camera manufacturers creating digital cinema cameras for filmmakers. "Camera manufacturers should listen to the filmmakers," Olsson says. "And also be ahead of the filmmakers. And then the filmmakers can take the tools and make something different out of it."

But it's not just the shape of the camera—it expresses gravitas through the mass of the camera itself. Holmdahl feels the weight of the camera—which is still light compared to high-end cinema cameras and large ENG video (but certainly heavier than DSLRs) is an advantage. Used to shooting with her Canon 60D, she was surprised at how heavy it was. "It weighs a chunk, but it has a wonderful balance and solidity to it that I think many digital filmmakers have been missing." She feels that the camera's elegance, despite how "silly as it sounds" expresses "an inherent want to use it, as though it was built for me. I felt it could capture the story I was encountering for others to understand with me." It seems like the Ikonoskop engages a mystical connection to the user—and this may be the inherent design-functionality calculus of the camera itself. It beckons to be utilized in the field and on film sets.

DIGITAL 16MM THAT LOOKS AND FEELS LIKE FILM

But it's not the design that coaxes such filmmakers as Fabrizio Fracassi to state: "After conducting some video tests, I was instantly reminded of my early experiences with 16 millimeter film and its organic qualities."[4] Inside any digital camera lies a sensor—not all sensors are equal, and it's not just the difference between CMOS and CCD. Some are designed with higher tolerances.

What stands out is not just the elegant form and function in a cinematic package, but some say the digital images look and feel like 16mm film. Gustafsson doesn't deny it, stating that it was "designed as a 16mm digital film camera"— not as a video camera—which separates it from the video camera market.

4 Ikonoskop.com. December 2, 2011. www.ikonoskop.com/what-other-people-say/fabrizio-fracassi/

Filmmakers Michael Plescia and Andrew Cochrane agree that there's something special about Ikonoskop's CinemaDNG camera.[5] Cochrane, who works for Guillermo Del Toro's studio, Mirada, says he "loves the Ikonoskop more than anything." He's played with other raw cameras—from RED to Arri Alexa, but with

> every other digital camera that I've used in terms of the raw camp side of things it becomes all about specs and data. DSLRs are about convenience to a certain degree, and the shallow depth of field, which is huge. The Ikonoskop is the first camera that is the closest thing to a film stock in terms of having a character that I've used. It's like Instagram without a filter. It's the way it sees the world.

He adds that the Ikonoskop is the only camera that he's seen that has "any type of character. Every other camera manufacturer is talking about how flat the image is, how little skew it has, how good its response is." He feels that it's the only camera (aside from the Digital Bolex) that advertises how beautiful it is and how beautiful its images are. "Look at Arri Alexa, Canon, Sony, Fuji, all of them," and they're all about spec features. "It's a spec war," he explains. The Ikonoskop and Digital Bolex sidestep all of that and have designed cameras that express character.

Michael Plescia, an independent filmmaker and special effects compositor, agrees.

> I'm such a film purist and will probably never have the money to shoot on film, but when I saw the Ikonoskop I felt like it was a cyborg, it was a metal body covered in flesh. It was the first time I had seen a hybrid, where I felt that in a blind taste test I might have said, 'That might be a really dense slow 16 millimeter stock.' It's not like anything I have seen.

And this is *before* the image is processed in the computer during post.

> When there is no post-processing, that slight inherent grain of the CCD is becoming visible—I still have my qualms with grain coming off a grid that's not coming off an array of randomized crystals in film that's changing the underlying frame—but there was something about the Ikonoskop that really did feel like 16 millimeter.

5 Interview with the author, May 22, 2013, Los Angeles.

The Kodak sensor Ikonoskop chose to place in this camera, Gustafsson explains, makes the digital aspect of the camera feel more like film: "A lot of our users feel that it is the closest thing they use to a film camera, as far as the image quality goes." Rental house, TAC Digital Cinema in Los Angeles (co-owned by Cochrane) promotes it as a camera that "produces dreamy images with a distinct yet hard to describe look."[6] Hardi Volmer shot his Estonian film, *Living Images* (2013) on the Ikonoskop. What stands out in the examination of the trailer to the film (https://vimeo.com/58624080) is how it looks like it was shot on 16mm film (see Figure 4.2). And it's not just the vintage set that complements the look of the camera or just a postproduction trick (such as with an effect from Magic Bullet), although film grain/dust effects were added. There is a look put out by this sensor that exudes old-time 16mm film.

FIGURE 4.2
Screen grab from Hardi Volmer's Estonian film, *Living Images*. Notice how the vintage set complements the 16mm look coming out of Ikonoskop's A Cam dll. (© 2013 courtesy of Hardi Volmer).

In addition, *Colby in the Corner Pocket* expresses a different color palette that also feels like 16mm film (see Figure 4.3).

In addition to the look of the image coming out of the camera, there's the fact that the lens mount is capable of utilizing several different lenses, including 16mm, a PL-mount for 35mm cinema lenses, as well as mounts for Canon, Leica, and Nikon lenses—providing flexibility for the cinematographer.

6 TAC Digital. www.tacdigitalcinema.com/

FIGURE 4.3
Still from *Colby in the Corner Pocket*. Notice the range of detail from the highlights to the blacks, capturing a range of exposure nearly impossible with a DSLR. (© 2013 by Alex Markman. Used with permission.)

ON-CAMERA FEATURES AND MENU SELECTIONS

Costing over US $9200, Ikonoskop's A-Cam dII is about four times the cost of a Blackmagic Cinema Camera and three times of the Digital Bolex D16. Yet the camera is sturdy as a brick and combined with sleek ergonomics, it's probably one of the best camera designs on the planet.

It utilizes Adobe's CinemaDNG raw format at a 12-bit depth, costing you 3.2MB per frame. It utilizes the Kodak (Truesense) sensor (10.6x6mm) with an ISO/ASA rating of 200 at zero dB. The global shutter angle can be adjusted from 5 to 360 degrees (no rolling shutter issues in a CCD sensor). The A-Cam contains eleven stops of dynamic range—less than Blackmagic's 13-stop Cinema Camera. Other technical specs include a frame rate of 1-30 fps, two channels of 16-bit 48kHz line-level audio inputs, SDI video out, as well as a USB 2.0 output.

The camera utilizes over a dozen buttons and input/output elements—from the power switch to an audio line input, as well as an HD-SDI output connector. There's a separate button for gain boost and changing the frame rate, as well as a pixel zoom and histogram selector. Additional features can be found in the menu button, and you can step through the menu sections with the scroll wheel and button. Unlike many cameras on the market, the menu selections are pared-down (see Figures 4.4 and 4.5).

The camera is easy to use. All you really need to do for the setup is to set the shutter speed and frame rate. When shooting 12-bit raw, the color balance isn't as important, since that can be changed in post. I did notice my highlights got clipped in the documentary I shot with Holmdahl, so staying within the 11-stop range is important. Also, the Sony battery used for this camera only lasts an hour. A low battery indicator pops up when there's 15–25 minutes remaining. The camera does include a 7.2–15v power input, so larger batteries can be

```
015:19 C001 T002 3dB

MENU            SET UP MENU
VIEW            CARD NO
FRAME RATE      TIMECODE
SET UP          COL.TEMP
MAINT.          DATE & TIME
 EXIT           VIDEO OUT

24.00FPS 180.0° DL   00:00:38:07
```

```
COLOR TEMP: TUNGSTEN

MENU            SET UP MENU
VIEW            DAYLIGHT
FRAME RATE      TUNGSTEN
SET UP          EXIT
MAINT.
 EXIT

24.00FPS 180.0° DL   00:00:38:07
```

FIGURES 4.4 and 4.5

An example of Ikonoskop's menu function in which submenus appear when you choose an item. Here, when selecting Set Up in the left column, several choices can be made (seen on the right side), including the color temperature selection. When Col. Temp is selected, you are taken to the submenu, where the two choices are revealed: Daylight or Tungsten. Also note that the bottom of the screen reveals the frame rate for recording (24fps), the shutter angle (180 degrees), color temperature (daylight), and the time code. (Menu image courtesy of Ikonoskop.)

connected to it, providing longer shooting times. See side bar, key menu items from the manual. Compared to menus in prosumer video cameras I've used, as well as DSLRs, the menu is easy to use and does not offer a lot of choices—making it simple to start shooting right away without worrying if there's an item on that shouldn't be on (such as auto exposure in a DSLR).

Filmmaker Michael Plescia feels that the simplicity of the Ikonoskop is a bonus:

> I enjoy that it's a very simple camera to navigate in terms of its controls and I think it is leading the movement in simple menus, simple controls. The A-Cam has barely any controls or many options, just the bare necessities for calibration and that lends to the feeling that you are shooting on a 16mm Arriflex, making it perfect for my realm of no budget filmmaking with a no bullshit camera.

One of the elements of the camera—the memory card—utilizes a proprietary design in order to push high bit rate while recording, driving up the costs: over $600 for an 80GB card, over a $1000 for a 160GB card (February 2013), and around $780 for the express card reader (see Figure 4.6). In comparison, a 128GB CF card ranges from $200 to $650, for cards within spec for the Digital Bolex (600x–1000x speeds recommend).

Key Menu Items from the Manual

VIEW: View recorded takes in the camera or on an external monitor. To view recorded takes on a memory card directly in the camera viewfinder or on an external monitor connected to the HD-SDI output, press Menu and select VIEW. Step/Select to the take you wish to view. Select PLAY. To view the same take from the beginning again, press Step/Select. To cancel viewing, press Menu. To exit view mode, select EXIT or press Menu again. The last take recorded on a memory card always has a delete option. To delete the last take, press Menu and select VIEW. Select the last take. Select DELETE. To confirm delete, select YES. Note: this delete option should only be used to delete random takes. To fully erase a memory card, use the ERASE CARD option in the MAINTENANCE menu.

FRAME RATE: Set up fps, shutter angle, interval recording (time-laps) or still take.

FPS: Press Menu and select FRAME RATE/FPS. Use Step/Select wheel to set the desired frame rate from the available presets (1, 2, 3, 4, 6, 9, 12, 15, 18, 23.98, 24, 25, 29.97 and 30fps). The fps set will be displayed all the time in the bottom left of the viewfinder.

SHUTTER: Press Menu and select FRAME RATE/SHUTTER. Use Step/Select wheel to set shutter from available presets (11°, 25°, 22,5°, 45°, 90°, 172,8°, 180°, 270° and 360°), or select the 005–360°–> option to set the shutter in steps of 1° (between 5 and 360°). To set the variable value, use Step/Select wheel to set the three XXX digits. The shutter angle selected will be displayed in the top left of the viewfinder after set.

SET UP

AUDIO: The camera can record two-channel line-level sound inputted through the audio input. The sound is embedded in the CinemaDNG files and needs to be extracted to WAV, AIFF or BWF files with the A-Cam dll Audio Tool application (available for download at: www.ikonoskop.com/downloads/software/).

To set the LEVEL OUT for monitoring, press menu and select SETUP/AUDIO/LEVEL OUT. Step/Select to a level between 0 and 11. The current level will be displayed in the top left of the viewfinder.

For level monitoring purposes there is a built-in VU meter on the side O-LED display. This can be turned on or off to your preference. To set the VU METER preference, press menu and select SET UP/AUDIO/VU METER. Select ON/OFF. The ON/OFF status will be displayed in the top left of the viewfinder.

DISPLAY: The side OLED display on the camera can be turned OFF to save power when not in use. To turn display on or off, select SET UP/DISPLAY and Step/Select ON/OFF.

VIEWFINDER MASK (VF MASK): Use to set a format mask and/or cross in the viewfinder.

ASPECT: To set aspect rate of the format mask, select SET UP/VFMASK/ASPECT. Step/Select the preferred aspect ratio (1:1.85 or 1:2.35).

CROSS: To turn on or off the cross in the viewfinder, select SET UP/VF

MASK/CROSS and Step/Select ON/OFF.

COLOR: To set color of format mask and cross, select SET UP/VF MASK/COLOR and Step/Select to your preference (BLACK/RED/WHITE).

MAINTENANCE (MAINT.): Camera and memory card maintenance functions.

ERASE CARD: Before you erase a memory card, make sure all the files are downloaded and write protection is disabled. To erase the memory card, press Menu and select MAINT./ERASE CARD. To confirm erase, select YES. To dismiss, select NO. (Note: always remember to set new card number to avoid multiple files with the same number to appear within a project.)

Ikonoskop. A-Cam dll User Guide Firmware version 1.26 2012-11-30. http://www.ikonoskop.com/downloads/

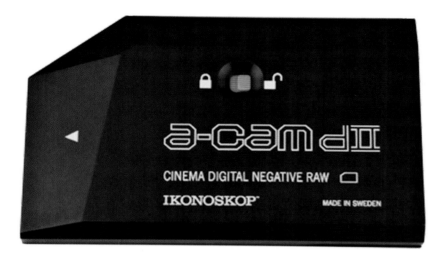

FIGURE 4.6
Ikonoskop's proprietary
memory card—the fastest in
the world, according to
Ikonoskop founder, Olsson.
(Image courtesy of
Ikonoskop.)

IN THE FIELD

Organic Farm in Stockholm

Given permission to field test an A-Cam dII, my friend Katie Holmdahl and I decided to shoot a short film, rather than just "test" it. We took the subway and bus to the outskirts of Stockholm and walked down a long dirt road to an organic farm nestled in an idyllic valley, among other farms. She had done some research about how this farm was trying to commit to providing work for immigrants.

Serving as my director, producer, and editor, Holmdahl says she wasn't sure what to expect with Ikonoskop's camera, having only some notion of its capabilities after perusing the company's website. "I had little idea of what meeting the camera would be like. To me, some equipment composes a tool, and some a creative partner. This falls into the latter category."

Despite the strong creative capabilities of the camera, she feels that "this is a camera that demands the attention of a cameraman." It's not like a video camera where you can almost point and shoot, but a camera that requires you "to be on your toes more" in order to get a quality image. Once you understand the simplicity of the camera—setting your aperture to within an 11-stop range, it's really a matter of working on composition. "I loved working on the visual quality, and also seeing the image on the little side screen on the right of the camera when my cameraman was shooting." The little LED screen allows the director to see the composition of the shot without having to wire the camera to an external monitor (which is possible).

Katie conducted interviews (in Swedish) while I operated the camera. Getting the highlights properly exposed was a challenge at first, since I made the rookie

FIGURE 4.7
Cropped screengrab from the organic farm project in Stockholm shot on the Ikonoskop A-Cam dII. Notice the clear skin tones of Rafael Altez. But also note the sky blown out. When using the camera, you need to stay within its 11-stop range, since it may be impossible to recover clipped highlights if you didn't expose for them properly. (Image courtesy of Katarina Holmdahl and Kurt Lancaster.)

mistake of thinking that 12-bit raw would allow me to overcome exposure range issues. You need to stay within the camera's 11-stop range (see Figure 4.7). Once we realized that, we began to have fun with the camera. The weight of the camera itself—in such a small package—allowed for stable handheld shots. We were able to move the camera with grace. As a shooter, I noticed how different the A-Cam dII was from my Canon 5D Mark II. These differences revolved around how I could just focus on two elements after setting the f-stop: composition and focus. I didn't have to worry about color balance or ISO. During interviews I stood still and got my close-up with focus. Also, when shooting b-roll action footage, I was able to move into different positions, moving from extreme close-up shots to wide shots with ease. Without an external EVF it was a bit of a challenge to get low angle shots.

Another challenge is the angled viewfinder, an angle favored by Olsson because it allows the left eye to remain open so the camera operator can look at her subject during interviews. It is set at an angle and you have to train your brain to shift that angle mentally to a straight shot. Holmdahl explains:

> Much like that experiment where you wear glasses to see the world upside down, your brain learns to autocorrect for the difference, and after a while you don't notice the angle. We were just starting to get the hang of it at the end of our shoot, and if I bought the camera, it would quickly become second nature.

SHOOTING A DOCUMENTARY WITH THE A-CAM DII

Despite such moments of adjustment, the camera was a joy to use for documentary work. You do have to be aware of the time limit of shooting raw. Depending on the size of the card, you could have just under 16 minutes of shoot time with an 80GB card and twice that for a 160GB. For filmmaker Holmdahl, she doesn't see that as a problem. "It forces those of us who have been rather wasteful of minutes by letting the camera roll on" with other digital cameras, she explains, "to plan our shots more efficiently. Much as one did with film." This type of planning wasn't too much of an issue for us on the organic garden film, since it is a short and we knew what kind of b-roll we wanted for our story. At one point, the battery did die and, without a spare, we resorted to Holmdahl's Canon 60D to complete an interview.

Playing back the results, Holmdahl felt that the Ikonoskop A-Cam dII delivered a "more cinematic look than the other digital cameras I've used, and I understand that's the whole purpose of this camera—it was made by filmmakers for film-makers." (See Figures 4.8 and 4.9.) Holmdahl feels this is a key difference when shifting from the 8-bit experience of prosumer video cameras and DSLRs to 12-bit raw of Ikonoskop's camera.

Much has been written about how we subconsciously experience media differently depending on how it is delivered to us by book, magazine, paper, analog film, digital images, gramophone records, or mp3 files. There is a richness in color variation in the footage shot on the Ikonoskop which I think adds beauty to the project.

FIGURE 4.8
The richness of color and sharpness of detail stand out when shooting raw. (Image courtesy of Katarina Holmdahl and Kurt Lancaster.)

FIGURE 4.9
Detail shot of a radish recorded on the Ikonoskop A-Cam dll. (Image courtesy of Katarina Holmdahl and Kurt Lancaster.)

This was more so than with any other camera she has shot with. She can't wait to shoot with it again.

COLBY IN THE CORNER POCKET

Alex Markman co-wrote and co-directed *Colby in the Corner Pocket* with Jake Fuller. Markman also edited the film. He tells me that the inspiration for the film "came from a weekend trip to Alex's parents' house in Long Beach Island, New Jersey"—about two hours from New York City. As Markman describes it, it's a "barrier town, really just a sliver of sand within sight of the mainland"— a sliver of sand 18 miles long. Its widest point is a breadth of five blocks from the "Atlantic Ocean to intracoastal," he remarks.

Markman spent summers there when growing up, but Fuller, the co-writer and co-director, had never visited. One January day they took a trip to Long Beach Island, driving later in the night on a Friday, not getting "into town until well past midnight." Being the off season, "the town was eerily quiet," Markman noticed. "One road stretches the length of the island, and as we pulled in," he explains, "we looked up and down that road and saw no one. It felt like we'd stumbled into an abandoned town. It was a foggy night, and while we knew we were in for a fun weekend, we were a little scared."

That's when inspiration struck. Markman and Fuller used the moment as a story setting and premise. "We decided to write a story that captured the feeling of wandering into a strange town for the first time," Markman says. "And we're interested in examining characters in small slices; giving the audience a taste

that leaves them wanting more. Since Long Beach Island is a wholesome place, we thought it would be interesting to see how a young gypsy (of sorts), in the midst of her travel, would deal with being stuck in such an environment. At the same time, Markman feels that the project "was a very personal film," he says with pride. He explains further: "It allowed us to explore subjects that have been burning inside us for a long time. What is the role of friends and family in all of our lives? And do they always deserve our forgiveness?" These themes would become the basis for their collaborative film, *Colby in the Corner Pocket.*

Although Markman wasn't the DP, he really liked Ikonoskop's A-Cam dII. He feels that "there's something very organic about the look of the A-Cam, that probably comes from a combination of using its CCD sensor and just recording a raw image format." Like others who have used this camera, Markman feels that "when you're watching the footage it definitely feels more like film than what the RED or even an Alexa might produce." At the same time, he also felt that it's also "like working with film in that you're not sure exactly what you're going to get until you look at the footage"—because of the nature of uncorrected 12-bit raw images. He also feels that despite this, "the images it produces and the size of the image made us fall for it." He not only loved the look coming out of the camera, but also the aesthetic package—from the 11-stop dynamic range to the size of the camera itself. It "opens a ton of possibilities. You can create the same quick movements that once you could only create with small digital cameras, yet get a very high-resolution image," Markman says.

In addition, he also remarks that the "motion, the global shutter, all make what you shoot look very filmic. And just the way the camera was designed with a sensor the same size as a 16mm negative, and being able to use 16mm lenses, makes it all pretty neat," he explains.

Markman notes how in one scene, where characters are running with the DP behind them, the camera shaking, "it was really nice," he says, "because you get that small camera feel with the movement, but there's no wobble that you'd get with a camera like the 5D and you might've gotten a bit of weird motion with the RED as well. It's a small moment, but we couldn't have done it without the A-Cam, unless we'd shot it on a Bolex or something similar."

Markman also feels that the 16mm film look revolves around how "you get so much more shadow detail which is probably one of the major aspects that makes it more closely resemble the look of film." (See Figure 4.10.)

However, unlike Holmdahl's experience with the camera, Markman didn't like the viewfinder. He felt that it wasn't as "accurate" as he wanted, so he felt that they were "shooting blind, in a sense"—which, according to him, made it more of a film-like shooting process. He also says that they found it a challenge shooting dark, lowlight scenes. With the low light, he found that "it handles blues poorly, and you often get artifacting, especially when in the dark you point the camera at a bright light source, (streetlamp, headlights etc.)." They

also ran into some issues with the workflow, not having the "proper hardware to watch footage on set," was a drawback, Markman explains. They ended up transcoding the footage after the shoot, creating Apple ProRes 4444 master files and proxies. By doing so, they have the flexibility of either "matching back to the cinemaDNG raw files" or "just match back to the Apple ProRes 4444," if they run into issues with the cinemaDNG files.

In the end, Markman remarks, "you fall in love with it pretty quickly." Although he feels that there are "growing pains, and shooting with it takes some getting used to, but it's definitely more ideal for someone who wants to take the time to learn the ins and outs of how to go about shooting with it." Despite these growing pains, he remembers that the first time he saw footage from the camera, he was "blown away. It did resemble 16mm," becoming quickly "obsessed" with the "phenomenal" look of the footage—especially after being used to shooting with the Canon 5D Mark II. "I had been waiting for a digital camera to come along that I might feel comfortable purchasing," Markman says, "and when I saw this footage, and then the camera itself, I pretty much made my decision: the A-Cam was it."

GUS

Michael Plescia is passionate about Ikonoskop's A-Cam dII. Despite some minor quibbles he has about the camera, he feels the pros outweigh any cons by a long shot. Indeed, he wasn't sure what camera to use on his film, but Plescia has his ear to the ground when it comes to the latest technology in the film world. He's friends with Andrew Cochrane, a director and visual special effects (VFX) supervisor at Guillermo del Toro's visual effects company, Mirada.

According to Plescia, Cochrane—who has access to RED cameras through his co-ownership of TAC rentals in Los Angeles—told him about a new camera from Sweden: "I have in my possession a camera you personally are going to want to become aquatinted with. I think it's something special and you need to check it out." Plescia dug into his research and came across an interview with Göran Olsson, one of the designers and owners of Ikonoskop. In this interview, Olsson spoke about camera design as a means to an end—he feels the camera person should have eye contact with the person on the screen (see Figure 4.11).

For Plescia—despite the fact he's technically minded—"hearing a camera designer speak passionately and intimately about a camera as a conduit for making the types of 'films we love' was so unlike other camera designers and marketing that I'd been hearing at that time." Indeed, Plescia gets annoyed about cameras being talked about as specs—resolution, frame rate variability, and stops of exposure latitude, "as if cameras were computers rather than paintbrushes. For me, filmmaking is deeply personal, akin to poetry, painting, or music writing, and it's where I find my deepest form of self expression so I was deeply intrigued by Göran's pitch" in that interview.

FIGURE 4.11
Ikonoskop's Göran Olsson demonstrates the importance of the camera design that allows one eye to look at the subject while the other eye is on the viewfinder. It was the passion in this interview—and the careful attention to design expressed here—that convinced Michael Plescia that the A-Cam dII was something different to any other camera on the market up until the release of the Digital Bolex D16.[7] (© 2010 Antonin Bachès/Les Films Associés. Used with permission.)

7 Les Films Associés, 2010. "Ikonoskop A-cam dII – Part 1: Introduction,

FIGURE 4.12
Still from *Gus*. (© 2012
Michael Plescia. Used with
permission.)

Plescia says, "What wasn't being talked about enough in these discussions of new cameras was the *look* that these new sensors and their accompanying compression schemes created." This was the camera for his film, *Gus* (see Figure 4.12).

Plescia was working as a visual effects compositor by day, and was writing screenplays at night. But he realized at some point that he was no longer having fun. "I felt somewhat distanced from my fond memories of my creative process as a teenager," he says. In order to find out what was missing, he went back to his teenage home movies on VHS tape. His reaction surprised him and became a wake-up call: "To my horror, they were good in ways my more recent screenplays were not. I became strangely ashamed that in some ways these grainy VHS tapes had more immediacy and electricity than what I had been writing—more personal, expressive, and alive."

He had used "gut instincts" when making these films with his friends— "essentially 'writing' with the camera itself." For Plescia, his "first language of storytelling" was not in words but with a camera. "No wonder I had felt cut off from my creative process when telling stories in solely screenplay format." He appreciated the craft of learning how to write a screenplay in school, but he felt that the rules of screenplay writing were "gumming up his instincts" of visual storytelling.

In a way, I had accidentally created a split personality filmmaker inside of myself. There was one filmmaker who had gone through film school and read all of the books and who thought that storytelling was about principles and story architecture and planning, and another filmmaker who had grown up with a video camera in hand and thought that

filmmaking was more akin to Jackson Pollock throwing paint around in states of abstract expressionism—that schooling took the fun out of the expression of filmmaking—a filmmaker who would have rather figured everything out on-set.

This realization changed how Plescia approached his filmmaking. "I knew then that I wanted a stepping stone project that would help integrate my newfound knowledge of storytelling principles with my former instincts." He looked for something personal, something small that wouldn't eat up two years of his life. He would write an outline or treatment and write only more details in a traditional screenplay approach, "details only written in where necessary—a scriptment so to speak—allowing for structure but with the freedom to create on set."

> Filmmaking should be more akin to Jackson Pollock throwing paint around in states of abstract expressionism.

Over the years, he had watched how his wife and her ex shared custody of their pet dog. "Although it was hard on both sets of owners at times, throughout it all I watched difficult moments of custody sharing get solved with compromise and communication by both parties. I had never considered myself an animal person until seeing the kind of depth and attachment my wife experienced, and I myself became very attached to the dog as a step-owner. As our dog became more elderly and was nearing the outer limits of the breed's lifespan, I experienced a vulnerability that I hadn't seen coming."

At the same time, Plescia read a news article about court cases dealing with custody disputes with pets. He was horrified to learn about "a few horrible incidents of spouses who after having been assigned sole legal ownership of a pet—despite heavy protest from their ex-spouse—had immediately euthanized the healthy animal out of revenge over the divorce. Legal murder out of spite. Although my wife and her ex behaved compassionately, it was a small leap for me to superimpose a 'what-if' scenario, and imagine what it would be like to experience a court decision that forced the loss of a dog like that and that's where the premise of *Gus* came from."

Plescia found his story, which he conceived as "a young woman as she loses custody of her beloved dog to her estranged husband and finds he has scheduled a euthanasia appointment. She escapes with the dog to her family's abandoned and remote cabin. The dog begins to behave strangely and disappears in a mysterious manner. The woman swears she will not leave the cabin without the dog and holes up alone with diminishing food supplies as her physical and mental health deteriorate rapidly. The story evolves into a study in how far somebody will go to prolong their love and attachment. Eventually her husband appears at the cabin insisting that the dog had actually been gravely ill, and that's why he was having the dog euthanized. The film then focuses on the estranged couple navigating two very differing views of a difficult situation."

He ended up writing the story for his wife, Nicole, who had studied acting and he felt had a lot of talent. This helped keep the production small. And they would use their dog. It became really personal. Plescia explains: "At that time our dog was still enjoying life very much and loved being at the cabin on vacations. But the story was written towards a looming emotional loss we knew was soon to come, as our dog's health was starting to show hints of decline. The story was a therapeutic exercise in a way, exploring a future loss and a future act of letting go we knew we'd soon face."

He would only shoot b-roll of the dog doing his thing without forcing him to do anything, without training or intervention, documentary style. But then art began to imitate life a bit too much. As they were shooting the movie "it became apparent that our dog's health was in a more sharp decline than we had seen even a few weeks prior. Even being at this former vacation spot was becoming too much for the dog and this raised immediate ethical and artistic dilemmas during filming." During one point, the "dog began to limp dramatically with arthritis and I left the camera running and documented it as we watched helplessly. If the shot had been of a trained dog under supervision from the Humane Society it would have been a perfect image to include in the film in order to underscore the themes of inevitable loss and denial inherent to the story. And even though off camera my wife and I were crying at these types of sights, somehow the act of filming the decline of an animal's quality of life for use in a fictional narrative seemed exploitative."

FIGURE 4.13
Indoor still from *Gus.*
(© 2012 Michael Plescia.
Used with permission.)

It was too much, so they decided to cut the filming of the movie halfway through the process "in order to get the dog back home where it might be more comfortable." The dog passed on a few months later. The film is currently on hold, as of this writing, as Plescia is working with his wife to find a way to "rewrite it around the absence of our dog."

> I always suggest never to overexpose anything in the entire frame. Ever. The camera looks like video suddenly when overexposing happens. The image loses its magic.

In either case, Plescia feels that the film—even if it's never completed—served its purpose, "giving us catharsis and a place to face an inevitable loss in our lives, and an opportunity to shoot on the fly and to discover layers of a story on set." In addition, he plans to release sections of the footage to showcase the "beautiful images the camera creates. Even if the story isn't ever told in the way we had originally intended, I plan at least to let the footage be seen so other filmmakers can make of the A-Cam what they will," Plescia explains. Figure 4.13 reveals the camera's sense of character that Plescia feels makes the Ikonoskop special.

Ikonoskop Production Tip from Michael Pescia

After Ikonoskop posted up some stills from my film *Gus* I got many inquiries from people that seemed very intrigued by the camera but worried about some of these technical things that they had heard. I always tell them, "None of them are deal breakers in the slightest, and the look the camera gives is so good, it is worth fighting for."

Here are some issues I encountered and overcame.

I always suggest never to overexpose anything in the entire frame. Ever. The camera looks like video suddenly when overexposing happens. The image loses its magic. And to me no exposure ever needs to flirt with being overexposed in the A-Cam just to eke out more range (you can play it safe with highlight protection) because of how healthy the lowlights are.

People have claimed that the camera has a smaller dynamic range than other cameras on the market but I don't really buy that line. Technically yes, maybe, I buy it, sure, science and all. But in terms of how far I was able to bring up the blacks on shots that seemed highly underexposed, it was a *dream* to work with the raw off the A-Cam, because it's *real* unadulterated raw. (Unlike RED Code raw-ish). It allowed me to only worry about highlights and not too much about my fills. I went a little far on a few setups and unfortunately found the bottom of the black

levels in a few shots but it is a lot harder to find "dead" black levels on this camera than one would think because there is *life* and information in the unadulterated grain at the bottom of the luminance spectrum.

The Kodak KAI-02150 sensor in the A-Cam has been rumored to encounter some artifacts in certain situations. In my shoot I only witnessed this "vertical line artifact" in one shot, wherein I had a bright light in the upper left hand corner quadrant and my lower right was dark (apparently there was some rumored magic combination of light setup to conjure this artifact). It was visible in the viewfinder and I neglected to notice that I was exposing hot. The sensor is broken into four quadrants and in low light settings when I did not realize I should have been gaining up the sensor. After grading up heavily I noticed a demarcation of different luminance on the four quadrants of the sensor. I can't blame the A-Cam but place the blame on my less than genius cinematographer (me) who was acting like a gain coward since he had been burned in the past by lesser cameras.

Since the Ikonoskop calibrates the sensor for its different gain settings, to avoid this pitfall I should have gained up and it would not have been a problem. For me I was able to correct the appearance of the quadrants in a few shots

painlessly and quickly and didn't resent seeing four subtly different exposed quadrants because for me I would have handed over my future first-born child for a digital camera that looked like film and so for being able to shoot on a camera that looked half-like film it was a small inconvenience to balance the quadrants in post with a little elbow grease while getting to keep my unborn child.

I could understand that for some people on fast turnarounds this would be a worrisome thing to hear about if they were researching an A-Cam purchase. But alas, just gain up in low light up to two stops. I would suggest don't be afraid of gaining up with the A-Cam, because ultimately the A-Cam's native grain—the grain that is not smoothed out by any onboard compression is beautiful grain and grain is good for us when the grain isn't a vibrating digital noise cluster muck. It's good for us when it has a very "almost film"-like quality to it like the A-Cam's does. Grain's good as a dithering agent in the color correction and it's good for keeping the frame and skin

alive. I have heard rumors that some of these problems have been dealt with in the A-Cam and in fact, the camera that I was shooting on for that portion of the production was a lender from Ikonoskop while TAC rental house's main camera was getting an upgrade overseas. An upgrade that I believe was already dealing with some of these issues. (I was lucky to be a very early user of one of the first manufactured cameras so it fell within the period of growing pains.)

One thing I did notice was that the A-Cam sensor can sometimes exhibit color shifts that cool down the color of human lips and casting purples into the shadows that users have had to neutralize in the color correction. I've often said affectionately of the A-Cam that it is a "moody" camera. One thing that helps with the color shifts are some DaVinci Resolve "Aces color profiles" that essentially neutralize the sensor's biases. I've never used them though, always just color corrected manually with Adobe Camera Raw (see Chapter 8) and it wasn't hard.

Looking sharp

In the Field with Blackmagic's Digital Cinema Camera

BIRTH OF A NEW CAMERA

John Brawley sits on a park bench across the street from production trucks and picnic tables. It's lunchtime after a morning shoot of an episode of the Australian series, *Offspring*, on location in the old movie theater, Westgarth Cinema, in a Melbourne neighborhood (see Figure 5.1). Headquarters of Blackmagic Design is less than 30 minutes away. Brawley, long graying hair and a seemingly permanently engraved five o'clock shadow, runs a relaxed crew on set. At his disposal are a pair of RED cameras and Angenieux cinema lenses, as well as a Blackmagic Cinema Camera—the first low-budget raw camera. He uses it as third camera and a primary camera when he needs to cram it in small spaces, where his big rigs cannot fit.

When asked about Blackmagic Design's raw camera, he discusses how they really understood the raw world with their postproduction hardware. "If you look at what Blackmagic has done," Brawley explains, "in post gear they have always been uncompressed. They really care about image quality so they really wanted to make the camera as good as it can be and for them it was about high bit depth." Setting the target on three areas: high bit depth, dynamic range, and uncompressed raw, Brawley continues, "they thought if they could do that, really well, and cheaply then you would have a really good camera."

Brawley, an Australian cinematographer, was brought into Blackmagic Design's offices in November 2011 and presented with a series of PowerPoint specs on the first camera they have ever developed. When Brawley first stepped into Blackmagic Design's room, he was certain that they were going to show him a new piece of postproduction tech. "I'd been asking them for a long time to do something about the raw recording for the Arri codecs and I was hoping that they might do it," he says. "I was about to start a film that was shooting on the Alexa and I was hoping that they were going to do a really cheap Alexa raw recorder. Do a raw version of their HyperDeck and record Arri raw. And so they blew me away with the specs for their camera." After they showed him their PowerPoint, they slid the camera across the desk, "which was just a mockup at that point. Didn't even have a prototype," Brawley says.

FIGURE 5.1
John Brawley sets up the BMCC in the Westgarth Cinema for a scene from an episode of the Australian series *Offspring* in spring 2013. (© 2013 Kurt Lancaster.)

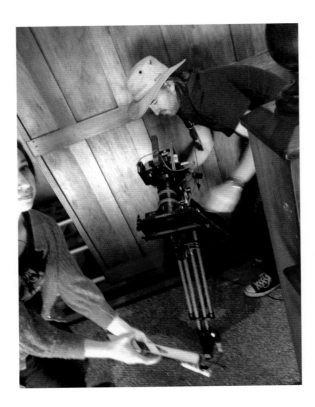

EVALUATING THE SENSOR

Soon after—they work fast—they had engineered a sensor to a circuit board and hooked it up to a lens and laptop. "That was the first thing I shot with," Brawley notes. They brought Brawley in to evaluate the sensor as a professional cinematographer. He explains: "They'd had a couple of bench tests with it where they'd just been shooting around the office, but no one had actually lit something. They had no idea even what the ISO of the sensor was. They had no idea whether what they were doing was right in terms of the pictures and so on." After overcoming the engineering limitations—from processing to calibration—they were finally able to get some images, and Brawley says the engineers at Blackmagic didn't realize how good the camera was. As engineers

they come from a post point of view, and its either one volt on the vector scope or zero. They hadn't really looked at pictures in a subjective way. You have choices when you're making cameras. You can get accurate, but usually accurate is not what you usually want. Usually you want it to have some personality and the feel. And accurate is usually kind of boring. They had to start judging the image in a subjective way and deciding if they liked what it looked

like. We started shooting a lot of stuff and doing a lot of tests. We shot a 5D at the same time in the same exposure and it was really high contrast situations. And they realized just how good this camera was because it was holding all this extra highlight information that was gone on the 5D. Now the 5D looked good—you looked at it and said all that looks nice. And then you saw the Blackmagic stuff against it and it was like—wow! This is actually something special.

A WIDE DYNAMIC RANGE

The dynamic range sold it for Brawley. As he says, the 5D footage looked good. "There wasn't anything wrong with it. But all of a sudden this—just looking from a dynamic range point of view—they started to even realize themselves that they've done something pretty special. I don't even think they expected the reaction that they got at NAB," Brawley muses.

Rather than start small, Blackmagic Design jumped into the cutting edge, designing a camera that could shoot raw video with a sensor between super 16mm and super 35mm at a cost of $2000 by summer 2013. It upended the corporate system of the professional camera world, including RED and Arri Alexa, and not to mention the Canon DSLR market (especially within the higher-end market of the 5D Mark II and III). They were to deliver what everyone

FIGURE 5.2
John Brawley shoots a delicate scene handheld in the bathroom on location in someone's home in a neighborhood of Melbourne. Notice the two performers on the back LCD screen of the Blackmagic Cinema Camera. Brawley likes the ability to fit the camera in tight spaces. (© 2013 Kurt Lancaster.)

was asking Canon to do—including Lucasfilm. Canon didn't and Blackmagic stepped in to the low-priced cinema raw void, announcing and displaying their camera five months after Brawley saw a nonworking prototype sitting on a table in Melbourne, and a month after Digital Bolex's public announcement at South By. They kept their mouths shut and quietly put out a camera that stole Digital Bolex's thunder at Las Vegas' NAB show in April 2012.

Less than a year later, Brawley is using it professionally on the set of *Offspring*, shooting in a variety of locations in Melbourne. See Figure 5.2.

However, Brawley tends not to shoot raw when DP'ing *Offspring*. He actually talked Blackmagic Design into adding ProRes to the raw capabilities of the BMCC. "I don't think I can take credit for getting them to put it in the camera but I certainly pushed very hard," he emphasizes. He wanted it for ease of use in post as well as to save space. "Initially when they told me what they were going to do it was only raw", Brawley explains, but they

> realized once they started shooting it generates a lot of data very quickly, which is fine if you're a studio film, but again, this style of shooting where it's very fast, we just don't have the room, or the space, or the time and we can't justify shooting raw. But the nice thing about the Blackmagic is you can flick a switch in the menu and you can just go between raw and ProRes within a scene if you want. You can do one shot as raw and do the next shot as Pro-Res.

He likes the flexibility. As for the complaints about the form factor—it can be a bit clunky to handle—Brawley feels that to keep the price low, compromises

John Brawley on Crop Factor

I really have a bugbear about crop factor in regards to full frame because those two words never existed before the 5D. Nobody cared. A lot of people that use this phrase don't actually know what they mean. It really ignores 100 years of cinema history, because cinema cameras weren't full frame, they were super 35 or what used to be 35mm.

I've tried to get people in the habit of saying it's not full frame its 135[1] that's the name of that format and it's not the golden number one either, because we've been shooting on 1.6 crop lenses for the last hundred years or more. I think people get really hung up about crop factor. We never had crop factors for super 16mm and 35mm,

it was like we just knew there was a different field of view with those formats and you never tried to calculate them and you never dismissed the 16mm guys who couldn't get a full frame "look." This is a very contemporary idea and it is just a fashion that people love the shallow depth of field look and I think it gets a bit tiresome once you have to try to pull focus on someone's eyeball. Realistically speaking there are very few times that you can actually use that kind of shallow depth of field anyway. It's great to have as an option but most of the time you're not going to be shooting in that style and it's impractical to do it. In a high turnover drama it just doesn't work.

1 See "135 film," http://en.wikipedia.org/wiki/135_film.

had to be made and one was to make the design simple: "Once you use it for a while you realize that it's more or less a silver box with a screen on the back and a lens mount on the front." What can't be doubted is the quality of the footage coming from the camera.

ON-CAMERA FEATURES AND MENU SELECTIONS

Compared to other cameras, the Blackmagic Cinema Camera is rather simple, and provides a relief in ease of use (compared to a Canon DSLR or C100 menus, for example). The BMCC's LCD screen is touch-capable and it works well.

There are four main menus in the BMCC (see Figure 5.3). I describe each below.

1. **Camera Settings**—here, you can set the Camera ID for metadata purposes, as well as the date and time. The other settings are important:
 a. Camera ID—the factory ID number of the camera.
 b. Date (set for metadata).
 c. Time (set for metadata).
 d. ISO: the native setting is 800. You can go down to 400 and up to 1600, but Blackmagic Design recommends 800 as the optimum setting. When I was shooting the *Carpetbag Brigade* scene, I had the first run through set at 800, but I noticed I was clipping the highlights. During the second run through, I knocked it down to 400, but in the end it didn't matter, since after I put the footage into DaVinci Resolve, I was able to recover all of the details from the clipped highlights—something I would be unable to do with a DSLR, for example.

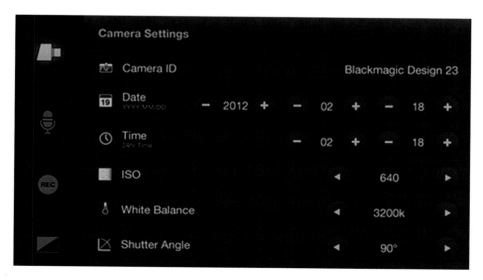

FIGURE 5.3
Camera Settings menu for the BMCC. (Image courtesy of Blackmagic Design.)

ISO TIP

Getting the shot is important and if you're shooting too dark use more light, otherwise you'll get too much noise in the dark to recover important data. But if light isn't available, boost the ISO, as needed. If you're in low light, going up to 1600 ISO isn't necessarily a bad thing, although you might get some noise. In digital cinematography, you want to expose for the highlights. As a fail safe against clipping highlights, Blackmagic designed an exposure button on-camera which automatically processes the exposure so there's no clipping on any pixel—when shooting in film mode. Even if this automatic value changes when using a different lighting setup, you could still easily match exposure shot to shot since you're working with 12-bit raw.

 e. White balance: there are eight presets:
- i. 3200K (tungsten light)
- ii. 4500K (fluorescent light)
- iii. 5000K, 5600K, 6500K, and 7500K (daylight settings under various conditions). When using the camera during my shoot, the camera was set for daylight, but I was able to bring it down to 3400K in post without any issues.

WHITE BALANCE TIP

In the end, choosing the proper color temp isn't as important in the 12-bit world of raw, since you can change it to any color temp in post and not damage your footage. If you're aiming for accuracy on set so you can see the look of the shot, then it's certainly more important. And if you're in ProRes 422 shooting mode, then it's essential you do dial in the proper color temp.

 f. Shutter angle: in film cameras, this indicates how open the shutter is in relationship to the film coming through the gate. If it's at 180 degrees (standard), it'll appear normal. If you're at 360 degrees, then it's wide open and you'll have motion blur, while if it's less than 180 degrees, the footage will be more staccato in appearance. According to the BMCC manual, if you set the angle to 172.8 degrees, you'll minimize flickering lights at 24p with 50 Hz electricity, while 180 degrees supplies the normal look for lights with 60 Hz electricity.

SHUTTER ANGLE TIP

If you're not sure what shutter angle to use, stick with 180 degrees. When you have time, shoot some test shots with a moving subject and static subject to see the results. Then you'll know which shutter angles to use based on the story you want to tell.

2. **Audio Settings**

 a. Microphone Input—adjust the input level of the mic.

 b. Ch 1 and Ch 2 Input Levels (adjust the level of each input).

 c. Ch 1 Input.

 d. Ch 2 uses Ch 1 Input (making them the same).

 i. On

 ii. Off

 e. Ch 2 Input.

 f. Speaker Volume (adjust the level of the camera's speaker).

Most reviews do not favor BMCC's audio capabilities. I was able to get usable audio out of the camera by hooking up a Sennheiser shotgun mic, using an XLR to 1/4-inch TRS cable. But it must be noted, it did not sound as good as my Tascam DR-40 using its *built-in* pair of mics. So just as DSLR shooters used external audio recorders, it's imperative that users of this camera utilize external audio recorders, as well. In either case, it's what professional filmmakers deal with every day.

The audio settings are straightforward, covering your ability to adjust the output level, choose line level or mic level, levels for each channel, to make channel two express the same input as channel one, as well as allowing you to set the headphone levels. A grave mistake of the design is the lack of audio meters while recording—the same mistake that Canon made with their DSLRs.

AUDIO TIP

Until there's audio meters on the camera, then you cannot use this camera as a run and gun machine without considering a secondary audio device—such as a Zoom H1 or Tascam DR-40, which can double as a microphone input for the BMCC as well as engaging its own recording.

3. **Recorder Settings**

 a. Recording Format

 i. RAW 2.5K

 ii. Apple ProRes 422 (HQ)

 iii. Avid DNxHD

The recording format is the most important setting on the camera. If you want the widest range of latitude on your shoot, choose raw 2.5K. This is where you'll have room to not only crop your film from 2440x1366 to 1920x1080 (50 percent more pixels) but it engages

the largest headroom for color correction and color grading. The other options compress the image: Apple ProRes 422 (HQ) and Avid DNxHD.

> ## RECORDING FORMAT TIP
>
> Shoot raw every time you want headroom during post. But be sure to have several SSD drives on hand. I would shoot raw for any fiction piece. Use ProRes or DNxHD when needing fast turnarounds or news shooting. Also, choose the one that will be best for your editing software. Either one of them will give you more space on the SSD drive and will increase your speed in post. In addition, they are powerful broadcast-ready codecs—but since you'll have less latitude in post, be sure to get the look close to what you want the final result to be or you may run into issues in post. You'll certainly notice how much better it is than working with the 8-bit DSLRs!

 b. Dynamic Range

 i. Film

Presents a flat, ungraded-looking image through a cinematic log curve. The best for color correction. If you're not shooting raw, this is the best one for those shooting independent film projects. Will provide a bit more dynamic range.

 ii. Video

Engages the REC 709 high-definition television with a 16:9 aspect ratio standard and provides the fastest way to edit footage. If you're shooting news or a project needing a fast turnaround, this may be your best choice. The image comes out graded and you lose some dynamic range.

When you choose ProRes or DNxHD, you'll be given the option of choosing film or video mode. The modes reflect a gamma curve choice and determines how the video gets encoded.

> ## DYNAMIC RANGE TIP
>
> Film mode is the best format for the BMCC. It's going to provide the range of latitude you want and need in post.

 c. Frame Rate

 i. 23.98

 ii. 24

 iii. 25

 iv. 29.97

 v. 30

These fall within the standard video frame rates that provide everything from 24 frames per second film rate look to the standard video rate of 30 fps. The 23.98 and 29.97 refer to television broadcast standards. Be sure to use 23.98 (or 29.97) when using Final Cut Pro—my audio drifted when using strictly 24fps.

 d. Time Lapse Interval

 i. 1–10 seconds

 ii. 1–10 minutes

4. **Display Settings**

 a. Dynamic Range

 i. Film

 ii. Video

Dynamic Range: as in the recorder settings, this allows you to choose video or film look—whatever you choose, it's independent of what you chose for your recording! This setting refers only to the look on the LCD screen. So if you're shooting the flat film look in the Recorder Settings and you want to have a look onscreen that's more dynamic, choose the video look.

 b. Brightness

 i. Slider adjustment. Sets the rear screen look without impacting the settings of your recording. You'll need brighter when outdoors and you can go dimmer in darker spaces to save some battery life.

 c. Zebra

 i. Set as a percentage

Zebra patterns will show up when you start clipping your highlights. In the production I did, the zebra patterns were set to 75 percent (probably too low, while 90 percent would probably be better for a camera with a high contrast range. Some shooters in film mode will set it at 100 percent—so when they do see the zebra pattern, they know they've clipped and can adjusting the image accordingly. Once it clips at 100 percent, there is no recovery of the blown out image in post.

ZEBRA TIP

When shooting ProRes or DNxHD pay attention to the zebra patterns, since you may not recover much information in post. I would not go over 90 percent in these modes. In raw mode, go with 100% so you know when you've clipped.

 d. SDI Overlays

 i. All: shows frame guide marks and status info on the LCD screen.

 ii. Status: the status info reveals your recording format (Raw, ProRes, DNxHD), ISO, frame rate, shutter angle, and battery life.

 iii. Guides: these provide you with framing guides (such as shooting at 16:9).

 iv. Off: turns off all screen information.

IN THE FIELD

Carpetbag Brigade by Kurt Lancaster
(https://vimeo.com/65856805)

Blackmagic Cinema Camera

Canon EF 16-35mm and 24-70mm f/2.8 L series lenses

Having a background in the performing arts—I still love directing plays and working in the theater world when possible—I was excited about shooting a segment from the Carpetbag Brigade's "Callings," a work that evokes charismatic wonder as stilt-walking dancers not only perform dizzying stunts, but tell a choreographed visual story as they do so. They're a postmodern tour de force and they happened to be performing the same week that I was lent a BMCC—a blessing from Blackmagic that I will not forget.

Finding the Story

Before shooting, I looked on the Carpetbag Brigade website and read the 'About' page. I needed permission to shoot and wanted to find out what this performance group was about. I read through the details, making note of key words and phrases that I could talk to them about. (See Stillmotion's "The Four P's of Storytelling" to learn more about this story-based process: http://stillmotionblog.com/storytelling-series/.) Carpetbag Brigade's mission statement became my initial production notes:

Mission

The Mission of The Carpetbag Brigade is to increase the quality, scope and impact of live performance culture through performer training, community outreach and aesthetic presentation. By utilizing performance art and its pedagogy as a tool to transcend language, class, and genetic heritage we seek to create bridges of understanding by sharing our craft locally and globally in diverse urban and rural settings.

The Carpetbag Brigade creates both spectacle-based dramatic outdoor performances and intimate indoor black box self-devised performances. By synthesizing acrobatic stiltwalking, butoh dance, contact improvisation, musical composition and physical theater The Carpetbag Brigade has pioneered a unique aesthetic approach and corresponding technique that has resulted in 10 original performances and tours to Europe, Latin America, Canada and the U.S. For five years they were the host group of the Tsunami on the Square festival and in 2007 they were the company in residence at the Universal Forum of the Cultures in Monterrey, Mexico.

After reading this, I knew I wanted to film them. Since I got my advanced degree in performance studies from NYU, my background and some of my readings from my university days became a point of contact—a way in—for getting this group to agree to the shoot. I called the contact number and was able to talk to Jay Ruby, the founder and director of the performance group. I discussed some shared background and we had an immediate connection. He came across as warm and enthusiastic, which helped me realize he would make a strong interview subject for the film (see Figure 5.4). I was not only in, but I had found my story.

Jay Ruby
Director, Carpetbag Brigade

FIGURE 5.4
The charismatic founder and director of the Carpetbag Brigade, Jay Ruby. He agreed to a ten-minute interview before their show. The sharpness of the facial features comes through with BMCC's sensor in raw mode. (© 2013 Kurt Lancaster.)

Setting up and Shooting for Story

I asked one of my top production students, Kent Wagner, to help me with the shoot. He would shoot with the Canon C100 using a 16-35mm f/2.8L lens from Canon, as well as the 70-200mm f/2.8L lens. I originally planned to shoot on my Zeiss Contax 50mm f/1.4 lens, but when I attached it to the BMCC,

the focus was soft, so I slapped on Canon's 24-70mm f/2.8L lens. The adjustment of the iris/aperture/f-stop is not intuitive. With an automatic lens, the iris button on the body of the camera will expose all pixels so nothing clips. If you're using zebra patterns (showing you what areas of the image are clipped), set the level to 100 percent—then if you *do* see the pattern, then you've destroyed that part of the image and there's no recovering it in post—so you need to stop your shutter down to avoid clipping. If you follow the 100 percent rule—even if you think you've clipped it, visually—you'll most likely be safe. To adjust the iris (if you're not using a manual lens) and with a lens compatible with the BMCC, press the forward and reverse buttons on either side of the play button on the back of the camera.

We were given permission to shoot during their tech rehearsal—a time when the performers would run through their show in full costume with sound and lights. Essentially, this gave me the opportunity to shoot the show without an audience, so I was able to get the camera onstage and get in close. I used the Manfrotto monopod with the fluid head and legs (see gear chapter), following Stillmotion's 3 Over 1 Rule (http://stillmotionblog.com/h234hs23dkw21/)—keep moving the camera and hold for at least three seconds (I try to do five to seven seconds), changing composition continually so you have a variety of angles and shot sizes to choose from during the edit. For the second run-through, I shot it handheld so I could set the camera on the floor and get some low-angle shots. For the performance in the evening, I set up the camera in the back of the house, setting the zoom lens at about 35mm in order to get a full wide shot of the stage. I would intercut the close-up and medium shots with the wide. Even though I planned to shoot with the slider, I did not end up using it since there were only two run-throughs during the rehearsal—and at less than seven minutes each—I felt it was wiser to maintain the monopod and handheld shots over the two short run-throughs in order to get enough variety of shots.

But before the shoot, I thought about the story, and I used some of Stillmotion's concepts—how you can find the emotional intent of a project by first doing research and then creating keywords and phrases that revolve around that research. The Carpetbag Brigade's mission statement I cited above was just part of the research, while another part of it was the pre-interview I did over the phone with Jay Ruby, the founder and director of the Carpetbag Brigade.

This core research became the basis of my questions for the interview with Jay Ruby, as well as my approach to shooting the film. If there's one element in which I failed, it was to convey the sense of liquid movement—I wanted to do this with the slider, but I didn't have time to set up the shot to make it happen. I also toyed with the concept of doing a pinhole camera shoot in order to convey the experimental concept of the performance, but since the camera was a loaner and I only had one camera, I didn't want to experiment and not get usable footage.

Story Proposal Worksheet

Use the following questions to help generate ideas:

1. Deep down, who is your subject? What really defines them?

 Physical storytelling through movement, acrobatics, choreography, physical theater. Influenced by the avant-garde. International scope.

2. What is your subject's mission, goal, or burning desire?

 To create intercultural bridges of understanding through performer training, community outreach, and aesthetic performance.

3. What makes them different? What makes them stand out?

 They use stilts in their acrobatic performance work. Contact improvisation. A mix of avant-garde performance forms.

4. How do they make the world feel? What emotions do they project?

 Digging deeper into Carpetbag Brigade's website, I found a link to reviews of past productions:

 http://carpetbagbrigade.wordpress.com/media/reviews/pastproductions/

 http://carpetbagbrigade.files.wordpress.com/2012/09/fringe-binge-callings-press-2012.pdf

From these I pulled out a few words and phrases based on what I read in the reviews:

- hypnotic
- mind-blowing
- liquid movement
- committed
- absorbing

5. What are your keywords or phrases?

- experimental
- physically engaging
- socially reflective
- acrobatic
- liquid movement

6. What is the purpose of your film in one clear sentence?

 To convey the excitement of the Carpetbag Brigade's physically based performances.

 For more information on Stillmotion's storytelling approach, check out their blog site on storytelling: http://stillmotionblog.com/tag/storytelling/.

 I've included my modified version of this storytelling proposal as a resource on my website, which I use in my production classes at Northern Arizona University: http://kurtlancaster.com/emf225/Story_proposal_template.doc

Both of these concepts were, however, valid since they stemmed from my keyword research. In either case, my research not only gave me confidence in the interview, but also in my shooting of the work. In many ways, I went hand-held with the BMCC in the second run-through because I wanted to get some low-angle shots, experimenting with such angles as a way to experiment with the visuals. The audience (and my wide shot of the evening performance reinforces this) can only see the performance from one angle of perspective—which in most cases is a full wide-shot point of view (see Figure 5.5). But by getting the camera in close and changing up the angles during the rehearsal run-throughs, I was able to provide multiple angles and details (see Figure 5.6).

For details and workflow on the postproduction color grading process, see Chapter 7.

FIGURE 5.5
A wide shot of the Carpetbag Brigade's segment from "Callings," their avant-garde stilt performance at the Clifford White Theater, Northern Arizona University. The BMCC is set up at the back of the house with a Canon 24-70mm 2.8L lens, set around 35mm at f/2.8. Color grading through DaVinci Resolve. Even from the back of the house, the BMCC image is sharp—much sharper than the Canon C100 or a DSLR from the same distance—which stems from the fact that the 8-bit compression does not compare to 12-bit raw. (© 2013 Kurt Lancaster.)

FIGURE 5.6
A detail shot of the Carpetbag Brigade's segment from "Callings" at the Clifford White Theater, Northern Arizona University. The position of the camera from a low angle and up close provides details that an audience cannot see from within the theater house. Shot with a Canon 16-35mm f/2.8 lens. Lens focal length unknown. Color graded with DaVinci Resolve. (© 2013 Kurt Lancaster.)

Ponte Tower by Philip Bloom

(https://vimeo.com/51295174)

Blackmagic Cinema Camera

Samyang/Rokinon 24mm T1.5 Cine lens

Philip Bloom is a camera connoisseur. Achieving internet fame through his blog about high-definition video DSLR cameras, he continues to conduct workshops on shooting with DSLRs as well as other large sensor cameras. During a trip to Johannesburg in South Africa, he decided to try shooting a real documentary on the BMCC. Instead of just using the cameras with test footage, he created a nuanced story about the notorious Ponte Tower in Jo'Burg:

> This was the challenge. Going to Ponte Tower in the middle of downtown Jo'Burg. A 70s architectural monstrosity from the outside that houses an astonishing dystopian science fiction atrium. For quite some time *the* place to live in the city, if you were anyone you lived in the massive 3 story penthouses with roof jacuzzis. Post democracy, it turned into something quite different. For the past 20 years it has been a centre for drug addicts and prostitutes. When I mentioned to some that I wanted to shoot a mini doc there, I was told that I was crazy, but that was from people who don't realise that Ponte is not what it seems. Are things changing for the better there finally?[2]

By starting with the question about the building changing for the better, Bloom begins his video as a story—this is key. Too many beginning filmmakers want to shoot footage, but they rarely think about story, which should always be the first item of business in filmmaking.

Finding a Story

The question is the beginning process for Bloom. When he visits a new location for a workshop, he always asks his hosts, "Got any ideas for stories?" He admits that it's hard finding stories. When asking local people, he runs into the issue "because they're so close to their own place they couldn't actually tell you what a story was. And when you tell them about something that you think is interesting they respond, 'Oh yeah, I never thought about that. It's here. I see it every day!' It doesn't click that people would be interested in that," Bloom says in an interview with me at NAB 2013.

Bloom's host told him about Ponte Tower and his initial reaction was, "A building, oh God." But after he showed him some pictures, Bloom became intrigued and wanted to know more about it, but they didn't know if they

2 Bloom, Philip. October 12, 2012. "South Africa 1: Shooting a documentary short with the BlackMagic Cinema Camera," http://philipbloom.net/2012/10/12/ponte/

could get access to the building. But they proceeded anyway. He'd only done a test shoot with the BMCC, so he wanted to challenge himself by doing an actual project, "the proper job," he says. He explains that he would never use a camera for a paid job unless he *really* knew how to use it and that usually takes a couple of shooting projects. "As a freelancer you need to be 100 percent confident with any tool you use," he tells me.

After he arrived on location, Bloom really realized that "it's an amazing building, an icon at the moment for poverty and crime." Over the past number of years, "they're changing it and making it safe, there's no crime there—at least not open crime where there used to be." He noticed an atrium in the central column, which is designed to help "bring in light," Bloom explains. "It brings in light for the top 20 floors and the rest of the 50 floors are in darkness. So it's like looking into hell, and then looking up to heaven, and I found it amazing. Especially the fact that there's white to middle-class people moving into the top. And the poor, black people are living below." This is the kind of location bubbling over with potential stories. See Figures 5.7 and 5.8.

Working Around On-set Challenges

Bloom found the camera "ergonomically challenging." But the biggest issue for him on this shoot revolved around the fact that the camera is not light

FIGURE 5.7
Looking up inside the atrium of Ponte Tower. "It brings in light for the top 20 floors and the rest of the 50 floors are in darkness," Blooms says. "So it's like looking into hell, and then looking up to heaven, and I found it amazing." (© 2012 Philip Bloom. Used with permission.)

sensitive. Any time he enters a location, he's looking for where the light is, because he's shooting natural. No light kits.

FIGURE 5.8
Interior of Ponte Tower, revealing windows and the light into the atrium from above. (© 2012 Philip Bloom. Used with permission.)

Bloom's first step was to film some shots, some b-roll shots, getting a sense of the space, and then he found someone to interview. He politely explained to all of the subjects he ended up shooting that he wanted to tell a story that would help "change the concept" of Ponte Tower as a crime-ridden place, "the preconceptions of the actual tower and that it's not what it is." They became interested in that approach and agreed to talk to him about it.

Once he did find a subject, he had to find a way to light him. And this, Bloom says, is where the:

> Blackmagic actually came in quite handy, because the way I wanted him positioned was to have his back to the light, which isn't ideal, but that was the light source. I had enough of a bounce from the wall back onto him to make his eyes still catch light, and I wanted this light on the wall behind him that was hitting it. And with the Blackmagic's dynamic range I was able to actually use it, and not lose the light on his face. He's also black and there's a bright light behind him. See Figure 5.9.

FIGURE 5.9
Philip Bloom uses the available light in a strategic way for his Ponte Tower documentary. With the dynamic range of the BMCC, he's able to expose for the bright light behind his subject, as well as pull out some detail in the shadow areas of the face. (© 2012 Philip Bloom. Used with permission.)

This is always a challenge when filming dark-skinned people, because of the wide latitude from dark to bright. So, Bloom explains, "you need a camera with a really good dynamic range that can capture the highlights and the shadows. So it worked really well for that." He also says that he enjoyed using the BMCC, because "by default it's got a relatively deep depth of field," which is useful when needing to maintain focus.

Using Existing Lights

After a while, Bloom had to find a subject "who knew the whole building, and I struck gold with one of the middle class guys at the top who's a journalist, who had actually written a story on the place." This person became "the glue that bound it all together." But the shoot became more of a challenge because it got darker. Bloom explains that it didn't matter whether he used a light-sensitive camera like the Canon C300 or the BMCC, which is less sensitive to light. "Just having a light sensitive camera does not mean you get the light that you want," Bloom says. A light may allow you to expose properly, but "you still need to create the modeling on the face. And you want to catch light in the eyes." He decided to place his subject near a window, as it was now night, but window reflections and city lights provided "some nice backlight from the outside." He explains his natural lighting setup: "I had a top light, a light in his room, which was relatively soft, but in the position I got him into, it gave a little bit of modeling on the face. I've got a catch light, and I've just about got exposure—well, I didn't really, it was a bit underexposed, so I pushed it in post." See Figure 5.10.

FIGURE 5.10
A journalist Bloom found in Ponte Tower explains the building's history. (© 2012 Philip Bloom. Used with permission.)

Exposing with Raw Cinema Cameras

by Philip Bloom

Dynamic range is slightly smaller in ProRes, because it's not raw. Now the raw gives you that ability to push and pull and select. If I shot something that was really blown out in raw, I can bring a fair bit back into that. At a cost of a darkened image. That's when DaVinci comes in—you can mask off those errors, allowing you to maintain those high-lights. But it takes a lot of thinking when you're shooting raw. When it's in ProRes, it's like any other video camera with a compressed codec. You've got to get it right in camera. You nail the look in camera.

To get proper exposure, expose in the middle. To acquire that means push one part two stops up, and then maybe pull back one area two stops down. It gives me that flexibility to actually keep both (I might have to mask in post, but I might not).

When you're shooting raw, you have more flexibility. I still think you should get it in camera as much as you can, but there's times when you have a shot with shadows and highlights in it which are quite strong, and you've got to decide, "Well, what's going to be the best for me, because I want to really have both." Suppose for example you expose for the shadows. The chance of you putting the highlights back that much are going be impossible. There's only so much you can do. It's not magic. And likewise if you exposed for the highlights, your shadows—you can't bring it back. It'll be so noisy, you're bringing it up by maybe six stops and it becomes hideous. So in

those sort of situations, you actually shoot in a middle ground.

To get proper exposure, expose in the middle. To acquire that means push one part two stops up, and then maybe pull back one area two stops down. It gives me that flexibility to actually keep both (I might have to mask in post, but I might not). You couldn't just bring down your highlights as it is. Just always remember, when you're shooting raw, everything is 800 ISO. So what you should always try and do—and this is my advice when shooting with the camera when you have a lot of light—is actually go to ISO 400, and now you expose with 400, then try and actually maintain those highlights.

It's already going to record a stop brighter, anyway, because raw shoots at 800 in the BMCC, and if you change it to 400, you're going to open up your lens to compensate for that. And that can't be changed in post. So when you are shooting raw, knowing it's shooting natively at 800, and if there is a lot of light, then don't shoot 800. Bring it down to 400, and stop down your lens. I tried to shoot 400, which goes against always trying to shoot for its native ISO of 800, because that's where it performs its best. But when you have those extreme bright areas and dark areas, I shoot at 400 because it's in the middle. I shoot in the middle, because it gives me that ability to get both. So it does require a bit of thinking, and a bit of playing around.

> You think that you have this enormous dynamic range, but there's only so much it can hold when you have something that's blown out. If you've exposed something and then you have something that's so blown out it's blown out by maybe six, seven stops. Just because it has thirteen stops dynamic range, doesn't mean you're going to get that back. Keep it within about three stops.

Do I have the dynamic range to cover this? It's as simple as using your lens and just having a look. See how much you need to turn the aperture down before you actually see the detail outside. If it's like seven stops you know that it's not going to work. You think that you have this enormous dynamic range, but there's only so much it can hold when you have something that's blown out. If you've exposed something and then you have something that's so blown out it's blown out by maybe six, seven stops. Just because it has thirteen stops dynamic range, doesn't mean you're going to get that back. Keep it within about three stops. If you're exposed onto the main part of the frame, bring that lens down by three stops. See how much is maintained within that, and if it's not enough and you really need to see it, four is a massive push. It's just about doable, but you're going to start getting into grays. Your whites will start turning gray. And that's not what you want. If it's got to that point, then clearly you need to do something actually there and then.

Raw is a wonderful thing, but for me, the fact that Blackmagic Design announced that they're going to bring out a lossless compressed CinemaDNG [for the BMPC] is wonderful news. Because with uncompressed raw the files are too big, the processing power is too intense, and I edited 98 percent of it on the road with a laptop. I did basic color correction within DaVinci Resolve—fixing exposure, then I exported out to Pro Res 422, and edited with that. I actually never went back to Resolve.

Postproduction Lessons

Bloom notes that in the postproduction process with the BMCC, "you can push the exposure, but because it's such a small sensor with all these mega pixels in it, the grain is really fine. Really, really fine. So when you bring up the exposure from the shadows, you see that grain. And it's actually really hard to deal with. Now you can clean it up, and I advise cleaning it up, but not too

much, because you don't want it to turn plastic. But what I found was if I didn't clean it up and I compressed it for Vimeo, it couldn't cope with it." He adds that the normally exposed material is fine—this is an issue in the shadow areas. "It's a problem when you're pushing exposure. Especially in the shadows, it really can look really quite ugly." He explains that there's a "reason why it's called a cinema camera. It's a camera that needs lighting." Because of this, he wouldn't recommend it as a "documentary camera"—where you "just have to go with what there is, and work with it. It's what I did on the Ponte Tower documentary, and I made it work, and it caused me problems, but I worked past the problems. And in a way I quite enjoyed the problems, to a degree, in that it's a challenge." In the end, the challenge really didn't "get too much in the way of the actual film itself," he admits.

However, he did feel it was a mistake to do the interviews in raw—since it eats up so much storage. "Let's not forget that Pro Res HQ in a camera of this price is incredible," Bloom says. "And it's an amazing codec, it's incredibly robust, and a dynamic range with the flat profile it comes with—the film profile—is wonderful, actually, it is truly wonderful. So, I think you should use both": interviews in ProRes and action shots in raw.

Finding a Story and Doing Interviews

by Philip Bloom

If someone tells me a story and I go, "Eh," then I'm not interested in it. But sometimes I certainly go, "Yes," and I want to know more about it, then I'll know somebody else will want to know about it. I went down to the beach, because it's got the most concentrated population of Indian people outside of India, and there's all these men on this pier fishing, it was a beautiful shot, but it was a photo. It wasn't a story. There were all these guys with their fishing poles. I don't know how they could do it, they were like that far apart, the rods, I'm like, "How can you fish like that?" So I started filming. Didn't know what I was gonna do, and this woman came walking up to the water with a plastic container, started scooping up the water.

And I asked, "What is she doing?" And he said, "Oh, she's just getting sea water."

"Yeah, but why is she getting sea water?"

"Oh, they drink it here. They think it's good for them."

"They what?"

"They drink it, they use it to cleanse themselves."

I'm like, "Okay. Well, that's our story." And it was simple as that. (Watch "The Sea Water Drinkers," here: http://vimeo.com/51831046.)

So, I just walked around, tried to find somebody who could explain it to me, and tell it to me, and find loads of shots, bang! I have a story. So it's a case of just sniffing it out and listening, and it's simple. If the story interests you, then it will interest other people. Not guaranteed. You could be a quantum physicist and there could be some minute breakthrough that means nothing to anybody else that excites you more than anything you've ever heard in the world, you make a film about it, and nobody cares. That can happen, but it doesn't matter, as long as you're happy. I'm lucky enough to have that news brain of 17 years of working in news, so I know what appeals. But now it's what appeals to me. As long as it's compelling, that's the most important thing.

But my best way of getting a good interview from somebody is to treat it like a first date, in that everything they're saying to you is absolutely, incredibly fascinating and com-

pelling. And all you want to know is more, and you're completely lost in that. The moment you start talking about yourself, it's no good, so everything they're saying is compelling, whether it's about the annual results of their company, to a really deep and personal story. It doesn't matter, you have that same, absolutely, completely entranced way of listening.

And that's the key thing when doing interviews and getting stories, because the moment people see that, they open up more. Probably less so with annual business results, but more for the actual real stories about people and stuff. They see that you're interested, and then they'll want to tell you more. The moment you show disinterest, then it dies off.

Tutto Metal Design: Artist Profile by Joe Tyler
(https://vimeo.com/63860004)

Blackmagic Cinema Camera

Canon 35mm f/1.4L, Canon 70-200mm f/2.8L, Tokina 11-16mm f/2.8

When Joe Tyler of Empty Bucket Studios first heard about the Blackmagic Cinema Camera through his production partner, Matt Urquhart, he was "shocked by the combination of the major feature set and price point." In fact, they were both so taken aback by the low price point that they "started searching for its Achilles' heel. I don't think we ever really found one—at least not one that killed our interest."

Tyler and Urquhart shot many projects with Canon DSLRs and the Sony FS100, but when they shot with the BMCC it was "nothing short of a revelation." He admits that they've never worked on high-end cameras (such as RED or Arri Alexa), "so my infatuation with the technology is at least fashionably late given that ultra-high resolution raw video capture has been around for years." For Tyler, what makes the BMCC stands out is how he doesn't even compare it to other types of video cameras, but to the raw results coming out of his still camera. "For a photographer like me that has developed certain habits and expectations, that's huge," Tyler says. "It may not be shooting 5K but the image clarity, dynamic range, and general latitude are much closer to my 5D raw still files than they are to anything else."

Add Features to the Camera

Tyler feels that the BMCC "is not that much different than using something like a 5D." He feels you will need to add certain features to it in order to make it work for you. Hooking up a viewfinder or loupe will be beneficial, he feels, as well as making sure the camera is "properly stabilized." External audio recording is a must, he adds. He doesn't consider these additional elements "tricky," since "they're the well-known working requirements of current small-budget DSLR filmmakers." Rather than being turned off from the DSLR approach to the BMCC, he feels that's "the beauty of the camera—for as different as it is, it feels so familiar." The main difference came as a surprise to him when comparing DSLRs to the BMCC—the discovery of "just how far we could

FIGURE 5.11
Still from *Tutto Metal Design: Artist Profile*. Note how the filmmakers utilized the light from the fire of the forge to light their subject, and backlighting (blue cast) comes from the rear of the subject from a window. (© 2013 Empty Bucket Studios. Used with permission.)

expose without blowing highlights," he notes. "It was almost difficult to trust the camera when it appeared like we were losing highlight information. So that's something we had to keep in mind when we were out shooting."

They approached *Tutto Metal Design* as a project of love. Tyler had always wanted to shoot in Ray Matthis' studio when he had "set foot in Ray's studio a few years ago." See Figures 5.11 and 5.12. He feels that "a blacksmith's shop is undoubtedly a great visual playground for a filmmaker, but Ray himself is really the story here. In addition to his devastatingly icy-blue eyes, his unbridled passion for creating art from fire and metal is apparent from the moment he engages you in conversation."[3]

FIGURE 5.12
Ray Mathis in an interview for *Tutto Metal Design: Artist Profile*. (© 2013 Empty Bucket Studios. Used with permission.)

3 Quotes from this section from author interview and from: Tyler, Jo. *Tutto Metal Design: Artist Profile*, Empty Bucket Studios. https://vimeo.com/63860004.

Preproduction Planning

Tyler and Urquhart did not storyboard the piece, but they did their due diligence in research—one of the key components for discovering and revealing a compelling story. "We spent a few hours at Ray's shop one day just talking to him, getting a tour, visualizing shots," Tyler explains. They used his interview—the material the artist was discussing—as shooting points. They did not allow him to prep answers in order to maintain spontaneity. So letting the story flow from the subject, allowed them to be quick on their feet and shoot what they needed. "I had been thinking about his video for a long time," Tyler admits, "and I pretty much knew what I wanted it to look and feel like." See Figure 5.13.

> One of the most important considerations for us was to 'do justice' to his work and his passion. We knew we had to create something that at least matched his attention to detail and commitment to making beautiful, emotive work.

Shaping the Look and Feel

The look and feel of the film was something that stemmed from their observation of their subject and his studio.

> When we sat down and thought about how we wanted to approach creating Ray's artist profile film, one of the most important considerations for us was to 'do justice' to his work and his passion. We knew we had to create something that at least matched his attention to detail and commitment to making beautiful, emotive work. We wanted to make sure that someone clear across the country (or clear across the world) could fully appreciate Ray's craft by virtue of ours.

Because of the need to show the subject's attention to detail and that commitment to make a work of art, Tyler felt that they needed to use the BMCC in order to best convey the look and feel the artist was himself expressing. As Tyler explains on the Vimeo site for the film:

> It required careful planning, careful shooting, and a commitment to go through a complex post-production process. In short, it required from us everything that Ray's work requires of him. There is nothing 'off the shelf' or prepackaged about this artist profile film, and we wouldn't have it any other way.

Tyler notes about the artist: "His finished pieces are the monumental accomplishments of a modest man." Their approach to the shooting of the film reveals their own modesty in crafting a strong work revolving around the cinematic aesthetics of the BMCC.

FIGURE 5.13
Joe Tyler setting up a shot in *Tutto Metal Design: Artist Profile*. Tyler utilizes natural light as well as a slider. Take note of the external battery and audio gear attached to the tripod. (© 2013 Empty Bucket Studios. Used with permission.)

The challenge for them was not shooting with the BMCC, but how they would deal with the postproduction process. They were not sure "what impact (if any) it would have on how we shot," Tyler explains. "Having taken the camera through a couple of complete productions we are much more comfortable with how and what we need to shoot, so the extra time involved was really just for the (short) learning curve." They shot the project in 2.5K raw, and color correcting and grading was completed using Adobe Camera Raw (see Chapter 8 for this workflow) and Adobe After Effects CS6.

ADDITIONAL FIELD NOTES

Audio

Watch out for audio drift. It'll happen in Final Cut X if you choose true 24p, as opposed to 23.97. Apparently Adobe Premiere does not have this issue.

I bought a cold shoe mount adapter (see Chapter 3) in order to place a shockmount and microphone on the BMCC. I also set up my Tascam DR-40 audio recorder to the side of my subject during the interview. The audio on the BMCC sounded distant and didn't even have the usable audio that I get off of my 5D Mark II when using Magic Lantern. I ended up using the Tascam audio (with its onboard mics), while using the BMCC as reference audio for syncing. So it's definitely worth recording audio on the BMCC as a reference, but don't rely on it as your main audio—you'll likely be disappointed. If you need to go portable and want strong audio, you may want to consider Sound Devices MixPre-D along with an audio recorder.

Shooting BMCC Raw or Compressed

by Joe Tyler

For as much as I love raw, the more compressed formats obviously have a place. The current limitations of SSDs alone basically require that any recording much over an hour cannot be done in raw. Raw is also probably not a good option if your project requires a fast turnaround time, or if you're in the field with a limited amount of drives and no way to unload. The bottom line is this: if you need a cinema-quality image, shoot raw. If you don't want it, don't need it, or can't manage it, shoot ProRes or DNxHD.

CHAPTER 6

Rich Textures and Skin Tones

In the Field with Digital Bolex's D16

INTRODUCTION

Michael Plescia, the filmmaker who opened this book with his insightful foreword, best sums up his take on shooting with the D16 Digital Bolex:

> The footage is a dream to work with. After laying a hand on it with my abusive curves to get a feel for the range, quality and depth of the raw, I can honestly say that this is the camera that filmmakers like me have been waiting for. I've never gotten images so rich off of any digital camera. Especially in skin. It's filmic, organic, and narrative feeling.[1]

This chapter will explore the process of shooting several projects with the beta test model of the camera, revealing in some ways how Plescia can make such a claim about a digital camera.

First, here are some of the features of the camera as described by Joe Rubinstein of Digital Bolex:

1. CCD sensor
 a. Is analog and has a more natural look and tone.
 b. Global shutter offers better movement with no [rolling shutter] Jello [issues].
 c. More advanced gain/image structure controls, so the image can be improved over time as seen with Ikonoskop.
2. Professional Balanced XLR inputs with Phantom power.
3. 24-bit 96K sound, compared to 16-bit 48K.
4. Interchangeable lens mount system, compared to adapters. Much more reliable/accurate.

1 Personal email, September 11, 2013.

5. Included Enterprise class SSD drive, compared to no included storage. The Enterprise SSD has a lot of value. It can write all day for five years!

6. Comfortable hand-held ergonomics.

7. High-end Optical Low Pass filter makes images look more natural and reduces moiré.

8. Software that is better suited for ingestion and low-budget filmmaking.

9. A company that is thinking about the whole system instead of one part. We are thinking about lenses, anamorphic, accessories, even distribution. Working to offer complete packages that work together seamlessly instead of parts that might not work together. It's a little like Apple making the computers and the OS and the monitors vs. PC where the hardware and software are made by many different entities. Sometimes the PC way is cheaper, but it rarely works better in my opinion.

 Basically we are creating a product that fits into the legacy of film cameras and the way you work with them. The Blackmagic offerings are more in line with the DSLR trend.

 Now all that being said, the Blackmagic offerings are still more appropriate for some people. It's really up to you and what kind of work you do. Cameras are tools and there is no perfect tool for every job, you need the right tool for the right jobs.[2]

The camera also contains two hand cranks that will engage certain assignable features, such as adjusting ISO, shutter angle, and focus assist. It also includes a removable pistol grip with a record trigger, as well as an HDMI output for hooking up an external monitor. In addition, the camera contains a removable faceplate containing different mounts: C, EF, PL, M43, and even a C mount turret.

But the key element of the camera—what makes it stands apart from the Blackmagic Cinema Cameras—is the choice of sensor: the analog CCD (although one of the key challenges Rubinstein admits that slowed them down—a CMOS would have been a much easier process). There's a certain complexity to not only calibrating the image, but getting the image right as it goes through the analog to digital converter. Not easy stuff to engineer. Ikonoskop used a sister sensor and it took them nearly five years to get their camera developed (on top of having to create a fast memory card to read the data files).

Yet, if there's any special sauce, any secret as to why images coming off of this camera are different to the images coming off of the Blackmagic Cinema Camera, for example, it is this analog sensor. It feels less digital, because the original image isn't digital.

2 Rubinstein, Joe "What Steps Are Left," May 17, 2013. http://www.digitalbolex.com/forum/film-filmmaking/what-steps-are-left/

ON-CAMERA FEATURES AND MENU SELECTIONS

The D16, like most of the cameras featured in this book, is pretty simple to operate. You just turn it on, adjust the aperture, and hit record (or pull the trigger when you're using the removable pistol grip). The image through the view finder (HUD, heads up display), reveals some of the menu items that are turned on, as well as audio meters (see Figure 6.0). It includes, along the top, the battery life, external power, card capacity, shutter angle, frame number, framerate, record on (in red), as well as audio information on the bottom (meters, audio type, bit depth), ISO settings, and shooting mode (Super 16 in DNG format).

Menu settings allow you to adjust color balance, ISO, and so forth.

The main menu has six items and I list them with their submenus below (see Figures 6.1–6.4 for examples).

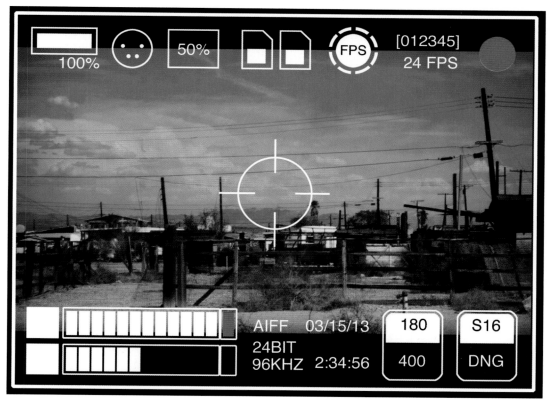

FIGURE 6.0
The viewfinder display for the Bolex D16. Image courtesy of Joe Rubinstein and Digital Bolex.

To navigate, use ▲▼ to scroll ▶◀ to select and return

IMAGE | Adjust settings that
SOUND | affect image capture
DATA
CRANK
DISPLAY
SETTINGS

MENU TO EXIT

FIGURE 6.1
Main menu of the D16 camera. Toggle through the menu item and select the submenus to make changes. (Image courtesy of Digital Bolex.)

1. **Image**
 a. Set Resolution
 i. 2048 x 1152 (2k)
 ii. 1920 x 1080
 iii. 1280 x 720
 iv. 720 x 480
 b. Format
 i. CinemaDNG (RAW)
 c. ISO
 i. 100
 ii. 200
 iii. 400 (this is the native ISO)
 d. FPS (frame rate per second)
 i. 23.98
 ii. 24
 iii. 25
 iv. 29.97
 v. 30
 vi. Custom
 e. Shutter angle—the higher the shutter angle above 180 the more you'll increase motion blur; lower shutter angles (below 180) make the image more crisp, more staccato.
 i. 45, 65, 90, 120, 150, 180, 210, 240, 240, 300, 330

2. **Sound**
 a. File Format
 i. AIFF / 24-bit / 96kHz
 ii. AIFF / 24-bit / 44kHz
 b. Ch 1 Mic
 i. Mic Off
 ii. Mic On
 iii. Line In
 c. Ch 2 Mic
 i. Mic Off
 ii. Mic On
 iii. Line In
 d. Ch 1 PHTM
 i. Phantom Power On
 ii. Phantom Power Off
 e. Ch 2 PHTM
 i. Phantom Power On
 ii. Phantom Power Off
 f. Vol Display
 i. Volume display ON
 ii. Volume display OFF
 g. HP Volume (headphone levels)
 i. Adjust level up or down

3. **Data**
 a. SSD
 i. Format the internal SSD drive
 b. CF Card A
 i. Format compact flash card A
 c. CF Card B
 i. Format compact flash card B
 d. Data Transfer
 i. Transfer data from the SSD internal drive to the CF cards (A and B)
 ii. Transfer data from the SSD internal drive to external computer/hard drive via the USB 3.0 port
 e. Directory Name
 i. Name folders

4. **Crank**—assign different functions to the two cranks on camera (later firmware may include follow focus, among other features)

 a. Crank 1
 i. OFF
 ii. Shutter angle
 iii. ISO
 b. Crank 2
 i. OFF
 ii. Shutter angle
 iii. ISO
 iv. LCD Zoom (allows focus assist through a zoom function)

5. **Display**—set the menu items for the built in LCD display

 a. Brightness
 i. Low
 ii. Medium
 iii. High
 b. Icons LCD—icons on the internal LCD
 i. On
 ii. Off
 c. Icons EXT—icons on the external monitor
 i. On
 ii. Off
 d. Frame Guide—set composition guides on the screen
 i. Off
 ii. 1:78
 iii. 16:9
 e. Crosshair
 i. On
 ii. Off
 f. Color Mode
 i. RGB Color (standard)
 ii. Grayscale
 iii. Non-Debayered

6. **Settings**
 a. Date/Time—set the date and time for your metadata
 b. Power management—you can adjust the Auto Power Off settings to:
 i. Disabled
 ii. 1 Minute
 iii. 5 Minutes
 c. Set Default (restore factory default settings to the camera).

FIGURE 6.2
The ISO submenu of the Image menu on the D16. You can set the ISO at 100, 200, or 400 (the native ISO of the sensor). Later firmware may allow an 800 ISO setting. (Image courtesy of Digital Bolex.)

FIGURE 6.3
The Resolution submenu of the Image menu. Here, you can set the camera to 2k, full HD, as well as 1280 x 720 and 720 x 480. (Image courtesy of Digital Bolex.)

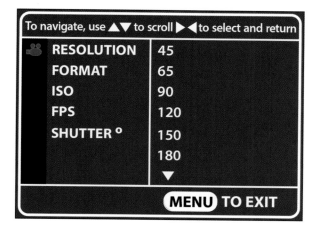

FIGURE 6.4
The Shutter angle submenu of the Image menu. Here, you can set your shutter angle to a variety of presets: 45, 65, 90, 120, 150, 180 (standard), 210, 240, 270, 300, and 330. (Image courtesy of Digital Bolex.)

IN THE FIELD WITH THE D16—A MOCK SUN MUSIC VIDEO

Downtown LA is like a miniature New York City—except the buildings are not as tall. It's a Friday afternoon with hot, slightly humid September air—not the dry desert Santa Anas. I drove seven hours from Flagstaff to downtown Los Angeles, parked the car in an outdoor lot for $5.50, then entered the small skyscraper housing the Digital Bolex office, taking a ride up the elevator to the top floor, then meandered down a hall to a small office space with a couple of desks. Joe Rubinstein and Elle Schneider are at work on their computers.

Their days are full as they enter the final stretch of the release of the D16, and they're sparkling with energy. This is not the low-key Joe and Elle in Toronto at the end of February 2013, trying to mask their disappointment as they had hoped to show me an image off of D16's sensor, which never happened. They're happy. The camera works and they've already shot a music video—with a band from Pennsylvania, Mock Sun, who have been crashing on sofas in Rubinstein's apartment.

The wait was worth it. Indeed, Rubinstein says that I will be the first person to shoot with the camera outside the company. Schneider shows me footage from the music video she made with the Digital Bolex D16. I sit down next to her, leaning over her MacBook Pro as she points out the footage of band members walking through post-apocalyptical-looking buildings near the shores of the Salton Sea, California's largest lake. The footage is beautiful. (See Figures 6.5 and 6.6.)

Schneider tells me that the band wanted a piece that expressed a certain mood. "We came up with some surreal locations, environments where the visuals could feel trapped and abandoned, and a monster character that best suited the mood the band wanted to create," she explains, in order to capture the "feeling of being plagued by personal demons."

On set, Schneider says it took her a while to get used to handholding the camera and getting the shots steady—especially when trying to adjust focus. She was used to shooting fashion campaigns on a Canon 7D, but she says that she "found shooting with the D16 was much more comfortable. My camera style for this kind of project is very movement heavy, and with the D16 I didn't have to worry about rolling shutter while doing handheld work, which I really needed to do in order to capture the focus blurring and woozy feeling of parts of the song." On the 7D, she would need to use a shoulder rig to get stability and to avoid the "rolling shutter issue," but she felt that the shots were a little too steady—not enough movement "to remove any natural frenetic energy."

"We shot with the beta camera model from a December 2012 build, so it's an old body designed to make sure the parts fit—not the newest and latest for attaching tripods and shooting. But all of the new cameras are in Toronto going

FIGURE 6.5
Still from a Mock Sun music video shot by Elle Schneider of Digital Bolex. Note the colors in the room, as well as the roll off of light and shadow on the subject's face. This camera loves skin tones. Filmed on location at the Salton Sea. (© 2013 Digital Bolex. Used with permission.)

FIGURE 6.6
Still from the same Mock Sun music video. Filmed on location at the Salton Sea. Note the scale of the figure in the space that pops with colors. The footage from the D16 loves to be graded (see Chapter 8). (© 2013 Digital Bolex. Used with permission.)

through extensive engineering tests," Rubinstein says, "and this is the one that could be spared. When the camera ships, all of the parts will be working, but for now, we're focusing on the quality of the motion picture image coming out of the camera as CinemaDNG files." That's the heart of it. Everything else is just extra.

As for the postproduction process on the Mock Sun video, Schneider has a "tendency to 'destroy' footage" in post, "pushing and pulling and saturating and graining and blurring and doing all sorts of things one isn't supposed to do to get a crisp clean image." (Remember, filmmaking isn't about getting a sharp image.) She says that DSLR filmmakers would also use "these sort of image tricks" in order to "mask their visual problems." But when used on a camera putting out a clean image, like the D16, Schneider says that such techniques can be "used to enhance an already very clean image." Further, she also found that the "footage from the D16 is so versatile." As she puts it, "I can even pull information from silhouettes, whereas on a DSLR those blacks would be completely devoid of color information. And I know I'll be able to create a really amazing and unique look to this video with the latitude it allows."

For Rubinstein and Schneider, as well as with those who have shot with the camera, there's really not a question of whether or not the camera expresses some form of a film look. For Schneider, she feels that this unique look of the footage from the D16 engages a

> combination of factors. CCD is one factor, not necessarily just how the sensor itself captures an image, but that its analog nature means that more engineering goes into its use, and as a result many different imaging decisions must be made along the way that can affect the final image. There's also the post process; how the images are treated, in what software, for what purpose, and of course the ability to use vintage lenses, which add some character to the image lost in a very clean digital environment.

I'm as excited to shoot with the camera as Joe and Elle were when they first opened the box from Ienso, the manufacturer of the camera. Rubinstein tells me I can shoot anything, but he suggests we go out to Venice Beach in the morning to shoot footage there. Rather than doing "test" footage, I prefer to shoot a "real" project, so I decide to try to find a subject to shoot at Venice Beach.

VENICE BEACH—BOLEX STYLE

Film located at: https://vimeo.com/74887302

I invite my friend, Michael Plescia to come on out to Venice Beach to shoot with the Bolex. He's shot on the Ikonoskop, so he's eager to see what the Bolex can do—he's been heartbroken since he found out that Ikonoskop stopped

production of their camera. For him, the Digital Bolex is his last hope for a camera company to get it right.

We meet up with Rubinstein and Schneider at the beach and we pull out the camera. Rubinstein tested several vintage 16mm lenses the night before and we choose a wide, normal, and long lens for the shoot. I attach my Zacuto Z-Finder and notice that the image is squished. We don't know if it's an issue with the camera or the EVF. But Rubinstein mentions that his SmallHD EVF works great on the camera. Foolishly, I ignore him, because I was used to shooting my Canon 5D Mark II with the Zakuto, but after a break in the afternoon, I attach the SmallHD EVF and fall in love with the camera's image even more.

I attached the Manfrotto monopod to the camera and shoot a wide angle of the beach, then I move up the sidewalk (see Figure 6.7), where artists and con artists sell their wares—from painters to a gray, bearded disgruntled man holding a sign stating that he will give life advice for $2. We come across several breakdancers about to give a performance. I set up the camera and shoot, switching lenses for the ten-minute performance. I move to different angles and try to get the shots I need (see Figure 6.8.) After the performance, I ask for an interview. We used my Tascam DR-40 to capture audio, since the beta model of the camera didn't have audio working.

FIGURE 6.7
Kurt Lancaster shooting the scenic Venice Beach sidewalk with the D16 Digital Bolex. (Photo by Elle Schneider. © 2013 Digital Bolex. Used with permission.)

FIGURE 6.8
A street performer at Venice Beach prepares his volunteers from the audience as he sets up a show in which he'll leap and flip over them. Take note of the blue sky, the exposure on the darker skin of the performer, as well as the skin tones of the audience. Colors pop in the shot and the skin tones look filmic. Graded by Michael Plescia and Kurt Lancaster in Adobe Camera Raw. (Image courtesy of Kurt Lancaster.)

Later in the day, I shot footage of the beach and sailboats on the water (see Figure 6.9), as well as shots at the skateboard rink. In the bright sun, I'm wishing I had ND filters on hand. So a few shots became clipped even with the aperture stopped up all the way on the lenses—despite that, I'm able to recover a lot of detail in the white foam of the waves.

Without image stabilization, it was a challenge sometimes to get the handhold feel I wanted. I did hold a later model of the camera, as opposed to the one I was shooting with, and it was heavier, making it easier to get stable handheld shots—but the beta test model was made with different parts and was actually fairly light. In either case, the monopod and tripod work well on this camera.

Ultimately, as I looked through the camera, I fell in love with the footage—I haven't been this excited to shoot film projects since shooting with Canon's 5D Mark II, with one caveat. When I first attached Canon's 70-200mm f/2.8 lens on my 5D and looked through the live view, I fell in love with the image, but when I imported the footage into my computer, I felt the image had lost some life. I was still excited about shooting with the 5D and eventually wrote a book about the DSLR cinema revolution, but I always felt a little cheated and I never knew why.

Until I met Joe Rubinstein.

Until I held this camera and saw the quality of the images coming out of it.

The 8-bit DSLR provides a 14-bit image on the rear viewscreen. It looks good. But when it gets processed through its 8-bit conversion . . . that's when the

magic dissipates. But when I import the D16 files into my computer, the images contain as much depth as I felt when looking through the camera in the field. It remained alive. The shots felt "thick", expressing the density of 16mm film. I didn't want to put the camera down.

And the postproduction process—although more of a workflow hassle than what I was used to in the DSLR world—proved much better in latitude, as I noted with the Ikonoskop and the Blackmagic Cinema Camera. The benefits of 12-bit raw give us color depth that is unparalleled in the history of cinema—at least in its price class..

FIGURE 6.9
Digital Bolex D16 shot of a sailboat at Venice Beach, California. Note how the color of the water pops, with details of the white froth recovered in post. Color graded by Kurt Lancaster in Adobe Camera Raw. (Image courtesy of Kurt Lancaster.)

BOLEX AT DUSK

Film located at: https://vimeo.com/74438041

One of the features of the D16 is its capability to remove the front plate that holds the lens mount and swap out other mounts—from EF to PL, it can nearly do it all. The camera comes with a C-mount, and for the beta test camera, that was the only mount available. However, Rubinstein had ordered a C to EF mount adapter, so I was able to try out my Zeiss Contax lenses (25mm f/2.8 and 50mm f/1.4) in downtown Los Angeles. Michael Plescia took some shots with it too. He was pleased with how it responded to light. He ended up doing an edit and color grade on the downtown LA footage, with an "attempt at accentuating the inherent celluloid look of the camera by marrying it with my

FIGURE 6.10
The colors on the lit marquee stand out in the dusk of the Digital Bolex, as shot and edited by Michael Plescia. "The D16 Bolex is about surfaces, textures, gradients, skin, performances, people," he says. "The grain is pleasing. The images feel like a story." Color graded by Michael Plescia in Adobe Camera Raw. (Image courtesy of Michael Plescia.)

shimmer-graining processes to give it an early 90s era Kodak appearance. This process is slightly destructive and introduces flicker, color fluctuation and softness not native to the camera," he writes on the Vimeo post of the video (see Figure 6.10 and http://vimeo.com/74438041).

Michael Plescia is a wizard at color grading with raw. He knows how film should *feel*, and he's obsessed about the shimmering effects of film grain—not the cheap postproduction knockoffs where the effect is layered onto the image, but the real deal, embedding the grain *before* you grade, so it feels more real. It's about the emotional response. He's tested his effect with the Ikonoskop's A-Cam dII, so he was eager to find out how the D16 would perform his vision. As part of the beta test camera, we completed the shoot at Venice Beach, then drove to downtown LA, near Rubinstein's apartment and the Digital Bolex offices. The video that we shot, Plescia took and edited, then created a color grade using Adobe's Camera Raw in Aftereffects (see Chapter 8 for workflow).

Below, he writes about his experiences in shooting with the D16 and doing the color grade to it.

Tips for Shooting with the Bolex

by Michael Plescia

Film at: https://vimeo.com/74438041

Mourning the loss of celluloid film? Hate tinny skin tones? Don't necessarily want more pixels, just better ones? Then get excited. I am.

After having the privilege to participate in a test shoot with a beta model of the Digital Bolex, I can state with full confidence that this camera is the real deal and is the one filmmakers like me have been hoping for. Congratulations to Joe and the Bolex team.

Why do I make such a claim? I've never before seen images of such a rich, filmic, organic and narrative quality from a digital camera. Especially when imaging human skin. The footage is a dream to work with and grade. It's like putty. When you lay a hand on it with abusive curves and you think it's going to break, it doesn't.

The D16 is certainly an adjustment from shooting with a DSLR. The way it sees light. What it wants to be pointed at.

It's not all about depth and bokeh and closeups like with DSLRs. The D16 Bolex is about surfaces, textures, gradients, tonal nuance, skin, performances. It comes alive in traveling masters, and lock-offs don't feel harshly static. You feel permission to film wider; to let the mise-en-scène unfold. The image has confidence so you have confidence that the camera will capture the life in front of it—so you have less of an impulse to overcompensate for a lifeless frame by moving the camera and over-cutting. It loves handheld in wider lenses. The grain is pleasing. Lowlights have a soul again. The image feels like story.

I couldn't be happier that the Bolex team committed to tackling the difficulty of harnessing these analog sensors and their immense data throughput. You don't see that extra data at first. Then, when you grade, you feel it.

Some pointers I've learned when shooting the D16 opposed to DSLRs: the Kodak (TrueSense) sensors give indescribably filmic images if you play by their rules:

1. It likes more light than less.

2. Highlight clipping should be avoided religiously. Don't do it. It ruins the illusion.

3. Images don't at first appear to come out of the sensor looking as beautiful as those of DSLRs'. The D16 Bolex is not an easy bake oven. At first glance, this can feel discouraging. But the data needs good grading—both to neutralize the image of any disproportionate color shifts and then to make it sing. It can look tinted at first, then colors that you thought were all mushed together, suddenly separate and the camera's magic emerges. This type of grading would break DSLR footage.[1]

After a good grade, I find the images from the D16 Bolex express a very substantial quality to them—they have weight, rather than feeling thin, tinny, pallid.

Note about the downtown LA beta test footage: my grade is an attempt at accentuating the inherent celluloid look of the camera by marrying it with my shimmer-graining processes to give it an early to mid-90s era Kodak appearance. This process is slightly destructive and introduces flicker, color fluctuation, and softness not native to the camera and does not reflect the true sharpness of the Digital Bolex sensor.

- Lenses: ZEISS CONTAX 25mm f/2.8 & 50mm f/1.4 and CP2 85mm and 21mm

- Cinematography: Kurt Lancaster and Michael Plescia

- Edit/Grade: Michael Plescia

- Music: Michael Plescia / soundcloud.com/rinjen

- RAW convertor: Adobe Camera RAW in After Effects

1 The tinting in the beta D16 appeared due to the lack of sensor calibration. Later calibration fixed the tinting issue.

ADDITIONAL FIELD NOTES

Many people are getting excited about shooting in 4K as this book gets written. Sony is releasing consumer-level cameras that shoot in this format. But for those shooting cinema, many are making clear arguments that 4K is not the answer—at least for now. Rubinstein makes a cogent argument that color depth is far more important than extra high image resolution.

To 4K or Not to 4K . . .

by Joe Rubinstein[2]

To me the core functions of digital cameras are:

1. Drive the sensor in a clean way with good A/D conversion.

2. Transport and store the image data collected by the sensor in the best way possible.

3. Provide the user a good experience and a high-value proposition.

This means we create the electronics that run our amazing Kodak-designed sensor, and then get out of the way so that filmmakers can have an image as close to sensor data as possible. Kinda like a film camera does with film.

Many cameras makers believe their job is to make your life easier by giving you a few limited shooting styles and smaller file sizes through compression, again limiting your choices, this time in post. We believe our job is to make a camera that gives the maximum control and freedom to the artist, both on set and in post. This is our North Star, the guiding light behind all of our design choices. How do we get the most accurate representation of what the sensor captured to the filmmaker in the most pliable format?

Raw vs. Compression

Debayering is hard. When running a really nice debayer algorithm in 2K resolution, most desktops computers can only do a few frames a second at the fastest, 4K takes longer. To do this on the fly most cameras use inferior algorithms.

D16 footage is impressive. Our designers and engineers have worked really hard, researching components, tuning the sensor to perfection, designing amazing analog to digital conversion modules, optimizing data paths and write speeds, and generally doing everything we can to protect the image integrity as it travels through the camera from sensor to storage. Basically it takes a lot of work to protect a 12-bit raw file as it travels through the camera. It isn't automatic. Cameras are either built for raw or they're not.

In the near future, when people inevitably make their camera comparison tests comparing raw footage on the D16 to other cameras, they will be impressed, even when the other cameras are much more expensive. But if/when we add compression formats, that will change completely. The processing power in our camera won't be good enough to run the best debayer algorithms. And when people do their camera comparison tests and compare our compressed footage to other cameras' compressed footage, the image will be pretty much the same, except without the rolling shutter. All of our other advantages, all of the research, all of the hard work, all of our design efforts will be washed away by the tide of compression.

This is why I am hesitant to do it.

Color Depth vs. Resolution

There has been a big push from a lot of companies recently for 4K. They say it is the future, and I'm sure it is. But there is another, more quiet tech revolution happening, and it is one I think may be more important in the long run. It's the Color Revolution.

2 Adapted from material postdated August 19, 2013, and used with permission. http://www.digitalbolex.com/to_4k_or_not_to_4k/

When you go to a movie these days, most of the time you are seeing a 2K resolution image from a DCP, which in size isn't that different from the 1920 x 1080 resolution of a blu-ray disc (yes there are 4K theaters, but I'm talking about your average screen in an average movie theater). However, there is no way a blu-ray looks anywhere near as good as the 50-foot movie theater projection. Part of the reason is that theaters use amazing projectors that are DCI compliant, but another reason is that the images they are projecting have 12-bit color depth. This is a huge difference from the 8-bit color we see at home, and the 8-bit color most reasonably priced cameras shoot, including many of the new 4K cameras.

Let's break it down. With 8-bit color you get 256 shades of red, green, and blue, which combined gets you 16,777,216 colors. Which sounds like a lot, but it's not, when you compare it to higher bit rates. With 10-bit color you get 1024 shades of RGB, giving you over a billion different colors. And 12-bit is 4096 shades of RGB and over 68 billion colors! That's some color rendition.

Why does this matter? Because just like resolution is advancing, so is bit depth. There are affordable 10-bit monitors and 10-bit video cards these days. They don't get as much radio play as 4K does, but are as every bit (and possibly more) revolutionary. So in the future when everything is Ultra HD, it will also be high bit-rate.

Bit-rate vs. resolution in imaging is analogous to bit-depth vs. sample rate in audio. In my opinion, it is much easier to hear the difference between 16-bit and 24-bit recordings, than it is to hear the difference between 48K and 96K sample rates. It's true that both 24-bit and 96K probably make recordings sound better, as the extra detail in 4K does, but the focus is usually pretty even on providing both simultaneously. People in audio don't generally push 96K and 8-bit together the way that video/ digital cinema companies push 4K and 8-bit together. When they do it seems a little wonky to me.

High bit-depth has been around for years just like 4K. And professionals and tech junkies have been preaching about it for years, just like 4K. And it is finally getting to a price point normal people can afford, just like 4K. And just like 4K, the distribution side of the industry isn't really ready for it yet, unless you are going theatrical in a major theater chain. There are very few computers and monitors that can handle 10-bit images right now.

I'm not suggesting anyone go out and purchase a new computer/video card/monitor in order to work in 10-bit right this minute. I'm proposing that when thinking about the future of imaging, we consider color depth to be at least as important as resolution.

Technology moves fast and we need to keep up, or at least we feel that way. But it actually isn't moving that fast. The first CDs were released in 1982, over 30 years ago. It has only been in the last five years that digital music distribution has become a major player in that marketplace. Blu-rays were first released in 2006. It's entirely possible that it will take blu-rays as long to dominate the marketplace as it did the CD and DVD, both of which took 15 years to reach a 75 percent market share. In today's fast-paced high-tech YouTube world there are still almost no TV broadcasts in 1080p. Most of the big players in online media delivered to your TV, like iTunes and Netflix, adopted 1080p just a little over a year ago, and most of the content on these platforms is still 720p. For television 720p is even considered a premium, for which subscribers pay extra.

The current HD standards were put into place in the mid-90s, yet standard-definition DVDs still outsell blu-rays almost 4:1. Many analysts thought blu-rays would be outselling DVD by 2012, but adoption has been slower than people thought. Many financial papers are still talking about the growing popularity of HD even today. HDTVs have only hit 75 percent of market saturation here in North America, and that was only in 2012!

How long will it take for all of our content delivery to be in HD of any kind? How long before it's 1080p? How many years will it take for a majority of screens to be 4K? How many millions/billions of dollars will it take? How much will it cost for servers to host libraries of 4K content? How long will it take to create the infrastructure/bandwidth capable of streaming 4K online in average homes? In essence, how long will it take to even show your 4K film to an audience in the format it was created in? Probably longer than we expect, considering all of the tiny moving parts that it takes to embrace new technology on a worldwide scale.

So is 4K the future? Yes, it definitely is. Is it here today? Well sort of, but not really. Netflix/iTunes in 4K? Sure, in 2030. Is 4K necessary for me to make movies? Absolutely not. Is 4K right for me? That's really the question at the heart of this debate, and only you can answer it.

I would say if you get hired to make *Avatar*, by all means, use the highest K you can find. But if you're making a gritty indie film, or most TV shows, I think 2K is more than appropriate. In the film world there were dozens of formats in the early years, and eventually the market settled down to S8, 16/S16, 35/S35, and 65mm. I believe the same will happen with digital. Over the next 20 years the markets will settle into a few tiers. 4K will be one of them, but so will 2K.

I'm a low-budget filmmaker, and I'm proud of that. To me, a higher bit rate is more important than faster sample rates or more pixels. I think in the end what's most important is that you can fall in love with the creative work you're doing. I had that years ago with 16mm film, and I'm finding that again with the D16. If you fall in love every time you see a 4K image then that's a good choice for you. I just don't want you to feel like if you don't have 4K you can't have great images, or that you can't tell stories. At the end of the day resolution is only one of many, many factors, and they all should be considered evenly, at least in my opinion.

PART III
Raw Postproduction

CHAPTER 7

Color Correcting and Color Grading CinemaDNG with DaVinci Resolve

In many ways, the use of raw video files takes us back to the basic elements of old-school filmmaking, where filmmakers were limited by the amount of film on a reel, which equates to the amount of space on a storage device. Also, directors would say what take should be printed—because the budget didn't allow for the printing of every take. By taking note of the best takes, the raw filmmaker can help save time and space by not using every single shot. The takes printed would become the work print. After an edit decision list (EDL) was created from the workflow, then the color timing (or correction), as well as optical effects, would be applied to the original negative. In the world of raw workflow, you can decide which takes you want to use and convert those to create, in essence, a work print from proxy files. The edit is applied, then the files are brought back into the color correction software (usually as an XML file), then the color correction and other effects can be applied to the original raw digital negative. Many raw shooters will grade their footage in DaVinci Resolve first, then export the files as Apple ProRes and do their edits after the color correction. In the latter case, you may want to lay out the shots you need in proper scene order, since you will need to match exposure for shots within the same scene, which is the process covered in this chapter.

One of the trickiest points with shooting CinemaDNG raw format is the need to go through a complex transcoding process. You can't just drag and drop it into Premiere Pro, Final Cut Pro, or Avid and expect to start editing (at least not at the time of writing in mid-2013).

However, Blackmagic Design created a free version of their professional color grading software, DaVinci Resolve (Lite). The first part of this chapter will take you through the steps in using the basics of DaVinci Resolve 9. (The pro version comes with the Blackmagic Cinema Camera.) It is not an instruction manual teaching all of the features of the program. Rather, it walks you through the steps I took in doing a basic color correction and color grading of the organic farm documentary I shot with Katarina Holmdahl in Sweden using Ikonoskop's A-Cam dII camera. As an easier alternative, I then cover the steps for using

Captain Hook's look up table (LUT) as a fast way to color grade with a preset process. I applied it to my BMCC short of the Carpetbag Brigade.

In the next chapter, I take you through the steps in grading footage using Pomfort's color grading software, LightPost, designed for the Digital Bolex D16—a powerful, yet easy-to-use tool for grading any CinemaDNG file. Indeed, any CinemaDNG file can use either software, so you can use Blackmagic or Ikonoskop with LightPost and use the Digital Bolex on Resolve. Resolve does have a built-in Blackmagic codec, however. I also examine Adobe Camera Raw for color grading with the Digital Bolex—which offers powerful tools for the grading process.

DAVINCI RESOLVE (LITE)

www.blackmagicdesign.com/products/davinciresolve/software

1. Opening DaVinci Resolve, you're brought to a login page. I haven't created a login name or password, so I just select admin (since I'm the owner of the software) and click Log In, which takes me to the project page (Figure 7.1).

FIGURE 7.1
Log In screen.[1]

1 All images in this chapter are screen grabs by Kurt Lancaster, unless otherwise referenced. The screen images for this section are from version 9. The update for 10 has the basic functionality with the most visible interface improvement occurring with the editing screen and tools in the Conform section. The overall interface and workflow hasn't changed.

2. On the project page I can see thumbnails of different projects. I can select a project I've been working on or create a new project and type in the title (Figure 7.2). I'm then taken to the main page.

FIGURE 7.2
Create New Project.

3. On the bottom left of the main page there is a project settings button. I click on it and select "Image Scaling," (A), selecting "Center crop with no resizing" (B) in the "Input Scaling Present" menu (Figure 7.3).

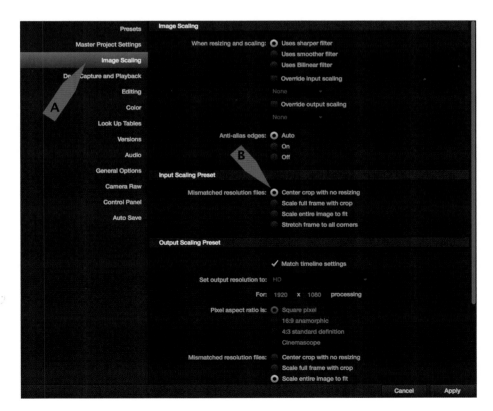

FIGURE 7.3
Image Scaling menu in the master settings menu.

4. In addition, I want to choose the Camera Raw menu (A), selecting the upper right drop-down menu(B),from which I choose CinemaDNG (C)—(the setting I want when using the Black Magic Cinema Camera, Ikonoskop A-Cam dII, as well as the Digital Bolex—any camera using the CinemaDNG format). (See Figures 7.4a and 7.4b.)

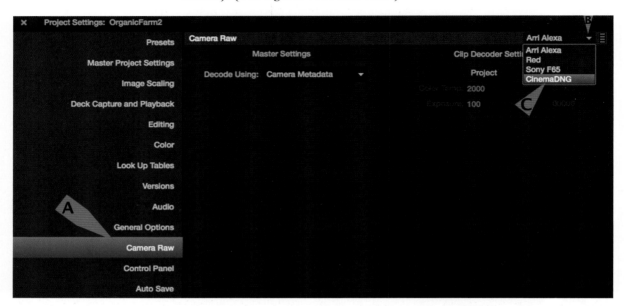

FIGURE 7.4

(a) Selecting the CinemaDNG submenu in the Camera Raw menu. (b) The CinemaDNG menu item gives me the proper "Clip Decoder Settings" for the footage I shot

5. Along the bottom of DaVinci Resolve resides the navigation bar, allowing you to move from a variety of pages, each providing a different function. The **Media** page is where you import media. **Conform** allows you to set your edit points (and even allows you to do a full rough edit, if you want).[2] **Color** is the page that allows you to do your color grading. **Gallery** allows you to bring in a corrected image (such as from Photoshop) and use that image as a preset color grade. **Deliver** allows you to export your corrected files to your editing software (such as Final Cut Pro) (Figure 7.5).

6. Browse your hard drives and find the files you imported and click on the folder. DaVinci Resolve places your footage as a series of individual picture files in subfolders (Figure 7.6).

FIGURE 7.5
Main navigation menu for DaVinci Resolve found on the bottom of the page.

FIGURE 7.6
Subfolders hold a series of still shots (24 stills per second of footage). You can change the size of the folders by adjusting the size slider on the bottom right of the window.

2 Version 10 of the software has much improved editing features.

7. Hit "command A" (for Apple computers) to select all of the folders you want to import into your Media Pool—the shots that you want to correct. If there are particular shots you know you will not use, then deselect the folders containing these shots. Next, drag the selected folders to the Media Pool window below. The folders now open up to a movie clip with a range of clip numbers below the image, indicating the range of stills in the folder (Figure 7.7; facing page).

8. Click on **Conform** in the main navigation bar (Figure 7.5) to take you to the timeline window. Press the plus (+) button on the top left to create and name a timeline (A). You can then select your files to drag to the timeline (B). You will need to do this step before color grading. You can also do basic edits on this page: cutting, moving, and trimming footage. You can preview shots and remove shots not needed. If you want to match exposure for shots in a scene, then this is the point where should put them in order so you can reference them when executing the color correction (Figure 7.8).

FIGURE 7.7 (facing page) Dragging the selected folders to the Media Pool opens them up as movie files containing the individual shots of each folder. Sliding your mouse along the clip will preview the movie.

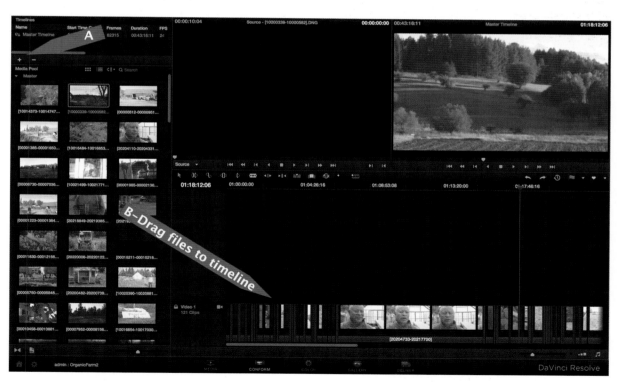

FIGURE 7.8
Conform is the timeline window for basic editing.

9. Take note of the image in the upper right viewer, which displays the image where the cursor on the timeline is placed. Noticed how washed out, flat, and blue the image is. This is uncorrected raw footage from the Ikonoskop A-Cam dII. If this were an 8-bit image from a DSLR, for example, I could get rid of the washed-out look and maybe dig some of the details out of the shadows, but not any (or very little) from the highlights. I've also included an uncorrected shot of the farmer, Rafael Altez.

FIGURES 7.9 and 7.10
The washed-out flat look of uncompressed raw footage.

If you want to do full manual color correction using color curves and wheels, go to step 10. If you want to use a LUT plugin first, go to the section "Captain Hook's LUT for Color Correction in DaVinci Resolve" on p.143.

10. Click on **Color** on the bottom navigation bar. You're taken to the page where color correction (adjustment of tone and uncorrected color) and color grading (achieving a look for your film) take place. See Figures 7.11 and 7.12.

 Here I can see the waveform monitor, vectorscope, red, green, blue parade, and histogram, as well as color wheels and color curves. The scopes change as you manipulate the color wheels and color curves. Learning how to read them is key in understanding the basics of color grading. There is a lot to unpack in these settings, but this is not a book on color correction, so I will not be going into detail.

 Briefly:

 - Waveform: The range of luminance in an image—it reveals the scale of brightness and darks read along the entire image from left to right, reflecting the luminance of the image. Ideally, you're trying to get the darks to just touch 0, while you want the brights to just touch 100.

 - Vectorscope: A tool used to reveal the chrominance or the intensity (saturation) of colors (hues). The farther out, the more intense the color; the closer to the center the more desaturated the image. Typically near the 10 o'clock position there is a skin tone line.

 - RGB Parade: Reveals the color mix (a color balance that is off, such as being too blue, will reveal the extra range of blue in the parade display).

 - Histogram (RGB): The tonal range of each of the colors; shifted left, it reveals a low-key setup (dark) and shift right shows a high-key setup (bright). In the middle lie the midtones (the range of skin tones on people). The more spread out the data from dark to bright the more contrast the image contains.

 DaVinci Resolve names the shadows, midtones, and highlights or brightness, as Lift, Gamma, and Gain. Gamma or midtones reflect the skin tones of your subject.

11. Adjusting the colors in the color wheels, the final image of the field now stands in contrast to the uncorrected raw image. Details of the clouds can be seen as well as retaining details in the shadow areas. And the farmer is no longer too red or washed out. See Figures 7.13 and 7.14.

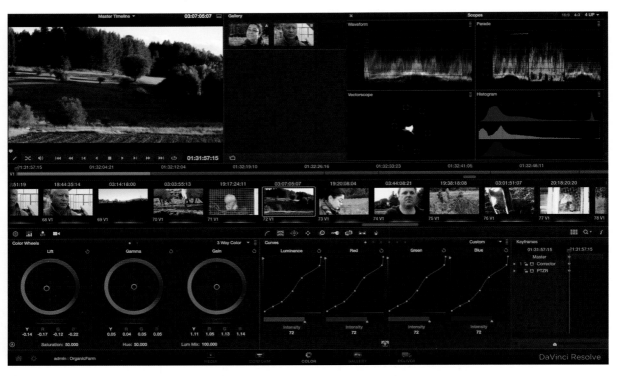

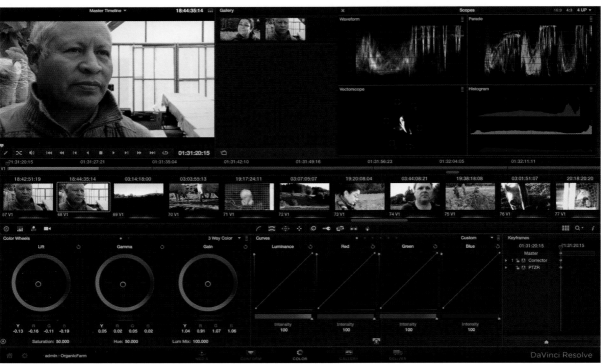

FIGURES 7.11 and 7.12
The color correction tool of DaVinci Resolve.

FIGURES 7.13 AND 7.14
The corrected image of the field after adjusting color curves and color wheels (while keeping an eye on the scopes) removes the bluish cast and washed-out look of the raw image, while retaining some of the details in the clouds. The farmer expresses a more natural skin tone, but notice the background is clipped—if you push your image too far in the highlights, there's no recovering of the information, even when shooting raw. Use a light meter if you've not mastered how to avoid clipping your shots.

12. Once I have a look down, it's important to realize that in order to save time you can lock it in as a preset, which can then be applied to other similar images. In this case, I create two. One for in the sunlight and one for in the shade. First I select the graded image and then click on option (or alt) and choose one number 1–8. This sends the preset to the Gallery (see Figures 7.11 and 7.12 as well as 7.16). To apply the preset, select the image (or images) that you want to apply it to and press command and the corresponding number 1–8 that matches the option number of the original.

Pressing the **Gallery** button on the main navigation toolbar, I am taken to a series of presets in DaVinci Resolve (Figure 7.15). I could choose to grade off one of these presets. In addition, I could also do a color correction in Photoshop (where you can adjust the dng file in Camera Raw) and import the image here and use that as my preset.

FIGURE 7.15
The Gallery page allows me to not only choose a preset, but to also import my own color graded preset (such as a still adjusted in Camera Raw via Photoshop, for example).

If steps 10–12 seem complicated, they are. You've got to have your color curves and color wheels down and really know how to read the scopes—it takes time. But there's an easier route, as detailed below in the, "Captain Hook's LUT for Color Correction in DaVinci Resolve."

Captain Hook's LUT for Color Correction in DaVinci Resolve

John Brawley cuts his projects using Final Cut X. His colorist, Captain Hook, created a look up table (LUT) for DaVinci Resolve designed specially for the Blackmagic Cinema Camera (and it'll work for the Blackmagic Pocket Cinema Camera, as well). (A LUT is essentially a plugin with predetermined values engaging a film-like look.) Location: www.captain hook.co.nz/blackmagic-cinema-camera-lut/ (be nice and send a donation if you find it useful for your work).

In this section, I will show you how to set up Captain Hook's BMCC LUT and then show how it was used in the grading of the *Carpetbag Brigade* piece featured in Chapter 5. The LUT is designed specifically for the Film mode of the BMCC and can work in both raw and ProRes settings of the camera.

Loading the LUT

1. Go to this link and download the LUT: www.dropbox.com/s/k1bj22z0zif6p4f/Hook_BMCC_BMDFilm2Vid.cube

2. Open the hard drive and follow the convoluted route to DaVinci Resolve's LUT folder (Figure 7.16): Hard drive → Library (A) → Application Support (B) → Blackmagic Design(C) → DaVinci Resolve (D) → LUT (E) → ARRI (F)

FIGURE 7.16
Hard drive path for placing in Captain Hook's LUT.[3]

3. Drop Captain Hook's LUT into the Arri folder (it's where it goes). You're done. The LUT will now appear as an option in DaVinci Resolve.

4. Open DaVinci Resolve and go to the Project Settings window and select Look Up Tables(A). Go to the dropdown menu for 3D Output Lookup Table (B) and select Hook_BMCC_BMDFilm2Vid (C) (see Figure 7.17).

5. Press the Apply button and close the Project Settings window. This gets you ready to go.

3 All images in this chapter are screen grabs by Kurt Lancaster, unless otherwise referenced.

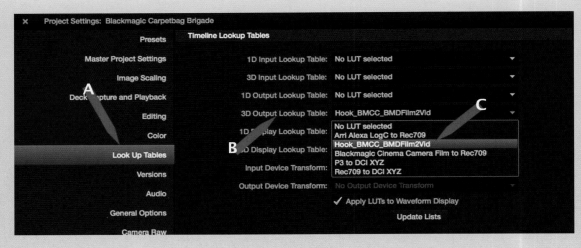

FIGURE 7.17
Selecting Captain Hook's LUT in the Look Up Table's dropdown menu.

Using a LUT

On the left side of the screen you'll see a window with your footage—notice how the color and exposure may be off (see Figure 7.18 for an example). This is due to the fact that Resolve is using the Rec.709 color space for HD television broadcast (listed by Color Space and Gamma in Figure 7.18). Even though you've selected Captain Hook's LUT in the project settings, you will need to apply it to each clip.

1. Below the Master Timeline window, notice the four button graphics: 'Color Wheels (A), Primaries (B), RGB Mixer (C), and Camera Raw (D)' (the camera symbol). Select the Camera Raw button. Below these buttons, you'll now see the Master Settings (E), Color Space (F), and Clip Decoder Settings (G) (see Figure 7.18).

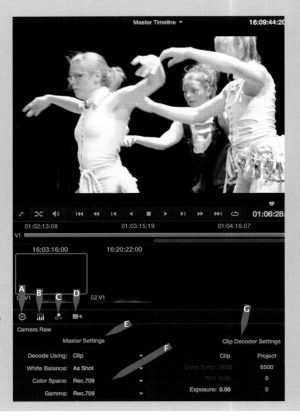

FIGURE 7.18
Camera Raw Master Settings reveal the setting for the raw image picture on top of the window. To the right we can see the Clip Decoder Settings (G), revealing the project color temperature set at 6500K, thus the warm look of the image. Also note the overexposure of the image, which will be easily corrected. (Resolve 10 places the Camera Raw icon first and adds another menu item, Motion Effects, for which there's no space in this book to examine.)

Several things need to happen in order to correct these shots. Rather than manually adjust the color (covered in the main section, above), we'll use Captain Hook's LUT. To do so, there are several steps to follow in adjusting the Master Settings.

2. Replace the default Project setting and select Clip from the Decode Using dropdown menu (Figure 7.19).

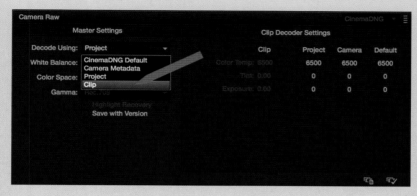

FIGURE 7.19
In the Decode Using menu change from the Project setting to the Clip item.

3. Select Custom from the White Balance dropdown menu (Figure 7.20).

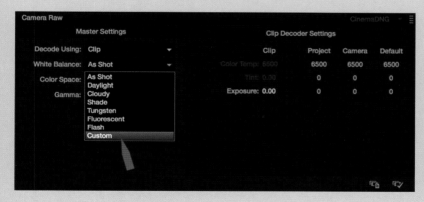

FIGURE 7.20
Select Custom from White Balance.

4. From the Color Space dropdown menu, select BMD Film (Blackmagic Design Film mode). This will also automatically change the Gamma menu to BMD Film, as well. You may also want to choose the Highlight Recovery check box below Gamma (see Figure 7.21), which will bring the highlights down.

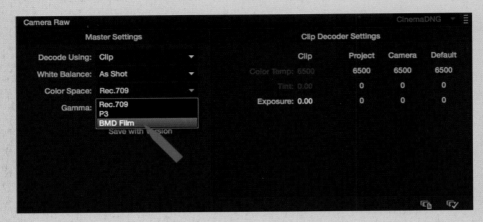

FIGURE 7.21
Select BMD Film (Blackmagic Design Film) color space.

5. Now I can fix the color and exposure issues. On the Clip Decoder Settings (right) side of the panel, I can adjust the Color Temp (dial in any color temp you want) and Exposure (in degrees of stops). I select 3600K to cool my image and knock my exposure down two stops in order to compensate for the blown out image (Figure 7.22).

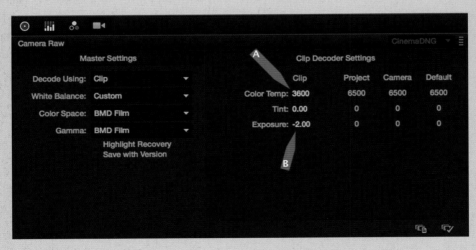

FIGURE 7.22
Adjusting the clip's color temperature (A) and exposure (B) provides an easy way to get my image adjusted quickly.

6. Looking at the results, I can now see I'm getting close to what I want. I end up setting the Exposure to −1.75 (Figure 7.23).

Adjust your final color using Color Wheels, (A, B, C) or one of the other tools at your disposal in DaVinci Resolve (see steps 10 and 11 in the main section, above). My final adjustment using color wheels gave me a subtle change to the image and captures what I want for the project (D, E, and F show my changes as corresponding digits). (Figure 7.24). (Resolve 10 includes an Offset wheel.)

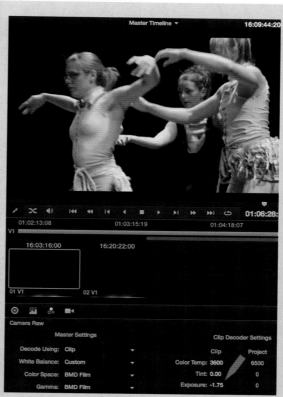

FIGURE 7.23
The image is now close to what I want with my adjustments indicated in the bottom part of the screen.

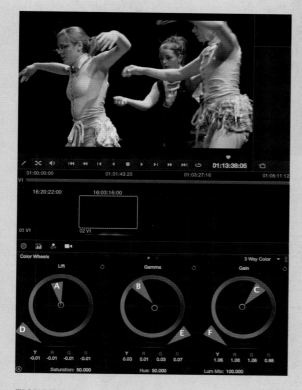

FIGURE 7.24
The final image color corrected by adjusting the color wheels (Lift (A), Gamma (B), Gain (C), which is equivalent for adjusting the blacks, midtones, and highlights). D, E, and F shows the value changes as corresponding digits.

EXPORTING A DAVINCI RESOLVE PROJECT

1. After color correcting and grading your images, click on the **Delivery** button on the main navigation bar. Here you can adjust your render settings for export. The Render Settings menu appears complex and you could choose Easy setup and select a preset from the dropdown menu in the Presets section. However, I choose the following from the Output section (Figures 7.25 and 7.26):

 I choose the QuickTime format (A) with the Apple ProRes 422 format (B) (I don't need it any higher since my project is web based) at 1920 x 1080(C). I make sure my compression quality is set to "Best" (D) and that I'm not outputting my files as one large clip, but as "Individual source clips," (E), so that I have individual movie clips I can edit in Final Cut. I also Browse (F) to a folder I created on my external hard drive (G) (see Figure 7.27), so that these .mov files get into their proper place (which I can then import into Final Cut). You can keep the source filename, (H) as well as add custom names with a prefix or suffix. I don't choose any items in the File Name and Output Options sections.

FIGURE 7.25 AND 7.26
This menu appears complex, but there's only a few items I need to worry about. The material in the File Name and Output Options I ignore.

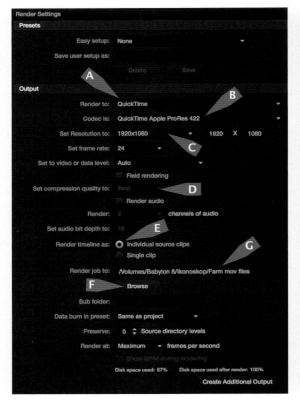
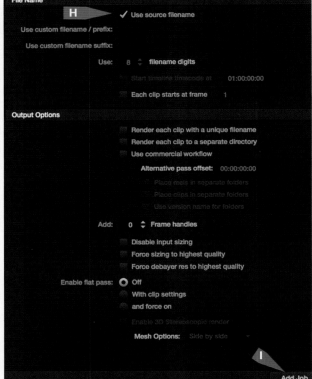

2. Next, I want to export all of my clips on the timeline (you could select which ones you want to render). First, click on the first clip and then press in the "in point" button (the left button in the far right buttons below the image), then scroll over to the last image on the timeline and select the "out point" button (the right button next to the in point). See Figures 7.28 and 7.29. Or more simply, right click in the timeline and choose "Select All."

3. Lastly, I press the Add Job button(I) (back to Figure 7.26). This brings up the job in the Render Queue, then click the Start Render button on the bottom area of the render queue window. See Figure 7.30.

If you plan to color grade in DaVinci Resolve after you complete the edit—which is the old-style Hollywood way—you will want to be selective on what takes you want to use and/or engage the use of proxy files. This will allow you to export lower res small files into your editing software, and then return the final edit to Resolve for color correction and grading through an XML file. Just be sure you save the Resolve project and don't make edits or make any name changes to files once you've exported the XML file, because after you return it from Final Cut or other editing software, it'll need to reference the original files in Resolve. And don't make any name changes of files in Final Cut, either!

FIGURES 7.28 AND 7.29
Select the in and out points.

FIGURE 7.30
The Render Queue shows the job rendering, taking under four hours to complete.

WHY YOU DON'T CORRECT A PRORES EXPORT IN FINAL CUT X

After color correction in DaVinci Resolve, I test and export as Apple ProRes (HQ)—meaning 10-bit compression at 422, and bring them into Final Cut X. This is where I do my edit for the film. I don't really want to adjust color in Final Cut, so I do all of my grading in Resolve—and this is why. In Resolve I originally did a -1 exposure pull, but I noticed the highlights were still clipped when I imported them into Final Cut (Figure 7.31, arrow A). Furthermore, I also tried to cool some of the clips down in Final Cut. I thought I would save some time by tweeking the correction in Final Cut (Figure 7.31, arrow B), rather than having to go back to Resolve and export the files again (another reason why perhaps working with proxy files, doing the edit, and exporting the XML back into Resolve is a good idea!). In either case, the result was poor.

Taking the footage back into Resolve, correcting it, and bringing the new ProRes files back into Final Cut, proved to be perfect (see Figure 7.32).

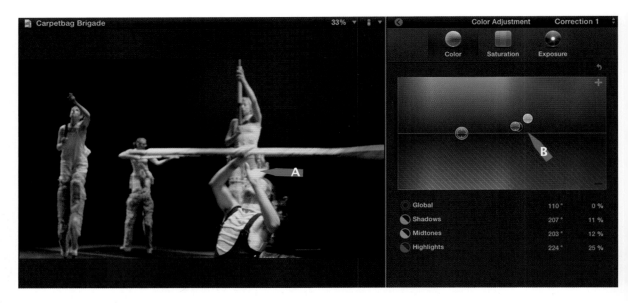

FIGURE 7.31
Adjusting exposure and color in Final Cut on Resolve's ProRes files resulted in the image beginning to fall apart, losing the sharpness and skin tones. This is the limiting aspect of grading compressed images and the reason filmmakers want to shoot (and grade) in raw.

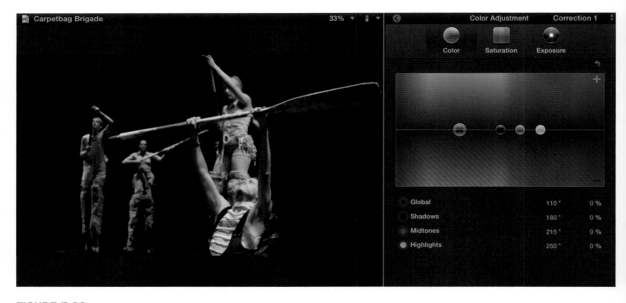

FIGURE 7.32
The corrected version done in DaVinci Resolve proved much better after looking at it in Final Cut Pro (no additional adjustments were made in Final Cut—I learned my lesson!). Notice the sharpness of detail and good skin tones.

COLOR GRADING TIP

Do all of your color correction and grading in DaVinci Resolve or another grading software, such as LightPost covered in the next chapter, while your images are in a raw state. Exporting compressed files and attempting to grade in your editing software will likely cause the shots to fall apart.

Check out Joe Tyler's comments about utilizing the advantages of the crop factor, as well as color correcting and color grading using Resolve for the BMCC (see below).

Color Grading With Raw Video

Part 1 by Joe Tyler, Empty Bucket Studios

Reprinted by permission

www.emptybucketstudios.com/color-grading-with-raw-video/

April 16, 2013

We recently shot a few projects with the Blackmagic Cinema Camera—a camera that records ultra high resolution, uncompressed raw footage. It allowed us enormous flexibility in color grading, adjusting exposure, and dealing with pesky image artifacts like chromatic aberration.

As an example of the amount of technical and creative control we have when working with raw-capable video cameras, I pulled out an illustrative frame from the Tutto Metal Design artist profile film. Let's take a look at how ultra-high resolution raw footage impacts our production.

In the first image, we see the raw footage as it was recorded in camera. (See Figure 7.33). It looks bad. Like really, really bad. The highlights look almost completely blown out and the whole image has serious color issues. In the words of Ricky Ricardo, "Lucy, you've got some 'splaining to do." But don't fire the DP just yet—there is a reason for the madness.

We had Ray seated for his interview right at the opening of his shop—two large doors that together were bigger than a normal garage door. We set up Ray so that he was just outside the morning sun—in the image below you can see the harsh sunlight on his knee and his bench. (See Figure 7.34.)

This type of lighting environment is one of my favorite ways to shoot portraits—the sunlight is diffused but it's still punchy where it needs to be. The natural light falloff into the room provides depth and subject isolation. But, of course, we weren't here shooting portraits. This was video. This type of subject lighting is not something I'd really consider with normal video cameras—even with something like a Canon 5D. The dynamic range between the subject and background is too great. Worse yet, the inside of his shop was lit with overhead fluorescents, so we had some nasty mixed light to deal with.

The Blackmagic Cinema Camera is different. It gave us the ability to hold on to the highlights on Ray's face while we really brought up the exposure to see more of the inside of his shop. The physical depth of his shop made that a tall order (the Inverse Square Law[4]), but the camera pulled it off very nicely. And once we loaded the shots into Adobe Camera Raw for color grading, we were able to correct the fluorescent yellow tinge inside his shop to produce a much more natural array of colors. (See Figure 7.35.)

Not too shabby. Obviously working with natural light in video presents other challenges (like spotty clouds changing exposure) but if you can pull it off, the results are worth it. The quality of light we were able to achieve

4 Halving the distance of the light source to the subject increases the intensity of the light four times, while doubling the distance decreases the intensity of the light four times.

FIGURE 7.33
The flat look of the BMCC film mode—the image imported as shot. (© 2013 Empty Bucket Studios. Used with permission.)

FIGURE 7.34
A behind-the-scenes setup of the interview. (© 2013 Empty Bucket Studios. Used with permission.)

would have been difficult to reproduce with artificial light. And the catchlights created by the large doors really light up his eyes, and that was particularly important for Ray because they are such a captivating feature. To get those same catchlights with artificial lights we would have needed a softbox or scrim somewhere in the neighborhood of 75 square feet. And while that kind of lighting setup is not totally out of this world for higher budget productions, it's certainly something we would rather not deal with.

As a side note, I wanted to demonstrate the amount of cropping flexibility we had when working with the BMCC. In the first image, we see a 100 percent crop from a 1920 x 1080 frame. (See Figure 7.36.) Normally on something

like a Sony FS100, 1920 x 1080 is the highest resolution we can record. And that's perfect for most things—if the project is going to be full HD we take extra care (read: extra production time) in framing and composition because we know there is no room for error in post-production.

Since the BMCC records at 2.5K (2432 x 1366, to be exact), we have over 50 percent more pixels to work with than in "regular" full HD (and over 300 percent more than 720p!). (See Figure 7.37.) In reality, 50 percent is not that much. But it does allow us to make a shot a little tighter than we were expecting while in production. And it allows us freedom to motion track, stabilize, and zoom

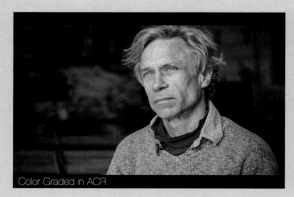

FIGURE 7.35
The results of the interview color graded in Adobe Camera Raw. (© 2013 Empty Bucket Studios. Used with permission.)

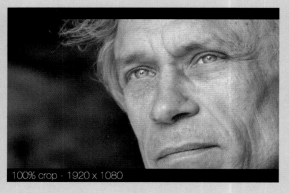

FIGURE 7.36
The image cropped for full HD resolution, 1920 x 1080. (© 2013 Empty Bucket Studios. Used with permission.)

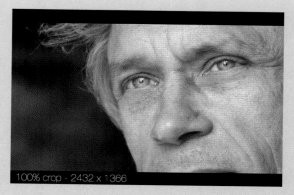

FIGURE 7.37
A comparison in size of the 2K full HD mode and the 2.5K resolution of the BMCC sensor. (© 2013 Empty Bucket Studios. Used with permission.)

FIGURE 7.38
The full size of the image at 2.5K (2443 x 1366). (© 2013 Empty Bucket Studios. Used with permission.)

while still maintaining a full HD output. Or we could just export the full resolution file to YouTube (which allows playback of the original resolution) for the enjoyment of those people who have one of Apple's many retina displays. Or we can grab a very nice, 12-bit raw still image for printing or use on the web. Those options are nice to have in your toolbox, even if you hardly use them.

Color Grading With Raw Video: Part 2

by Joe Tyler, Empty Bucket Studios

Used with permission

www.emptybucketstudios.com/color-grading-with-raw-video-part-2/

April 22, 2013

All video production companies think critically about color during each stage of the production process. In pre-production, we might make note of a particular logo's main colors or the overall palette of a brand. During production, we concentrate on shooting in a way that emphasizes important colors and attenuates distracting colors. In postproduction, we have the ability to creatively use color grading on individual shots to match our client's vision and desired aesthetic mood.

Color is one of those things that, as media consumers, we're all conditioned not to notice. If done well, an image's color design will blend into and enhance the viewer's overall experience, even if the coloring is very

surreal or unorthodox. Of course, if color is executed poorly it may very well draw attention to itself in a way that detracts from the perceived quality of a particular project.

The task of coloring is being made far more approachable with the democratization of raw-capable video cameras. Raw image formats allow postproduction flexibility to a degree that is simply not achievable with highly compressed, "baked" footage. Raw is the harbinger of a post-codec world.

To demonstrate the myriad ways we can approach color grading in postproduction, I selected a still frame from the Tutto Metal Design artist profile film. To begin, we have the shot as it was recorded in the Blackmagic Cinema Camera (Figure 7.39):

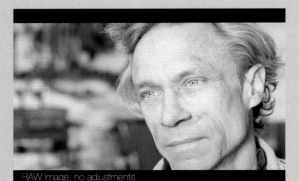

FIGURE 7.39
The raw image is washed out and flat in order to preserve data in the highlights and blacks. (© 2013 Empty Bucket Studios. Used with permission.)

If you're wondering why it looks so bad, read through our post on raw image capture and color grading. We swear it looks like that on purpose.

Raw is all about flexibility. You can do as little or as much as you want (though we definitely don't recommend doing nothing). The next image is essentially a simple color correction—basic adjustments were made to fix white balance and balance exposure. If that's as far as you want (or need) to take your footage, you could be done at this point. (Figure 7.40.)

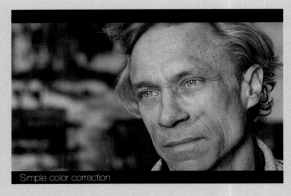

FIGURE 7.40
The simple color correction removes the flat look of the BMCC film mode. (© 2013 Empty Bucket Studios. Used with permission.)

Of course, some projects call for a little more. What story are we trying to tell? What emotions are we trying to evoke? What impression do we want to create? Sometimes those questions are not yet answerable during production, and we want to see everything in context before we make our decisions. Raw allows us the freedom to experiment with different aesthetic looks in a non-destructive way.

In the next two images (Figure 7.41 and 7.42), you can really see the difference between two color grades: the first is "warm" (more orange) and the second is "cool" (more blue). What does the color say about the subject? The warm subject looks calm, reflective, and friendly. The

FIGURE 7.41
Warm hues alter the feel of the shot. (© 2013 Empty Bucket Studios. Used with permission.)

Cool Color Grade

Day-to-Night Conversion

FIGURE 7.42
Cool colors added to the image create a different feel for the shot. (© 2013 Empty Bucket Studios. Used with permission.)

FIGURE 7.43
Day-for-night conversion reveals the power of a 12-bit color grading potential. (© 2013 Empty Bucket Studios. Used with permission.)

> Raw image formats allow postproduction flexibility to a degree that is simply not achievable with highly compressed, "baked" footage. Raw is the harbinger of a post-codec world.

cool subject appears more aloof; maybe even sinister. Color grading has the power to change your impression of someone, even when all else is equal.

Finally, raw allows us the ability to render special effects like day-to-night conversions. With total control over the image's 12-bit tonal range, we can plunge our scene into darkness and make it appear as if we were filming by moonlight. (Figure 7.43.) It takes time to perform this kind of conversion, but if you consider the amount of headache it could save when compared to actually staging a full production at night, you could still easily end up saving time and money.

DaVinci resolve is a complex software and not necessarily easy to master. In some ways it's about as complex as Adobe Camera Raw, which has a simpler interface with a lot of powerful complexity below the surface—the workflow for this is covered in the next chapter and is recommended for shooters of the Digital Bolex camera. In fact, the Digital Bolex team, working with the German software company, Pomfort, designed a much simpler software than either one of these for color correction and grading, which is explored in the first part of next chapter, followed by the more complex Camera Raw.

CHAPTER 8

Color Correction and Color Grading CinemaDNG with LightPost and Camera Raw[1]

Like Blackmagic's DaVinci Resolve, Adobe Camera Raw—found embedded in Adobe's Photoshop, Lightroom, and After Effects—is an advanced color correction and grading software that can be used to manipulate CinemaDNG raw files found in such cameras as the Ikonoskop A-Cam dII, Blackmagic Cinema Camera (and Pocket Camera), and the D16 Digital Bolex. (Note: the footage for this chapter was shot on a beta version of the D16 and was not fully calibrated.)

Adobe Camera Raw offers a simple interface and powerful tools for shaping the look and feel of your CinemaDNG files. This chapter covers the steps needed to bring the DNG files into Camera Raw via Adobe Bridge, and how to convert the files into QuickTime files (ProRes) through QuickTime Pro. But first, the chapter will cover how to use Pomfort's LightPost, software designed specifically for the Digital Bolex D16 camera.[2] Some people may prefer Adobe Camera Raw over LightPost—although the Pomfort software is much easier to use—because Camera Raw gives them full control of the image across the full spectrum of color and dynamic range. LightPost will give you a faster grade, but not quite as much control over the image.

POMFORT LIGHTPOST

LightPost was designed specifically for Digital Bolex's D16 camera. It is easy to use and contains some potentially powerful tools when needing to do a quick grade. The software can be purchased at: http://www.digitalbolex. com/product/lightpost-software/

1 I'm indebted to Michael Plescia for the section on Adobe Camera Raw. He graded his Ikonoskop-shot film, *Gus*, with Camera Raw and convinced me it's the best software for grading the Digital Bolex camera, for the reasons noted in the chapter. He guided me through the complexity of the software, showing me its simplicity at the same time.

2 At the time of writing, the software is still being calibrated for the camera, so I will take you through the steps needed to use the software, but the color grading may not be as accurate as the full version coming out after the deadline for this book.

There are four steps for using the software:

1. Copy
2. Organize
3. Color
4. Export

1. Copy

Ideally, this is best when copying files from the memory card, the D16's internal SSD, or if you're working from files already on a hard drive, as this step allows you to back up footage. If you've already imported clips to a folder on your hard drive and you do not want to copy them, proceed to step 2.

a. Press the copy button (A) (see Figure 8.1).

FIGURE 8.1
LightPost's Copy room, or window.

b. Scan your source drive (B) or choose the clip you want to import by pressing the Add button (C) and locate the clip (D) (see Figure 8.1).
c. Select the destination drive for the copy (E) (see Figure 8.2).
d. Press Start Copy (F). The clip or clips will copy into your selected hard drive and folder you selected.

FIGURE 8.2
Select the destination drive of the clips.

2. Organize

After your files have been copied (or you've added clips to the library), you're ready to organize your clips.

a. Press the Organize button at the top of the window (A) (see Figure 8.3). You'll see the folder you copied imported under Import Folders on the left. If you didn't copy files from the Copy room, you may choose "Add clips to library . . . " (B) and choose the files you want to add (C). A new folder will appear. In addition, there are other Smart Folders below this where you can organize clips that have certain tasks to be completed, such as "Is Not Graded" or "To be Transcoded." This is a great function if you're working on a larger project as well as in a team, so you can organize your workflow.

b. Select and click on the folder you want to work with. All of the different clips will appear as thumbnails (A) (see Figure 8.4). You can also select a list view, as well (B).

FIGURE 8.3
LightPost Organize room.

FIGURE 8.4
The clips appear as thumbnails on the left. You may toggle between thumbnail view (A) and list view (B).

c. Select the clip you want to grade (see red arrow)—it will appear in the center window (see Figure 8.5). Along the bottom of the screen is a timeline of all the clips in the selected folder. You can move the cursor along the bottom to preview any of the clips. You can also mark in and out points on clips, choosing what you need so you don't end up needing to exporting everything you shot. This will keep your file sizes under control. If you hover your mouse over the main view window, playback controls will appear (not shown). Metadata of the shot is shown on the right.

FIGURE 8.5
LightPost's Organize room, where you can see your clips, select in and out points for selected clips, as well as peruse metadata for a clip. Note the ungraded color from the uncalibrated D16 beta test camera used for the shoot.

3. Color

This is the step where the fun begins. You can manipulate the clips to nearly any kind of look and feel that you want for the film by adjusting the following tools (which are combined in pairs). Note: I explain the sliding scales and position of the cursor in the color correcting interface as if on a quadrant (negative values to the left and down while positive values are to the right and up)—they're not referencing the number scale that appears (some of which moves from 0 on up). See Figure 8.6.

- Temperature and Exposure (C). Appears as a quadrant on the bottom and sliders on the right.
 - o Color temperature: Negative values cool the image, while positive values warm the clip.
 - o Exposure: Negative values darken or stops down the brightness of the clip; positive values brighten the clip (opens up the f-stop values).

- Tint and Saturation (D). Appears as a quadrant on the bottom and sliders on the right.
 - o Tint adjusts the amount of cyan and magenta appearing in the image. Cyan increases in the negative values while magenta appears in the positive values.
 - o Saturation adjusts the intensity of colors in your clip. The negative values desaturate the image (making it grayscale) while the positive values intensify the colors.
- Shadows Tone (F). Appears as a color wheel on the bottom and sliders on the right.
 - o Adjusts the darker (shadow) areas of your image—red, green, and blue may be adjusted separately with the dial (E) or sliders.

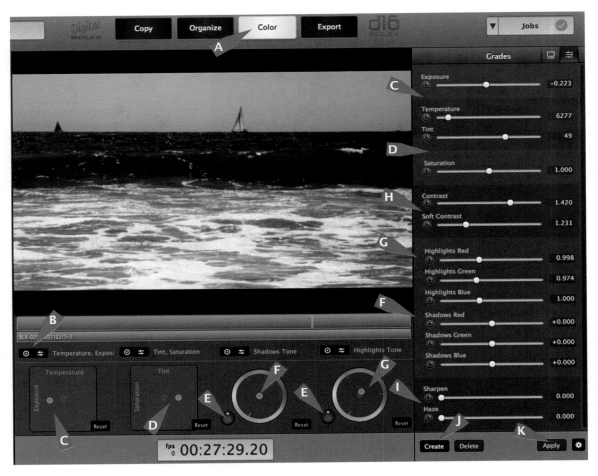

FIGURE 8.6a
LightPost's Color room with color wheels and sliders.

- Highlights Tone (G). Appears as a color wheel on the bottom and sliders on the right.
 - o Adjusts the brighter (highlights) areas of your image—red, green, and blue may be adjusted separately with the dial (E) or sliders.
- Contrast and Soft Contrast (H)
 - o Contrast: Positive values intensify the shadows; negative values intensify the whites, creating a washed-out or milky sheen on the image.
 - o Soft Contrast: Similar to contrast, but with less intensity.
- Sharpen and Haze (I)—combines the tools of sharpening or blurring for shadows and highlights separately.
 - o Sharpen: 0.000 presents a softer image, while values to the right (up to 3.000), sharpens the image, making the image crisp.

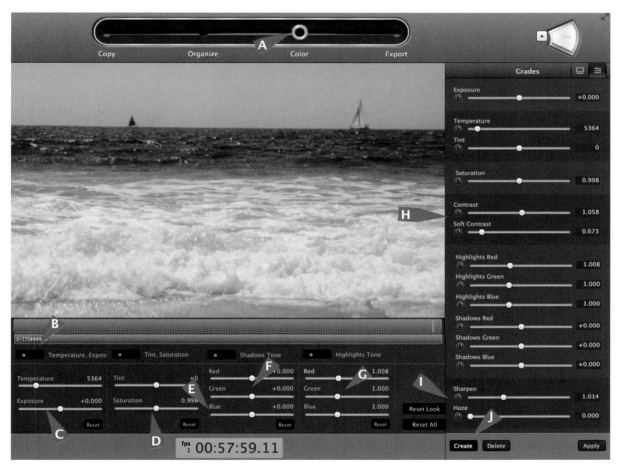

FIGURE 8.6b
LightPost's Color window with sliders only.

o Haze: A 0.000 value present a neutral image, reflecting the values of Sharpen. Sliding it to the right (up to 1.000) softens the image, casting a slight blur to the image.

Once you grade an image you can select Create button (J) to create a template that you can apply to other clips – which appears when switching between slider and window view (button upper right). Select another clip you want to match this grade, then hit Apply (K) in Figure 8.6a.

a. Press the Color button (A).

Adjust your values as needed in order to get the look you want. You can toggle (B) between visual view or slider view for the Temperature-Exposure (C), Saturation-Tint (D), Shadows Tone (F), and Highlights Tone (G). Both Shadows and Highlights Tones have a dial (E), which adjusts all of the tones at once, incrementally. Also note, the panel on the right, which includes sliders for all of the values listed on the bottom, in addition to Contrast and Soft Contrast (H) and Sharpen and Haze (I), which are not represented elsewhere. You may also hover on the main image clip, center, and playback controls will appear where you can set in and out points (not shown).

b. Click on Create (J) when you have a look you like and want to keep it as a template to apply to other clips (K). The clip image will appear beneath Grades. Move to another clip and select Apply to set these changes to another clip. (Create several and test them out.) LightPost includes several presets.

4. Export

After you've graded the film, you will probably want to export the clips for editing in your favorite editor. The final step allows you to export the files for different types of .mov templates. See Figure 8.7 for the layout window of Export.

a. Press the Export button (A).

b. Choose the clips you want to Export on the left (you may choose all).

c. Select where you want to send your files. Press Add (B) if you need to add another drive not on the destination list (C).

d. Select your export setting for the hard drive (D). There is a range of settings from Mobile applications to full Post (or film out) (ProRes 4444). You will see these settings appear below (E). Here, you can change the codecs, size (from custom to 2K), how to resize the files (with or without letter boxing), the types of debayering, as well as limiting file exports to the in and out points you set in the Organize room.

e. Press Start Export.

f. Import these files into your editing software, such as Final Cut Pro.

The advantages of using LightPost are ease of use and a fast workflow. Although you can get a strong grade by using it, I find that you don't have as much control over the final look of your film. For more precise control over the color grading process—at the cost of an increased workflow—I like using Adobe Camera Raw.

FIGURE 8.7
LightPost's Export room. Take note of the different templates for exporting .mov files: Post, Editorial, Proxy TV, 720p, and Mobile applications.

ADOBE CAMERA RAW

At first glance, Adobe Camera Raw seems like a complex software, but I'll clarify the steps for color correction and color grading by breaking this unit into three sections and guide you through each step of the process. (I will not go into an explanation of all of the tools found in Camera Raw—which deserves a book of its own—but just enough to do some good color grades with your footage.)

1. Use Adobe Bridge to import DNG files.

2. Workflow for color grading in Camera Raw, then exporting them as raw tiff files.

3. Create a movie file using Apple's QuickTime Pro (the file you can import into editing software).

1. Using Adobe Bridge to Batch Select Your Clips

Open Adobe Bridge.

1. Select the computer (A) and/or hard drive (B) containing your folder.

FIGURE 8.8
Adobe Bridge. Select your hard drive.

2. Select the folder and open it. On the top of the screen, there's an ordered list going from your hard drive (A) to your folders (B) to your subfolders containing the .dng files for each shot (C).

FIGURE 8.9
List of dng folders in Adobe Bridge. Select the one you want to grade.

3. Select all of your dng files in that folder and right click, selecting, "Open in Camera Raw...". All of the clips will open up in Camera Raw via Photoshop.

FIGURE 8.10
List of dng clips that have been selected from the D16 Digital Bolex in Adobe Bridge. Right click to bring up the menu, "Open in Camera Raw. . ."

2. Camera Raw Workflow for Color Grading and Exporting

After you've selected all of your images from a particular shot, you'll be working with Adobe's Camera Raw to do color correction and grading. This is the most complex part of the process, but it is also the most fun—it is here that you can shape the magic of your Digital Bolex D16 camera (or any other CinemaDNG file). There isn't any particular formula for the workflow. You may find a better way to execute your grade using different steps. Trial and error will lead you to some fun discoveries! Once you get the hang of it, you'll find the entire

process easier. At the same time, once you find a look that works for your project, you can save it as a template to apply to other shots and other projects.

After you enter Camera Raw, follow these ten steps:

1. Adjust color temperature and tint to neutralize the image (correcting the color).
2. Rough in your exposure and contrast.
3. Shape the image through Tone Curves.
4. Bring the shadows/black and highlights/whites to life and resolve crushed blacks and clipping issues.
5. Adjust clarity/blur, vibrance, and saturation as needed.
6. Remove tint from the shadows using the Camera Calibration tool.
7. Adjust the HSL (hue, saturation, and luminance) to bring out the color.
8. Examine the image and tweak using a variety of tools as needed. Be sure the skin tones remain accurate.
9. Save the image as a template for future use.
10. Select all of the images, synchronize them, then save them.

1. Adjust color temperature and tint to neutralize the image (correcting the color)

When you open the images in Camera Raw, select the one you want to grade from (this will become your template and you can apply it to all later when you finish, using the synchronize tool).

a. Check your bit depth. If it's at 8 bits, change to 16 bits by clicking on the bit text on the bottom of the screen (A), this will bring up the Workflow Options menu where you can change it to 16 bits (see Figures 8.11 and 8.12). (Select 16 Bits/Channel from the Depth dropdown menu.)

b. Adjust your Temperature and Tint (B and C in Figure 8.11), until you're starting to get accurate colors and skin tones.

2. Rough in your Exposure and Contrast

As can be seen in Figure 8.14, I brought down the Exposure (A) a bit (-0.55) and increased the Contrast (B) just a tad (+2). Michael Plescia notes that at this stage the highlights will still be milky and the darks too dark, but the core—the subject of the image—should be balanced. The CCD TrueSense sensor on the D16 reads different frequencies in the sky and skin tones, Michael Plescia notes. (See Figure 8.14 for the contrast and exposure values.)

FIGURE 8.11
Basic. Check your bit depth first by looking at the bottom of the screen. The image shown here reveals the image as it came out of the camera before correction is applied. (This image is from the beta production model of the D16 before calibration of the sensor occurred. The calibrated models bring in images that are untinted.)

FIGURE 8.12
Select 16 Bits/Channel from the Depth dropdown menu so you're working with the best bit depth.

3. Shape the image through Tone Curves

Along the top row below the histogram on the upper right is a series of buttons. Choose the second one, Tone Curves (A). You'll see a linear line graph where you can shape S-curves. Michael Plescia says that adjusting curves is the most important step for achieving the correct soft highlight curve, but he finds that he can't nail it with only curves and so he doesn't worry too much if the image clips a little bit in areas of the image that are not as important, such as a single cloud, for example, or a single patch of sky away from the subject. You can achieve those with the highlight, shadow, and black/white sliders (step 4).

a. Select the Point tab. (B).

b. Be sure you're on RGB from the dropdown menu. (C).

c. Click on this line to create a point. You'll end up creating three or four (D, E, F, G). Use the curves to make mid-tones rich (the skin tones of your subject). Plescia says that at this stage the skin tones may be a bit off. The colors should begin to pop, but you don't necessarily have to pop it off the background—it just depends on the kind of story you're telling.

FIGURE 8.13
Tone Curve. The image is now getting accurate and the colors are beginning to pop. The most important thing at this stage is to be sure the skin tones are accurate. You may need to return to the Basic window and adjust your temperature and tint as you play with the curves (switch back and forth as needed).

d. As you eye the skin tones while working with the curves, be aware, Plescia says, that added contrast will exaggerate the appearance of any temperature or tint issues. You may want to go back and tweak temp and tint in the Basic window. Once the mids are nailed, the richness of the image will pop out. But if you try to fix the highlights and darks too much, at this point, you may end up spoiling the mid-tones.

4. Bring the shadows/black and highlights/whites to life and resolve crushed blacks and clipping issues

Go back to the first screen, Basic menu tab. Bring up shadows (E) and blacks (F) and lower highlights (G) to bring them to life—the mids will stay relatively the same. This is the point you fix any crushed black values and any clipped white values (see Figure 8.14).

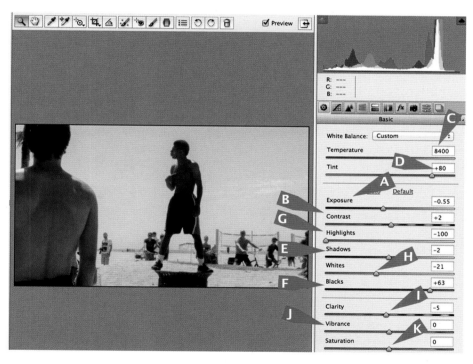

FIGURE 8.14
Basic. Here, you can see the result of the image after adjusting the Temperature to 8400 (C) and the Tint to +80 (D) offsetting the cyan/green tint coming off the beta model raw files, as well as the adjustment of Exposure (A), Contrast (B), the application of the Tonal Curves (in step 3). Now we play with the Shadows (E) and Blacks (F) as a pair in order to bring these to life, then move on to the Highlights (G) and Whites (H). I move back and forth among all four of these to make sure the darks and brights have some detail, with elements of roll-off. Note the details of the cloud against the blue sky, while the skin tones of the dark- and light-skinned performers remain accurate.

5. Adjust clarity/blur, vibrance, and saturation as needed

For this particular scene, I only bring down the clarity a bit—too much sharpness may make the shot too "video" like, while I want to attain some level of a "film" look. Adjust any of these as needed to attain the look and feel you want for your film (see Figure 8.14).

- Moving the Clarity slider (I) will adjust the sharpness or blur of the image. Plescia says that this is a smart tool allowing your negative values to provide blooming highlights while avoiding blurring in the mids. The positive value increases sharpness of the image.
- Vibrance (J) increases the intensity of muted colors, leaving the saturated colors alone (it acts as a kind of fill light except for colors).
- Saturation (K) intensifies or mutes all of the colors in the image.

6. Remove tint from the shadows using the Camera Calibration tool

Plescia argues that Camera Calibration (Figure 8.15, A) is the most important tool in Camera Raw when it comes to grading the TrueSense CCD sensors found in the Ikonoskop and Digital Bolex. These sensors will tend to tint towards green or magenta in the shadows, contaminating the image—at least it did so in the beta production model of the D16. Rubinstein states that the sensor has been calibrated with no tinting. In either case, you want to nail the skin tones with this tool. Under Shadows, adjust the Tint (B) I slid it over to −80. I also bring up the Red Primary (Hue and Saturation) to +30 on each(C)— this takes out more of the green and helps make the skin tones accurate. I leave the Green (D) and Blue (E) Primaries at zero. Adjust these sliders as needed until you've taken out as much of the shadow tints as possible and/or nail your skin tones.

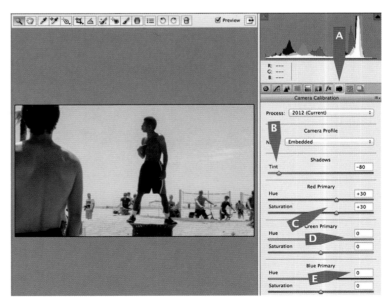

FIGURE 8.15
Camera Calibration. Camera Raw's Camera Calibration tool is a powerful way to help get accurate skin tones and if there is any contamination this is where you fix it.

7. Adjust the HSL (hue, saturation, and luminance) to bring out the background color, such as the sky

Click on the HSL button (Figure 8.16, A). This is another opportunity to adjust your color. Plescia likens it to the color sniper stage—because you can pinpoint certain colors in your grade. This is due to the fact, Plescia notes, "that these are essentially mathematically selective color keys allowing you to grab that one single annoying color that went wacky and bang it into place." He tends to use HSL to correct something specific, like a red stoplight that looked purple or somebody's lips that were running purple. For my grade, I select Saturation (B) from the menu tabs and bring up the Aquas (C) and Blues (D) in order to liven up the sky a bit. Adjust any of these colors as needed for the look you want to bring to your film.

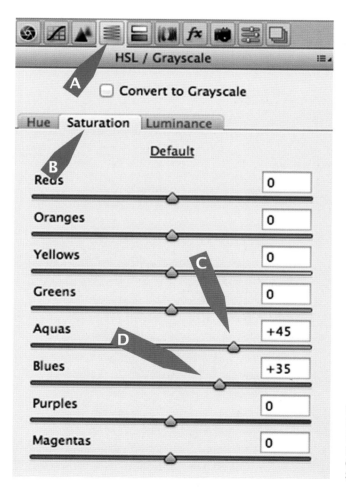

FIGURE 8.16
HSL/Greyscale. Camera Raw's HSL/Greyscale tool allows you to punch up or draw down a variety of colors. For this project, I stay on the Saturation tab.

8. Examine the image and tweak using a variety of tools as needed. Be sure the skin tones remain accurate

This is the final step to shape the look of your shot, scene, and film. Examine everything closely to see if the skin tones are accurate (the most important)—adjust using a variety of tools, as needed. Then examine your highlight and shadow detail to see if you're coaxing as much detail as possible without impacting the skin tones. Make sure the overall color and exposure is what you want for your film. After examining the image closely, I notice a bit of green in the shadows. I go to the Tone Curve tool (A) and choose the Point tab (B) then select the green Channel (from the RGB Channel drop down menu) (C) (see Figure 8.17). I minutely bring down a bit of green in the shadows (D). I create other anchor points (D) so the curve stays on the line as much as possible—so I'm trying to control the shadows. A bit more reds come out in the skin tones, but this tends to give the image more life. Use these specific color curves to take out any color tinting you don't need. Make minor adjustments, since a little tweak goes a long way in subtracting the color.

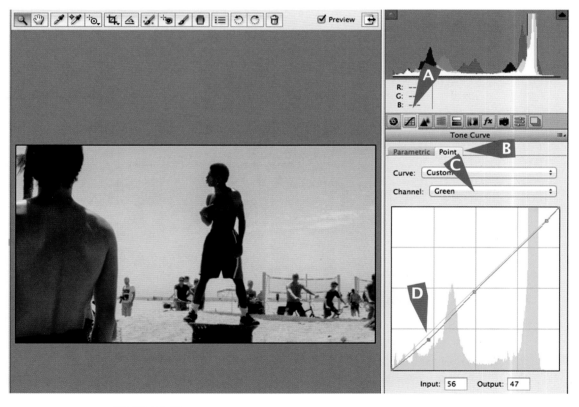

FIGURE 8.17
Tone Curve. Adjusting the green channel in the Tone Curve tool, I pull out green from the shadows.

9. Save the image as a template for future use

Click on the dropdown menu (A) in the upper right menu bar and select Export Settings to XMP (B) (see Figure 8.18). Choose the folder you're using for the project. When you want to use a template file, then choose Load Settings (C) from the dropdown menu. This is useful for maintaining a similar look from shot to shot within the same scene.

FIGURE 8.18
From the dropdown menu (A), choose Export Settings to XMP (B) in order to save the adjusted image as a template you can apply to other images later. When you want to apply the template to another shot, choose C, Load Settings. . .

10. Select all of the images, synchronize them, then save them

After you've adjusted the image until it attains the look and feel of the film you want, realize that you've only adjusted one image from the sequence of shots.

a. To apply those changes to all of your images in the shot, choose the "Select All" (A) button on the upper left of the screen.

b. Press "Synchronize" (B), then press OK (C) (see Figure 8.19).

FIGURE 8.19
First, Select All (A), then press Synchronize. (B) You'll be taken to this Synchronize menu. Just leave everything as it is and hit OK (C). (Unless you want to make adjustments.)

c. Press the "Save Images. . ."(D) button, lower left.

In Figure 8.20, choose where you want to save the file (A), any name you want to apply (B), file extension (C) (.tif) (there's also .jpg, Photoshop, and digital negative). I want the raw image of .tif, as well as the Format in TIFF (D) since I'm not making any more adjustments and I certainly don't want to compress it down to .jpg. Then choose Compression = None (E).

d. Hit Save (F). The dng files are converted to tiff files.

FIGURE 8.20
The Save Options menu of Camera Raw. Select where you want to save your image, choose the file extension of .tif and TIFF Format.

3. Create a Movie File using Apple's QuickTime Pro

This is the final step of this raw workflow. Now that you have a series of .tif files for your shot, you can convert them into a ProRes movie file that you can use in Final Cut or other editing software. These steps show you how. (Note: you'll need to pay for QuickTime Pro, since you cannot execute this process through the free QuickTime Player.)

1. Choose "Open Image Sequence. . ." from the File dropdown menu (Figure 8.21). It'll converge all of your TIFF files into an uncut sequence.

FIGURE 8.21
QuickTime Pro contains an "Open Image Sequence. . .", indispensible for a good raw workflow.

2. You'll see an Image Sequence Settings window pop up where you can choose the frame rate of the project from a dropdown menu. I chose 23.976 fps (Figure 8.22).

FIGURE 8.22
Choose the frame rate for your film.

3. Choose File→Export (CMD E) and direct the file to where you want to save it (Figure 8.23). Name the .mov file (A) and place it in the proper folder (B) on your hard drive.

4. Choose the Options button (C) and adjust these settings as needed (Figure 8.24). This window provides a summary of the settings, which you can change by hitting the Settings button.

FIGURE 8.23
The Save window allows you to name (A) and place your file (B), as well as to choose Options (C) for your QuickTime movie conversion.

5. Go to the Compression Type (A) to get to the dropdown menu (Figure 8.25). For this project, I chose Apple ProRes 422 (HQ) (B), since it's a web based project. For a full film out, then choose Apple ProRes 4444 (C), or other compression scheme, as needed. If you choose C, then the Compressor bit depth of Millions of Colors (D) is set. If not, then your window will look like Figure 8.26 (see step 6).

FIGURE 8.24
QuickTime Movie Settings menu has further buttons with additional menus.

FIGURE 8.25
QuickTime Pro has a variety of compression templates to choose.

6. I keep the Frame Rate Current (A) and select Gamma Correction to None
 (B) with no Interlaced scaling (C). Hit OK (D). (Figure 8.26).

FIGURE 8.26
QuickTime Pro allows you to choose your compression template and make further adjustments in the Video Compression Settings window.

7. You'll be taken back to the Movie Settings window where you can see a
 summary of your settings (Figure 8.27). Hit OK.

8. Hit OK and your .mov movie file will be built from the sequence of TIFF
 files. Import the .mov file into your editing software.

FIGURE 8.27
Examine the summary of your movie settings before exporting.

Although this entire sequence seems a lot, by breaking it down into the three major steps and by following the suggestions within each section, hopefully this has made the process easier to handle. I feel that Adobe's Camera Raw is the best grading software out there for engaging in the coloring of your CinemaDNG files from these cameras. Perhaps using DaVinci Resolve for the Blackmagic Cinema and Pocket Cameras makes more sense, since Blackmagic has the ability to tweak the software to match the specs of these cameras— especially when using Captain Hook's plugin Look Up Table. At the same time, the uniqueness of the TrueSense CCD sensors found in the Ikonoskop and the Digital Bolex requires a bit more fine-tuning in the postproduction process and I've found Camera Raw to be a solid tool to bring the most life to these cameras. With the calibration of the Digital Bolex camera, Pomfort's LightPost is a strong option if you're looking for an easy to use and quick grade. Use Camera Raw if you have the time and need to engage subtle changes and detail work.

Conclusion

The Importance of Color Depth and the Uniqueness of Cameras

When I first saw DSLR footage on Vimeo about four years ago, I got really, really excited about the possibilities. Looking at Philip Bloom's *Skywalker Ranch* (https://vimeo.com/8100091) and Vincent Laforet's *Reverie* (https://vimeo.com/7151244)—I wasn't getting shots like those on my Panasonic DVX100 nor on prosumer HD video cameras. I remember being on set of Po Chan's *The Last 3 Minutes* (https://vimeo.com/10570139) and looking with amazement as Shane Hurlbut, ASC took Canon's 5D Mark II and worked cinematic magic with it. Excitement pulsed through my veins—I wanted one. Indeed, I wanted to share that excitement with my film and multimedia journalism students at Northern Arizona University.

I even wrote a book about the revolution, *DSLR Cinema* for Focal Press, which came out in October 2010. The 5D Mark II, and later the 7D and Rebel T2i/550D promised many film students and low-budget independent filmmakers that they, too, wouldn't have to settle with video crud, but potentially shoot cinematic-quality films.

I bought gear, I shot with a 5D. I remember shooting a scene, the subject looking great through a Canon 70-200mm f/2.8 lens—the glass wanted to make that image so beautiful, and through the live view LCD screen, it did. I didn't know it at the time, but the image was uncompressed. Of course it was. The 5D shoots beautiful raw stills and the live view mode gives you that sense of raw beauty.

But when I put it on the computer, it didn't look so hot. In the back of my mind I wondered where the magic went. Something just felt off. When I shot on Arriflex 16mm film in my NYU days in the mid-1990s, I would look through the glass, get the film developed and that beauty, that magic, shone through the film.

And when I shot with the 5D I felt that same sense of filmic excitement, until after the scene was "developed." At the time I didn't know much about 8-bit compression. I didn't know how the image was being compromised, thinned out to save space. But I lived with it, because if you got that image to look

close in-camera, you were going to get a good image on the computer. I've always wanted to make movies and before I knew any better my brothers and I would shoot on VHS in the 1980s and early 1990s, then we shot some projects on Hi8mm—these were the things we could afford. We didn't know much about cinematography. All that I do know is that nothing I've ever shot with looked like the stuff I shot in Greenwich Village on 16mm film.

That is until I shot with the Digital Bolex, the Ikonoskop, the Blackmagic Cinema Camera. These cameras are different than anything else I've shot with. My favorite is the D16. It's personal. It's magical. I can't wait to film a work of fiction and a documentary on it. (Others may like the Blackmagic or if they can afford it, the Ikonoskop.)

How do I know these cameras deliver the goods? After I imported the clips from my Venice Beach documentary shot on the Digital Bolex D16, placed them into my MacBook Pro, and opened them up in Adobe Camera Raw I knew something was different. The same thing happened to some extent when I imported Ikonoskop and Blackmagic Cinema Camera footage into DaVinci Resolve. But with Camera Raw, I felt I was digging deeper into the digital film—more so than with Resolve (this is a personal preference, so please use the software that works best for you).

But what I saw was what I shot—it was dense. I could manipulate the image like I was in a dark room mixing chemicals—but now I was mixing temperature balance, tint, contrast, exposure, and film curves.

The magic's beneath the hood, where we find skin tones. Roll off of light and shadow. Details and color popping out through digital pixels. But it wasn't film. What kind of magic has the Digital Bolex team wrought? Those were the first thoughts rolling through my mind when I first saw that footage from Venice Beach on my computer.

I, of course, had seen and manipulated the footage in the Blackmagic Cinema Camera and the Ikonoskop, so I knew there was something special going on even before the Bolex. But it was at this moment it all clicked. And this is what some people may not understand about these raw cinemaDNG cameras— the magic isn't in the sharpness of the image (although that's a side effect of 12-bit raw). It's not about 4K vs. 2K or HD. It's about color depth—not ultra high resolution.

Some might look at the short film I shot with the D16 and say that the images you see at Venice Beach are just a postproduction effect, a trick—show me what the camera can do, already! Anyone can layer effects and make an image look like film, right?

But I've applied Magic Bullet to my 5D footage—and those things do look like an effect—sometimes like a plastic Halloween mask when overdone. But the footage in that D16 is something different. I shot this at the height of noon on Venice Beach and I'm getting exposure on a dark-skinned street performer

against a blue sky. That's not something I could get in an 8-bit compressed image coming out of a DSLR, for example.

It reminds me of the days of shooting on 16mm film. I can almost touch it, feel it, manipulate it into the magic of what filmmaking can do—shimmering dreams on the edge of your senses and document real life in a magical way. The footage is organic and those who color grade with this footage will feel the difference in the density of the image. It was clear when I was grading footage on the Canon C100 in Final Cut Pro compared to the density of the Blackmagic Cinema Camera image I was getting in Resolve when I was working with the Carpetbag Brigade footage. It simply *felt* different. 12-bit is simply denser than 8-bit in the grading process.

So don't let the marketing hucksters at the big camera companies tell you otherwise. They're selling to the masses with their sleight-of-hand sharp images, fooling everyone into a sales formula: $fi = (uhr)^2$ (filmic image equals ultra high resolution squared).

Maybe those who live in the era of high pixel count and sharpness think that ultra high definition is what cinema cameras should be. But they tend to be the ones who have never shot on film. Don't get angry at them. They don't know any better. Pity them. Teach them. Guide them to the D16 or the Ikonoskop or the Blackmagic Cinema Camera, if you prefer. (I hesitate to say this about their 4K camera, because I'm afraid they may have fallen into the resolution trap—jumping on the 4K hype bandwagon—but I haven't shot with either, so I'll stick to what I know.)

But if the pixel peepers don't listen to you, move on and make your films. Stay away from them. They're not good for you—the ones who like to compare who has the bigger size . . . pixel count. They're not making films. After all, the Bolex and Ikonoskop teams mission wasn't to make the perfect camera for everyone. They stood out as being something different.

Even Blackmagic created something different—but ultimately their design, the scope of what their camera can do—never came across as something spectacular, outside the initial assessment of the image. Operationally, the Cinema Camera has its flaws. And the Ikonoskop entered the stage too soon—they had to create new technologies to do what they wanted to do and they outcost their market, despite the fact they had the best ergonomically designed camera.

But are the big companies listening? Hopefully not. We want Joe Rubinstein and Elle Schneider of Digital Bolex, the hackers of Magic Lantern, and the Grant Pettys of the world to keep doing their thing—crafting new designs and technologies for filmmakers who care more about the image than expensive camera specs. And perhaps that's the new revolution occurring in the world of independent motion pictures. Professional cinema cameras for those shafted too long by the big companies, giving us inferior products or superior products outside our budget.

So whatever the flaws, each of the cameras in this book is unique and we should celebrate that uniqueness. If you're a Blackmagic Cinema Camera fan, rejoice that this camera shoots 12-bit CinemaDNG raw. Celebrate the fact that the Ikonoskop isn't like the Blackmagic, and feels like poetry when you handle it. Celebrate the fact that Digital Bolex could have made cameras like everyone else, but chose not to. Why should these companies make something somebody else already made? So let's rejoice that there are companies on this planet that don't want to be the next Canon or Sony. Rejoice that there are those who dare to dream and make their dreams a reality, for that's exactly what these other companies have done, here, with their cinema cameras. You'll have your favorite. I'll have mine.

As for me, when I shoot with the D16 Digital Bolex, it's like they made the camera for me, for those like me, for you—the ones who really care about shooting on film, but never had the chance. This may be as close as you get. They've made me proud to be an independent filmmaker again.

Am I giving up on DSLRs? No—these are important cameras that are easy to use and are good tools for learning filmmaking. Learning their limits and getting a strong image in-camera makes these cameras viable for low-budget filmmakers and film students. The new crop of low-budget cinema cameras are more expensive, and need more bandwidth and hard drive space. They take time to process and get into post. Time's needed to grade them. They're not for everyone, not for every project. They're special. I'll still shoot projects on my 5D Mark II—I still love and teach with DSLRs. But when I have a special project—documentary or fiction—and I have the time and resources to go the extra distance for something special, I'll be shooting with the D16. No question.

New filmmaking lessons await the film student and independent filmmaker. The principles of lighting, exposure ratios, dynamic range, digital film density, color richness/grading/timing in the postproduction process (digital development, if you will)—will become the tools of the digital filmmaker and these are very similar tools that analog filmmakers used.

The CinemaDNG raw revolution is upon us, providing us with the tools previously afforded only to those with big budget money. What will we do to step up and seize the power of raw cinema? Choose your favorite CinemaDNG cinema camera and make movies that are as powerful as your imagination.

Afterword

The Organic Look of Digital Film

by Joseph Rubinstein

As a high school student I fell in love with black and white 35mm photography. I spent all day in the dark room, I begged my teacher for more film. I volunteered to assist the night classes so I could spend more time developing and printing. My first job was at a film processing lab and I spent all of the money I earned there on more film so I could keep shooting. Something sort of magical was happening. I was converting moments from my life into preserved pieces of art. I was saving my experiences so they didn't dissipate.

This is no small thing; in fact it's meaning-of-life level stuff. I was discovering meaning and value in myself and life in general. I was figuring out which parts of life would be forgotten, and which parts had a little more permanence.

When I went to college I fell in love with film all over again, but this time it was 16mm motion picture film. At one time I had five 16mm cameras and dozens of lenses. The long history of 16mm film meant that I could purchase lenses that were 50 years old and still use them on my cameras. The format was more intimate than the 35mm one, and felt very personal. The lenses themselves were like undiscovered treasures. Each one gave a different view of the world, each moment unique. When I played the images back I felt like it was magic, like I was capturing something with unique beauty, fleeting moments of life congealed into something more lasting, the ephemeral made concrete.

I never got the same feeling from any of the video cameras I tried, even when the resolution was increased to the seemingly impossible 1080p. I felt like the images were dead, predictable, alienating. I was afraid that this amazing feeling would be trapped in time like the images themselves.

Then I found it again. Transitioning back to still photography I found I could fall in love with the images again if I could shoot raw, which retained the original sensor data. It was like having the dark room back, but this time in my house. And again I spent all day there, based my business on it, and obsessed. The business I mention is called Polite in Public, and our company goal was to bring studio-quality photography to people who didn't often get access to

it. It was still the early days of high-end digital cameras and not everyone had access to them, and therefore many people had never been photographed in that way. Our focus was on getting professional quality gear and photography out to where the people were so they could see themselves presented this way. The business took off and was a big success. But this didn't quite fulfill my true desire to get that feeling back. For me personally to feel that again the images would have to move. I wondered how hard would it be to make a camera that created raw sensor data like the still camera, but at 24 frames per second?

After about nine months of deep research, I found out this was possible, and that no one was doing it for the 16mm format. I felt compelled. I needed to do this. I sold my half of a company I spent six years building and dreamt of a camera that could give this feeling back to me.

Well I'm happy to report that feeling is back, and it's here to stay. The organic look of the footage, its raw moldable nature, on this intimate 16mm format is exactly what I have always wanted. Shooting again feels like magic, the ephemeral converted to the concrete, fleeting moments of life again feel more lasting. I feel like I can create beautiful things that could be around after I'm gone. Like I said, meaning-of-life level stuff.

Joe Rubinstein is the founder and CEO of Digital Bolex.

Appendix

Why You *Must* Have 4K and Raw and Why You Absolutely *Don't* Need It[1]

by Philip Bloom

OK . . . a confusing title. Let me clarify. I would shoot raw and 4K on every single shoot if I could. It's wonderful. I want everyone to shoot raw and 4K. There we go. BTW it is actually raw not RAW. It's not an acronym. It's a word. Raw data. Unprocessed. You know . . . raw! I hate unnecessary caps and there is nothing worse THAN WHEN PEOPLE WRITE EVERYTHING TO YOU IN CAPS BLAMING THE CAPS LOCK IS STUCK. I DON'T CARE. I CANNOT READ IT SO PLEASE BUY A NEW COMPUTER NOW OR GET SOME WD40 PLEASE! Phew . . . that's better!

I am not a negative nelly, poo-pooing raw or 4K. Far from it. I am just a cautious person by nature. When I see everyone clamouring for it, I have to ask the question "why do you want it?" which usually gets the obvious answer along the lines of they "want to be able to shoot the best images with the best latitude." I then ask the more important question, "why do you need it?" Of course I get the same answer! That should not be the case. That is the key. What you want and what you need are two vastly different things.

Raw is brilliant. 4K is sexy as hell . . . BUT they both come with a number of quite severe headaches for the vast majority of people (including myself) who are clamouring for it. If those headaches were not there, then I would tell everyone to go for it, but as I am in somewhat of a position where people listen to me (still an utterly bewildering thing to me) and take what I do or advice I give as verbatim (which you should never do, mine is just one opinion so please feel free to ignore this or take my advice on board and listen to others too as you should never take one person's opinion as gospel) then I must explain the issues we face. I am not being devil's advocate either, as I genuinely believe these issues are real and would be quite a problem for many. Not everyone though. Some people are perfectly kitted out to take this on and their work is ideal for it. So whilst my title of this article is essentially black and

1 Excerpted from Bloom's blog post of May 16, 2013 (http://philipbloom.net/2013/10/10/4kraw/). Used with permission.

white, the actual arguments are not. There are many shades of grey and most of us, if not all of us, fall into this grey area at some point. There absolutely is a use for both of these for SOME jobs . . . just not for all.

When I shot lots of RED Epic which was only ever raw and 4K/5K, the images I was getting looked so gorgeous and the flexibility in post was amazing. Truly eye opening. The problem I had was in post and in storage, and this is with R3D files, which are way more manageable than other raw/4K formats floating out there. I ended up getting a very expensive Mobile RED Rocket card to make my post life more bearable. I still spent a small fortune on hard drives.

These Epic images were indeed epic, some of the finest looking images I have shot, technically, you know . . . in a pixel peeping kind of way (please do not pixel peep as it makes the palms of your hands go very hairy!). They were not my finest work creatively—that of course is nothing do with the camera. That comes down to me. An important point to make. One I have made countless times before . . . a better camera WILL NOT MAKE YOU A BETTER SHOOTER OR FILMMAKER. It will make your images look better compared to if you had shot on a lower end camera for sure. 4K and raw will not make your work any better. Although it may help you mask mistakes so the appearance of your work is better.

There is absolutely nothing wrong with making the appearance of your work better than it actually is. When I first shot tapeless using XDCAM discs, I used to erase shitty shots and make my rushes look better . . . but *only* when I gave them to the client. Not if I was editing them myself, I didn't care how clean they were. But I wanted my client to have clean rushes. It made me look way better than I actually was.

That is the joy of raw, the ability to do so much with it in post is just incredible. You can fix so many in-camera issues, not all of them of course, but many. It can rescue shots due to lost detail in highlights and shadows, fix those white balance issues . . . it can help make the most of difficult shooting situations when you can't deal with the issue in-camera like you would normally, for whatever reason (as in different lighting). That is not the whole point of raw at all, it's not there to fix things in post, it's a big plus of it. It's more for getting past the limitations of codecs giving limited dynamic range, so you get more creative choices in post. So couple raw with the stunning detailed high resolution images that 4K give you, then you simply have the best images possible and the most flexibility in post. BRILLIANT. After all, that is what everyone wants!

Of course, all of this is utterly irrelevant if your content sucks. No point shooting on a high-end format like 4K and raw if your content is below par. It is not going to make it any better just because it's raw and 4K. If that was the case I would shoot everything I did in 4K and raw, no matter what, so I could magically take even my most mediocre work and make it much better!

Until recently, 4K and raw video was pretty much exclusively RED. Without Jim's visionary company, the high end cinema arm of camera companies would

have rested on their laurels. RED gave them a massive wake up call. Good. Everyone needs a good kick up the backside every now and then. Blackmagic Design are another visionary company, but let's talk about them later.

So which company was accidentally the main catalyst for everything changing? Canon of course. Not by design, by accident really. The 5D Mk II revolution was not intended but a happy collection of circumstances that collided in an event of universal magnitude that rivaled the big bang in its significance to humanity. OK, maybe a wee bit of an exaggeration, but certainly for us filmmakers it kind of felt that way.

Canon never set out to change everything, but they did. As much as some corners may whine that it has watered down the industry and created way too much competition, I for one am utterly grateful for what happened. Prior to this, I saw so many people get work because they had the gear, not the talent. Now the playing field is leveled, talent can shine. It's not all great of course, as more competition means less work for some, and many saw a collapse in their amount of work and the amount they were able to charge. This sucks but it's inevitable. It happened to the stills industry quite a long time ago after all.

In fact it was the coming of DSLRs that ironically made me move my career plans from being a photographer to a video cameraman. A photographer friend of my father took me aside and said, "Philip, I know this is what you want to do, but everything is going to change in the coming years and the incredible time we are all having will come to an end. Digital will take over and with that will come a huge influx of people into the industry cheapening it and dropping the quality. It is inevitable. Have you ever thought about moving images? That's where the future is". Utterly true, and this was back in 1988. If he had said to me "but beware of the end of 2008, a French-American will come along and drop a New York based short on us, shot on a camera that will do the same for video that is going to happen to stills" then I would have laughed at him and just ignored him. Well, that happened.

Of course we have lived with the issues these cameras gave us and of course the freedom too, but people want more now of course, especially with DSLRs being in a bit of rut at the moment. They are fed up with compressed codecs. So when RED brought out the Scarlet many people saw this as their way out of DSLRs and into the big league. Now of course this is utter nonsense. As I said before, no camera will actually make you better. Some cameras will help you get work though. C300s for example are massively popular right now and owner operators are reaping the benefits of this. Most of the people I know who bought Scarlets were gutted when this massive investment from their T2i didn't pay off. For some it did, but for most no. Why? A CAMERA DOESN'T MAKE YOU ANY BETTER! I may have mentioned that to you already.

Blackmagic Design in April last year dropped a bombshell on us. A $3000 raw shooting video camera (that also shoots on, the much ignored feature of the camera, ProRes HQ and Avid DNXHD modes, which are damn fine). $3000?

WHAT?! How is this possible? Well, mostly due to a lot of off the shelf components and a clever knowledge of how to deal with video due to their experience in the postproduction market. With limited R&D costs, they were able to bring out a camera with such high end features and low cost that it was probably the biggest kick up the backside we have had since the 5D Mk II.

. . .

Now with the additional excitement of the new Magic Lantern hack, which has quite incredibly brought raw video to the 5D Mk III, the raw clamor has reached unparalleled heights. Although this hack is still in a very early stage, it will undoubtedly reach a more stable level pretty soon, and everyone will be desperate to shoot everything in raw on the Mk III. Why? Because it's raw . . . you know? It's better. Yep. It is. A hell of a lot better. Not just that, but the image itself is better than the Mk III is able to give us normally. There is more detail, and with raw much more dynamic range of course. There are a number of big caveats though which I will get to . . . but the achievement of these people is incredible and should be applauded hugely.

I am assuming most people know what raw is. I didn't at first when I came across DSLRs so if you don't know, are too embarrassed to ask and haven't yet googled it then here is a description [http://en.wikipedia.org/wiki/Raw_image_format].

Anyone who shoots stills knows how massively better raw photos are to manipulate than JPEGS. That's the crux of the whole argument. It's a digital negative. This is the same that raw video offers us over codecs like MXF, ProRes and AVCHD. You may notice I am not using the word uncompressed. Uncompressed IS NOT raw. Please don't get them confused. There is uncompressed raw. That is what the Blackmagic Cinema Camera gives us, and its files are massive. The RED for example shoots raw but is compressed. The amount is up to you when you use the camera, there are different levels of compression. R3D is for me probably one of the best formats I have ever used, not the simplest to use, but the most powerful yet workable. The user can decide the level of compression that works for them while still maintaining raw. Compression is our friend. Well, lossless compression is our friend! Why? Money and time. Money, as our storage needs are slashed, both in cards/ SSDs/ hard drives. Time as the files are much smaller meaning they're quicker to work with, and of course time is money, so really it all comes down to one thing . . . money. Money is why we should not shoot raw for everything. The same can be said of 4K.

. . .

With the Magic Lantern hack, I have heard of people having success with slightly slower cards. That's great, but I am pretty certain their cards are going to stop fairly frequently. I don't know about you, but I have no desire for my camera to ever stop rolling when I don't want it to. 1000x cards are needed for the

current Magic Lantern hack, which means a lot of money is needed for data acquisition and that is before we even get into offloading them.

I love my 1DC though. I can take it anywhere with me in a simple shoulder bag and shoot 4K stock footage whenever I want. I can shoot guerrilla style in 4K, which is pretty lovely as the camera is so compact and of course I love the image. I just hate the format. Not just the cost in cards and in storage but in the time it takes for me to deal with it in the edit.

For so many years I have been editing full HD files on my laptops with no issues. None of this proxy nonsense. I don't need that. I remember going into a production house about six years ago to check out an edit for a series I had done for Channel 4 in SD. They were editing in 15:1 as they didn't have the storage capacity for the original DV tapes . . . yep DV, shot on the lovely DSR-450. I found this astonishing as I was editing XDCAM full HD on my MacBook Pro on 5400RPM USB 2 drives. Now though with my 1DC, I cannot edit without using proxies. My computer cannot cope with it and I need very fast drives to edit the files from. As I travel for around 10 months of the year, I edit the vast majority of my work on my MacBook Pro Retina. Powerful computer but not powerful enough. So even if Apple astonishingly did release new MacPros it would make little difference to me right now as I am never home!

So let's go over the main pros and cons of raw.

Pros

- WAY better dynamic range than most cameras.
- Huge flexibility in post.
- Can help mistakes made on shoots or help us get past issues we couldn't overcome.
- It opens up many creative options in really hard shooting environments, making my life as DP easier often and this is not about laziness.

Cons

- Generally cannot be edited natively, proxies are needed after going into software like DaVinci Resolve to interpret the raw data and tweak them before exporting to the proxy format. This is very time consuming.
- Much larger files than compressed codecs meaning lots and lots of cards. Though there are raw compressed options out there like R3d and CineForm which I am expecting will be licensed and put into the new 4K Blackmagic Production Camera.
- The huge cost in acquisition media and the enormous cost of storage on top of this.
- You need to learn new skills. This is almost a pro actually. Working with raw is not as easy as many think. Education is key here.

- It's not magic. You still need to know how to expose properly and I actually think a light meter comes into its own here, knowing how many stops of light difference there are between the shadows and the highlights. STILL hold the highlights more than the shadows for most raw cameras as a rule.
- People will want to shoot everything with it, then hit a massive bottleneck on their projects in dealing with files. It will be a hard but necessary lesson.

Philip Bloom is a filmmaker who offers workshops around the world.

Index